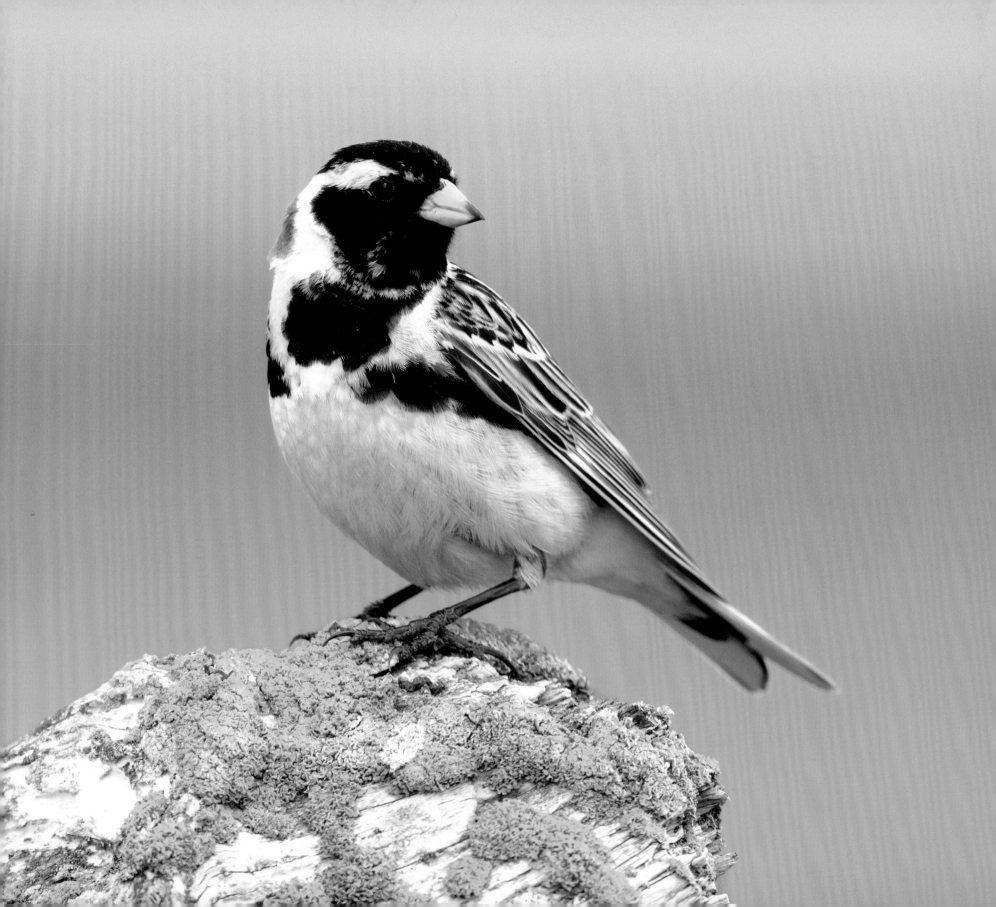

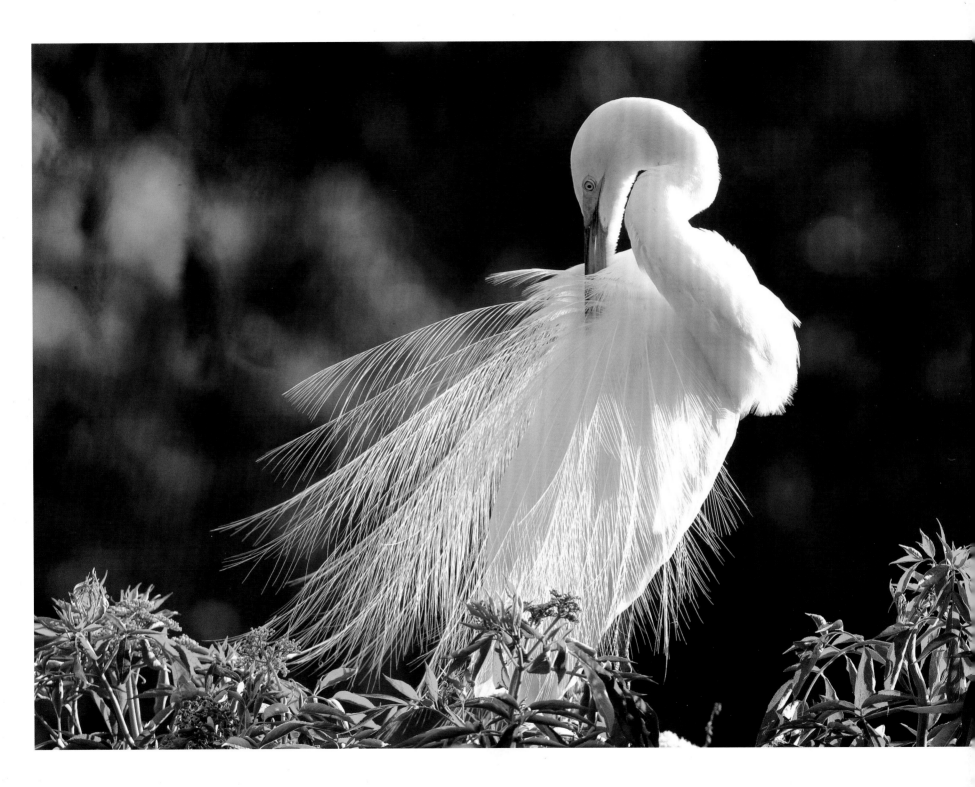

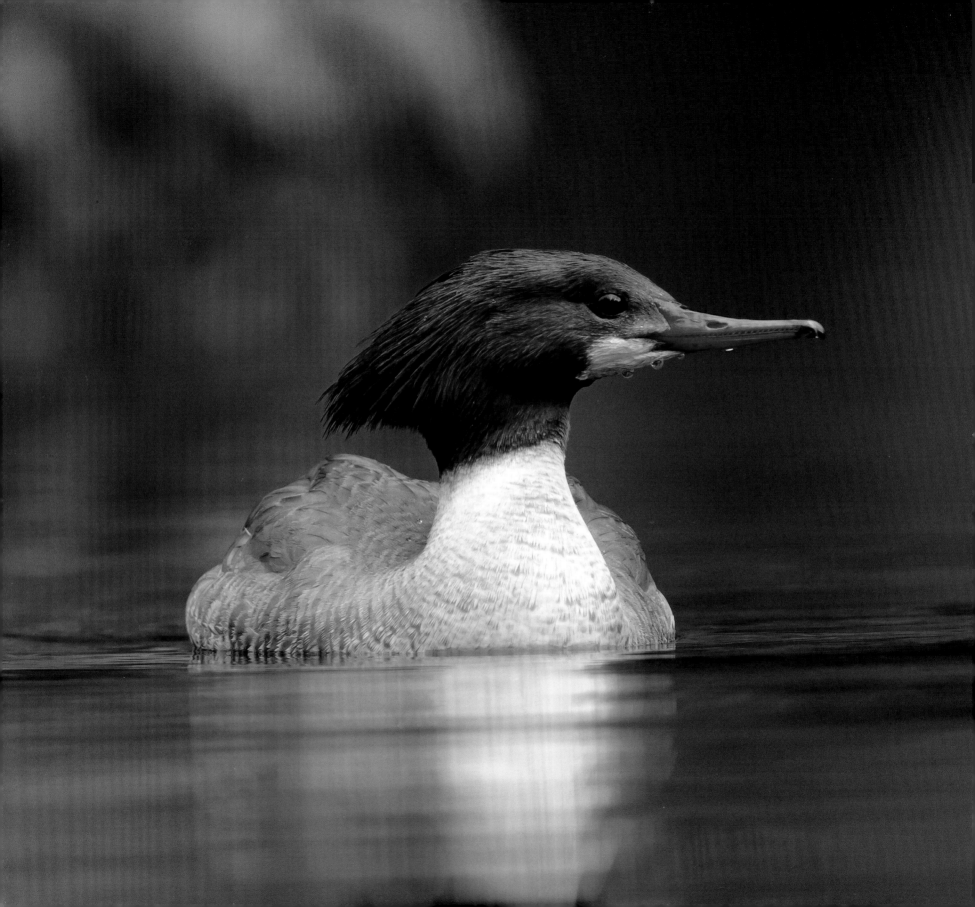

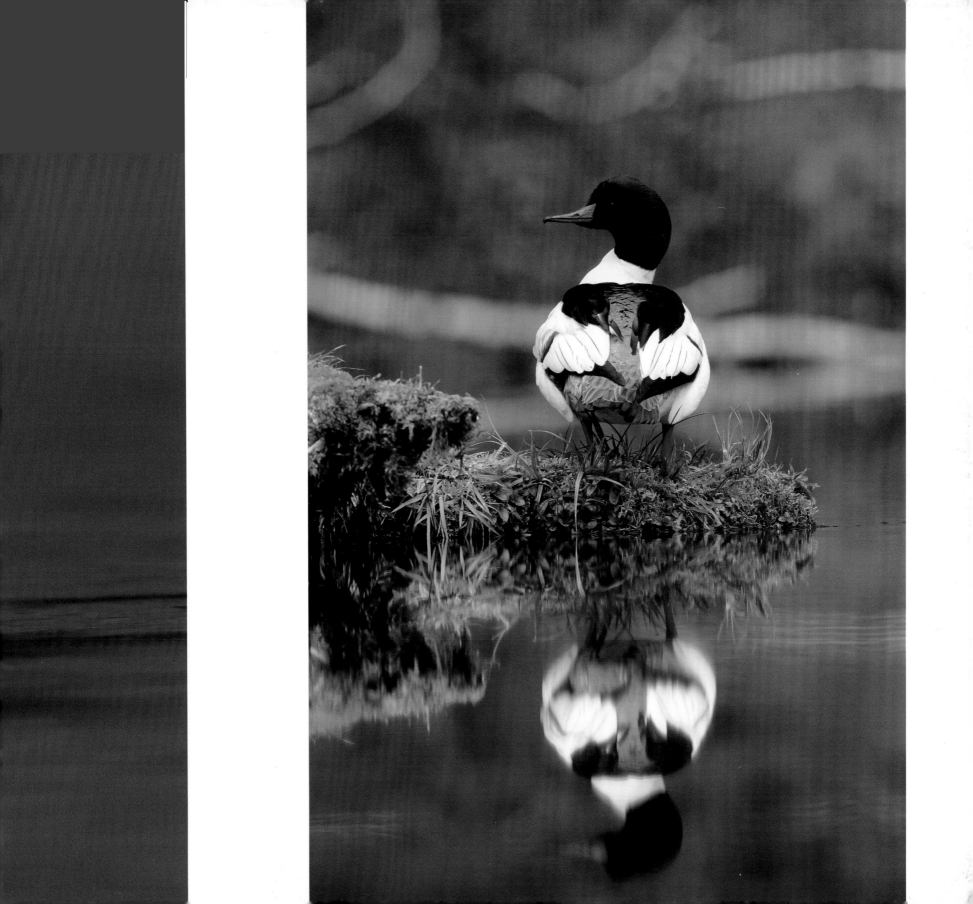

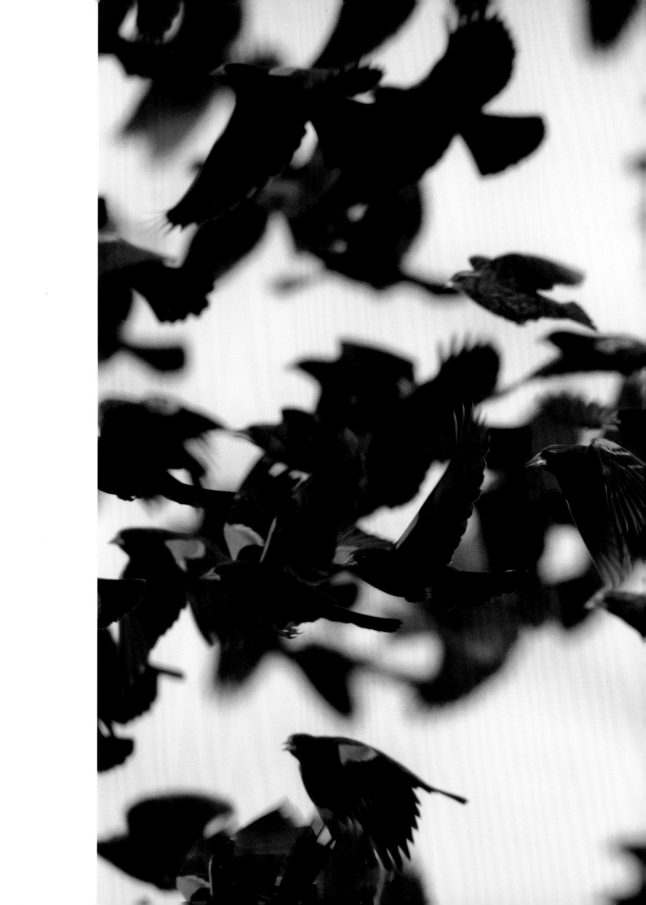

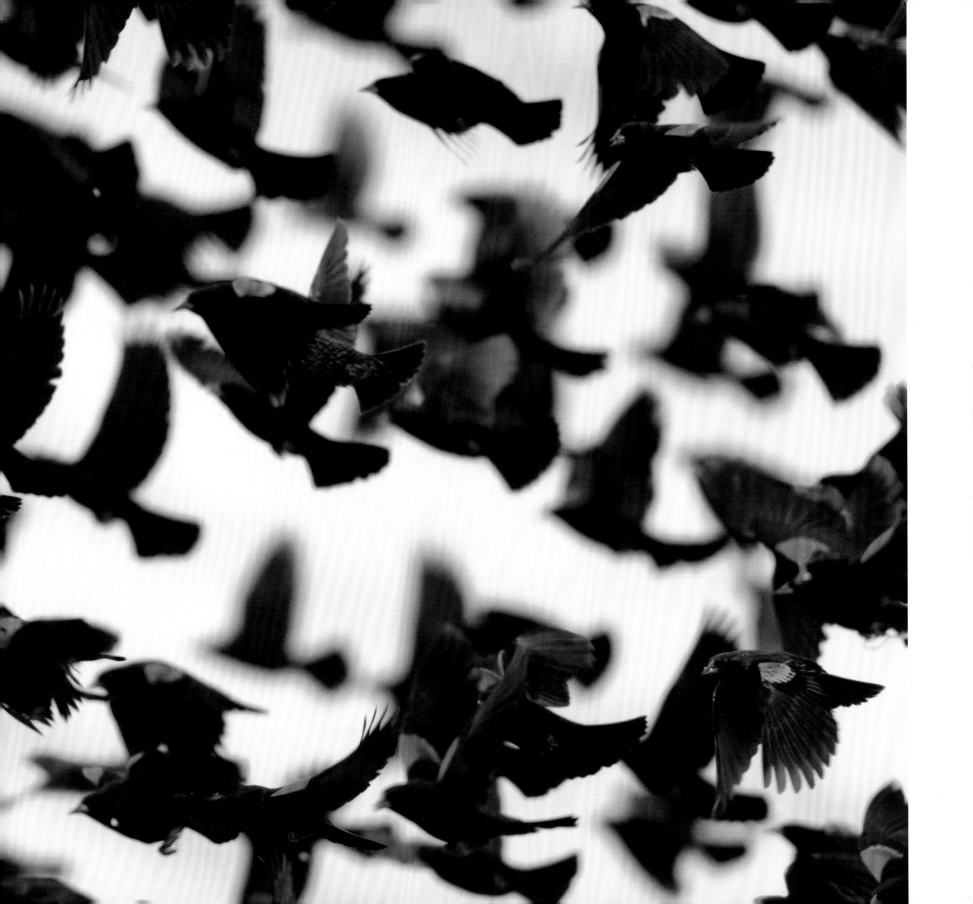

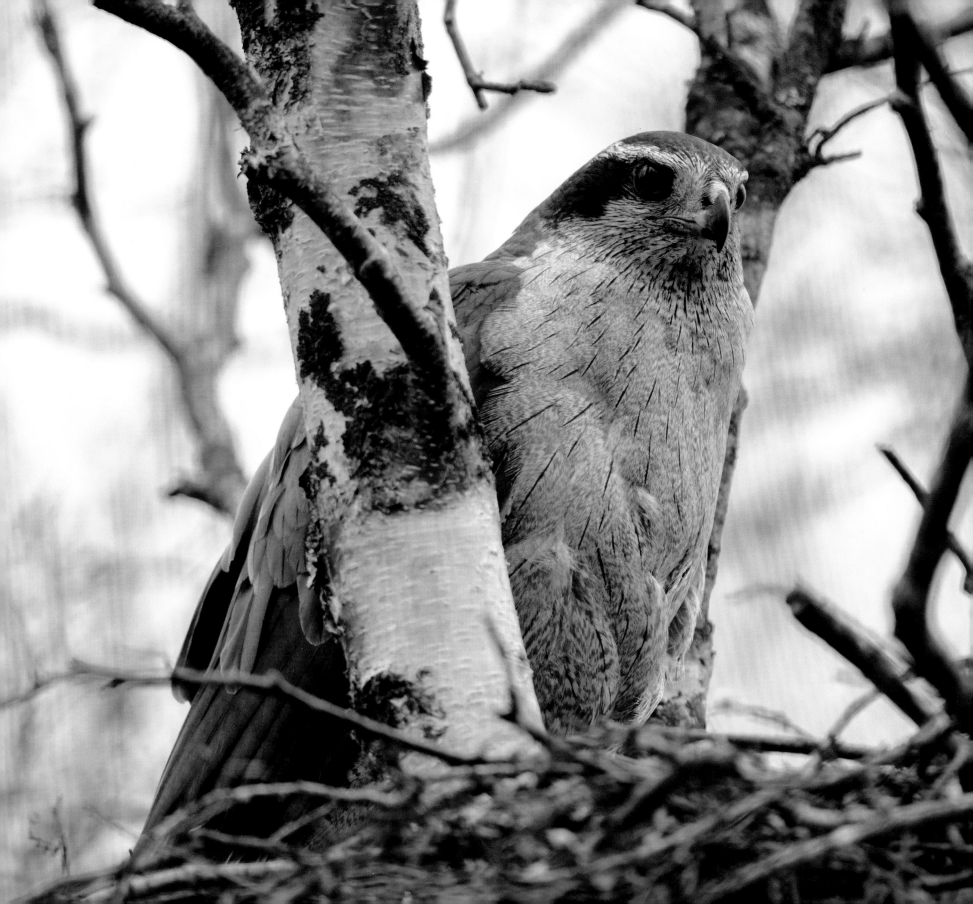

100 Years of Listening to Nature

THE LIVING BIRD

The**Cornell**Lab of Ornithology

Photography by Gerrit Vyn
Foreword by Barbara Kingsolver

Essays by Scott Weidensaul, Lyanda Lynn Haupt,
John W. Fitzpatrick, and Jared Diamond

Additional text from Sandi Doughton, Miyoko Chu,
and Dennis Paulson

MOUNTAINEERS
BOOKS

Mountaineers Books is the nonprofit publishing division of The Mountaineers, an organization founded in 1906 and dedicated to the exploration, preservation, and enjoyment of outdoor and wilderness areas.

MOUNTAINEERS BOOKS

1001 SW Klickitat Way, Suite 201, Seattle, WA 98134
800.553.4453, www.mountaineersbooks.org

Manufactured in China on FSC®-certified paper

18 17 16 15 1 2 3 4 5

Copy Editor: Julie Van Pelt
Design and Layout: Jane Jeszeck, www.jigsawseattle.com
All photographs by Gerrit Vyn.
FRONT PORTFOLIO page 1, Northern Flicker; page 2, Lapland Longspur; page 3, Great Egret; page 4, Female Common Merganser; page 5, Male Common Merganser; pages 6-7, Red-winged Blackbirds; page 8, Northern Goshawk
DEDICATION PAGE Yellow-billed Loon
PAGE 12 Short-eared Owl
BACK PORTFOLIO pages 204–205, Snow Geese; page 206, Male Northern Shoveler; page 207, Male Wild Turkey; page 208, Female Northern Harrier

Library of Congress Cataloging-in-Publication Data
The living bird : 100 years of listening to nature / The Cornell Lab of Ornithology ; photography by Gerrit Vyn ; foreword by Barbara Kingsolver ; essays by Jared Diamond, John W. Fitzpatrick, Lyanda Lynn Haupt, and Scott Weidensaul ; additional text by Sandi Doughton and Miyoko Chu.
 pages cm
 ISBN 978-1-59485-965-6 (hardcover)
1. Birds. I. Vyn, Gerrit. II. Cornell University. Laboratory of Ornithology.
 QL673.L68 2015
 598—dc23
 2015007255

ISBN (hardcover): 978-1-59485-956-6

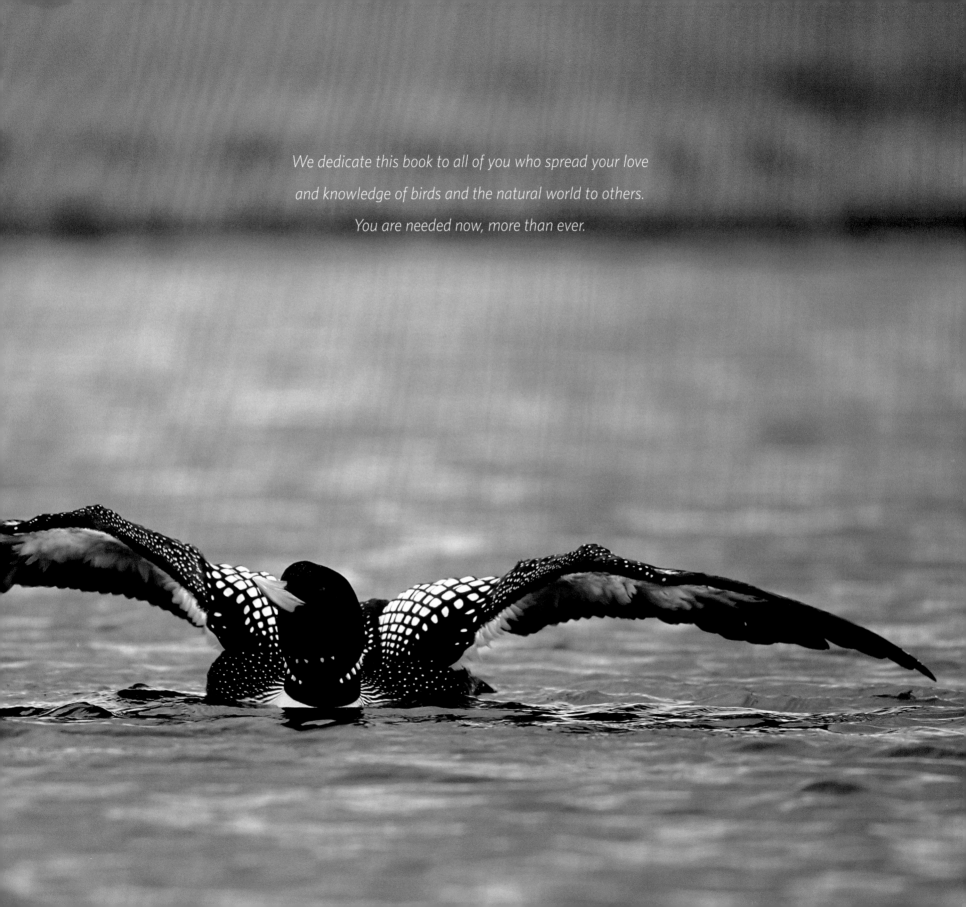

We dedicate this book to all of you who spread your love

and knowledge of birds and the natural world to others.

You are needed now, more than ever.

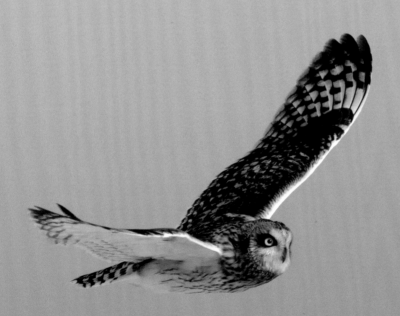

CONTENTS

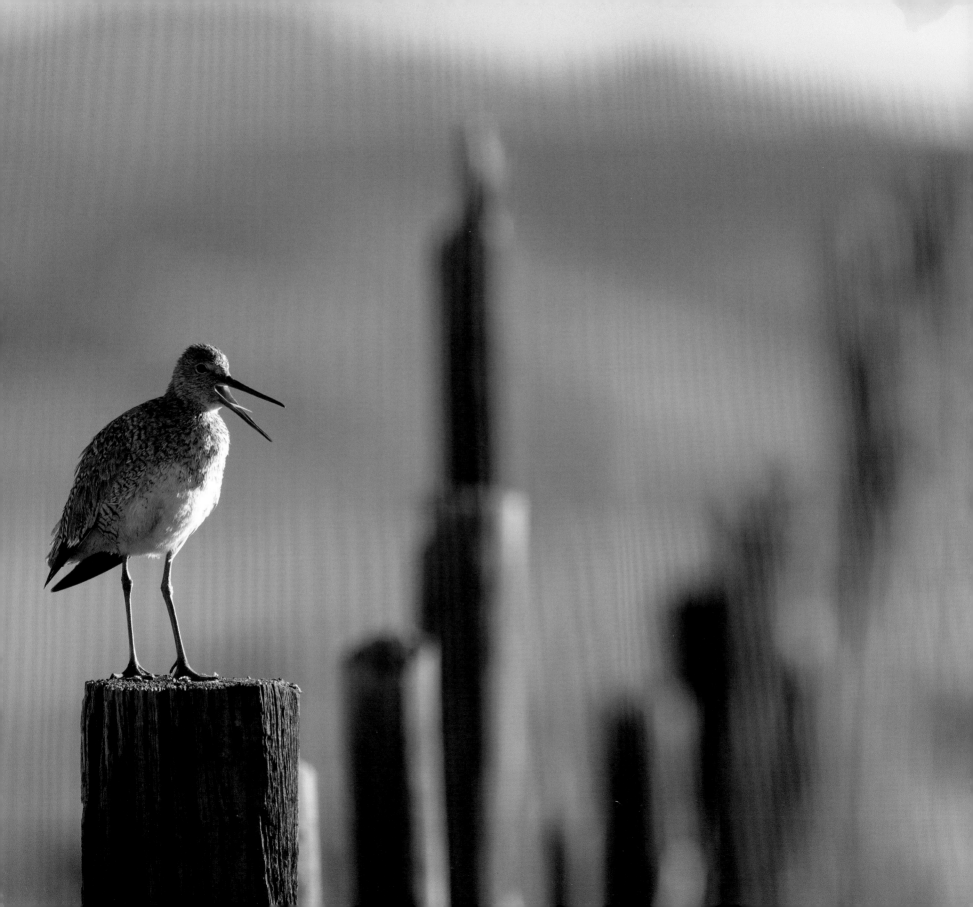

BIRD-WATCHING WITH MY DAD

Barbara Kingsolver

OPPOSITE A Willet calls in a Wyoming pasture where it will raise its young, far from the Gulf Coast where it may have spent the winter among other Willets and shorebirds, dodging beachgoers and probing for crabs. A bird on a fence post may seem unremarkable at first glance, but dig a little deeper, and each bird has a fascinating story to tell.

I HAVE TRIED to look away from the birds. I know it's possible. People can manage their whole lives birdless, or the next thing to it, hearing them only as background music to more important human events. In art and film they are regularly used as interchangeable decorations. When I glance around the movie theater nobody else seems bothered by the Eurasian Jackdaw that flits across what is supposed to be North Carolina, for example, or the circling movie eagle that screams with the unmistakable voice of a Red-tailed Hawk. In my life I've aspired to a comfortable indifference to particulars like these. Our history is complicated, the birds' and mine. It could even be called star-crossed. They came into my life at the worst of times, introduced by exactly the wrong person: adolescence; my father.

For most of my life until then I had absorbed my parents' passions without judgment, as an embryo drinks nutrients from the natal soup. In their rare free time together my parents always went to the woods and I followed, memorizing the wildflowers and trees as my father named them, training my ear to the language of botany. I cultivated a wildflower garden of my own and spent most of sixth grade on an ambitious science-fair project that involved mapping the wildflower taxa in our county. A few teachers might have been impressed but my peers were not remotely. I date the end of childhood from that science fair: I stood among the minimalist rows of beans in Dixie cups clutching my surplus of maps and specimens, confronted with a full-frontal gaze at the nerdiness of my résumé. By the time I entered high school I had fully reinvented my vocabulary and professed interests, training my high beams on popular music and boys.

And so I didn't notice exactly when my father lifted his gaze from the forest floor to the trees and bought binoculars. I was jolted to attention when he announced we were going to spend a family weekend at a statewide gathering of birders. Over the next few years I was conscripted into many tours of duty among avid bird hobbyists. I went sour on the birds in equal and opposite proportion to my parents' enthusiasm. Through the interminable evening slide shows—*the challenging* Empidonax *flycatchers may be distinguished by*

these subtle field marks—I defiantly read novels, or attempted to, in pure darkness. I howled against the early morning bird walks and always skulked at the back of the group, the sole teenager in attendance, keeping my distance from the binox-eyed tribe in khaki vests and terrible hats, determined never to know my wigeons from my mergansers. No one could make me.

Soon I left for college, confident I had freed myself from any further association with life lists and bird counts. From the safe distance of another state, my antibird credo softened over time to bird agnosticism. I was a biology major, after all. I could notice a cardinal if it flung itself against the library window. From there I ventured west to Arizona, a landscape utterly different from the woodlands of my childhood. I found it culturally fascinating, and biologically hostile. The botanical names that still rang faintly in the back of my head found no purchase here, in a desert where prickly opuntias crowded out all softer makes and models. I struggled with a terrible dislocation. To my surprise, it was the birds that came to my rescue, both the familiar and their next of kin. Cardinals were still cardinals here in feather and voice, and along with them came the almost-cardinal that is the Pyrrhuloxia. I recognized creatures whose habits and bobbing tails betrayed their wren-ness, despite their being supersized and having a fondness for nesting in cacti. And the hummingbird, heretofore known only as "the Ruby-throat," proliferated into marvels of variety poking at my flowerbeds. The Black-chinned gave itself away with a peculiar metallic wing-buzz like a tiny outboard motor. A sleek green Broad-billed arrived the first week of April, year after year, always coming back to build her teacup of a nest in the same myrtle tree outside my kitchen window.

And I couldn't help being mesmerized when a roadrunner flung up her stick platform in a shrub near my back

door and reared her family on a flabbergasting supply of lizards. I mean to say, she reemerged from the neighboring desert every fifteen minutes with yet another vanquished lizard dangling from her beak, all day long, for the weeks it took to fledge her young, which looked like little ptero-dactyls. I could not have guessed so many lizards existed in the near vicinity of my back door. Step by step, the birds of Arizona drew me into an understanding with my new bio-logical home.

Still more tests lay ahead for my life plan of bird dis-affection, as I eventually fell in love with and married an ornithologist. He had so many other irresistible qualities, I tried but failed to hold against him his publication record on White-eyed Vireos. When I took him home to meet my folks, their approval was a given. My fiancé did get nervous when my father requested to sit down with him to ask a serious question. This was it: "In the Christmas count for your area I noticed you had House Wrens. Is that usual?"

It was probably as good a question as any in the arena of prospective mate choice. We can never quite know what we're in for. My marriage has involved compromise like any other. He promised to stop interrupting me in conversation to point out a bird—unless the bird is outside of its normal recorded range, or a life-bird. In turn, I've agreed to take vacations in places that are rich in exotic bird life. I've learned to stand still and be transfixed by a toucan guarding her nest, or a hoatzin sunning himself in a swamp, or a manakin stirred to such ecstatic ardor that he moonwalks on his branch like Michael Jackson. I've also learned that our familiars can earn our deepest affections. On many sleepless nights I've taken comfort from the sweet pillow talk of courting screech-owl pairs. Wrens reliably make me smile. I never once forced my children to take a bird hike, and for this favor they've rewarded me richly. Like me, they sort of like the birds.

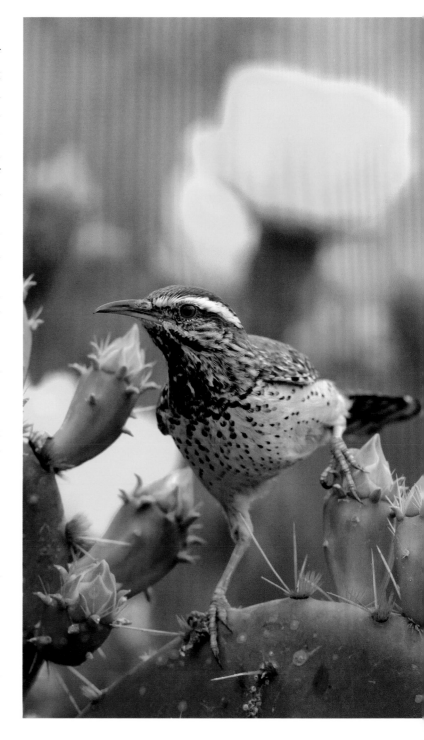

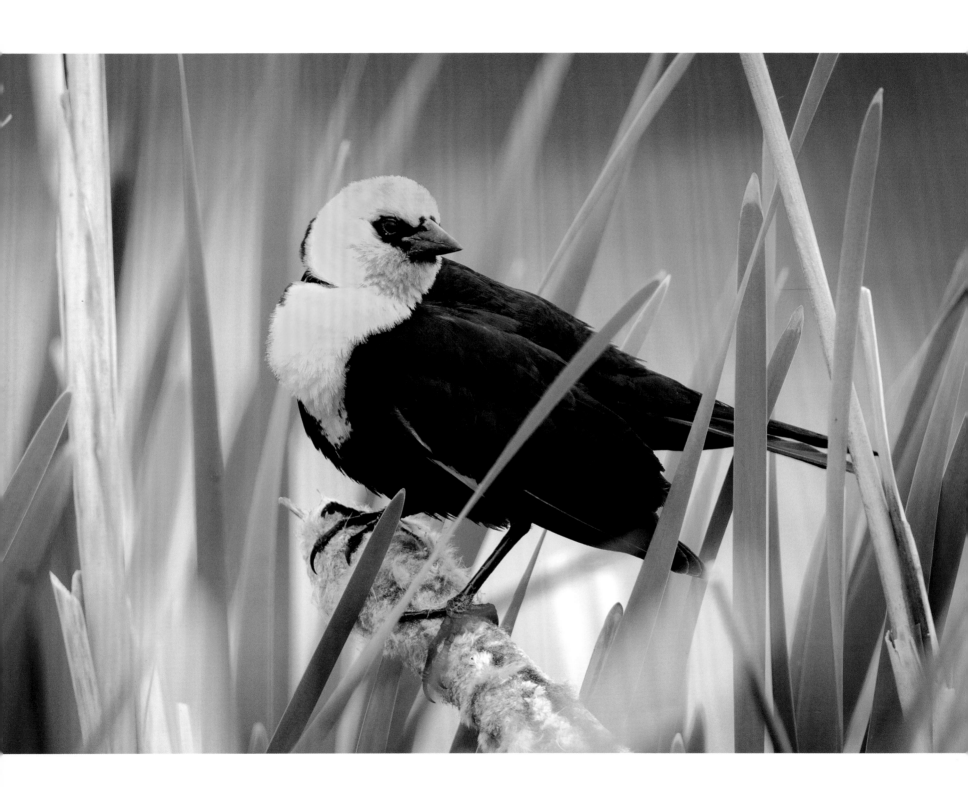

I've more than forgiven my parents for trying to pull me into their cult. Given the people they were, devoted to improving the world around them, it's no surprise that their dedication to avian life took on the same dimensions as their other work. After their children left home they went full-throttle into birding trips and study, but I was becoming a busy working mother and didn't give these ventures a lot of thought. I knew vaguely about Christmas Bird Counts, a tradition whose roots go back to 1900, when it began as a sort of clubbish holiday bird-shoot, later to be retooled without the guns as a carefully organized bird census. When my husband eventually invited me to join one of these counts in southwestern Virginia, where we now live, I was impressed. The CBC, as it's called, is now the largest and longest-lived citizen-science initiative on the planet, involving more than two thousand individual regional counts in the United States and Canada, putting some sixty thousand observers in the field on the assigned winter day. In 1966, the US Geological Survey decided to harness the birding workforce more effectively by creating the North American Breeding Bird Survey. Each year during May and June, the peak of breeding season, the BBS enlists volunteers to collect data by driving prescribed survey routes, always starting half an hour before sunrise, stopping every half mile to spend exactly three minutes looking and listening, recording every bird species present over the length of the 24.5-mile route. Surveyors drive their routes twice, at least four weeks apart, early and late in the breeding season. The combined data pools they've produced are immense, and useful.

In retrospect, I'm proud that my parents enlisted as foot soldiers in this bird-watcher army. While I was avoiding birds so assiduously, they were learning the skills they needed for the census, and in 1971 they signed on to two of the continent's forty-one hundred survey routes. For the next four decades they organized their schedule around this charge and did it together, rising in darkness, packing clipboard, binoculars, and a thermos of coffee into the car, and setting off on what they called their "bird runs." They flipped a coin to see who would be the observer, who the recorder. When my father grew hard of hearing and couldn't reliably hear all the birds, he ceded the observer role to his able partner. He has told me how much they looked forward to it: "Being outside at sunrise in beautiful rural country, with the air filled with birdsong every June, was a high point of our year." As the decades passed, their mobility declined but their dedication did not flag. From their trusty old Toyota they ran their Breeding Bird Survey until the last year of my mother's life.

I can tell Dad is wistful about the end of his run, and I can only imagine how he misses the Grasshopper Sparrow songs he can never hear again. When he lost his bird-watching partner of half a century, I worried about what might be left to keep him engaged with life. Fortunately, he has found plenty to live for, but in the first days after my mother's death I made an impulsive promise to take Dad on a trip, wherever his heart desired. He lit up and answered immediately: Panama. All his life it had beckoned to him as a crossroads of this great world, for ships, yes, but more to the point, for bird life. Where northern and southern biomes meet, on an isthmus where the maritime populations of two oceans are within shouting distance: imagine the birds we could see. So we made our plan. With sound mind and freedom of will, I organized a birding trip with my father. My husband and I also invited our daughter Lily, to celebrate her high-school graduation and impending college enrollment as an environmental science major. The rain forest sounded like her idea of heaven.

And so it was, for all three generations of us. We slowed our steps to an elder-friendly pace, pooling our knowledge, our eyes, and our ears, and tracked the birds into the deep

glades of Panama. We paused also for sloths, monkeys, all manner of gigantic insects, and especially frogs, which are Lily's special passion. But the birds were the leaders we followed, and mercy, what birds. If we each undertook this trip with our own griefs and losses to bear—loved ones, species, the stability of a planet—what we found in the rain forest was a tent revival for the church of biodiversity. It's hard to lose faith in nature while one is so mobbed with trogons, parrots, and antpittas that a quorum can't agree on which way to aim their binoculars. The birds sang us back to life, back to belief in seeds and forests, mating and profligacy, and surely some kind of green, full-throated future.

We came home with full memory cards of every kind, but my favorite hour might have been the afternoon of the Rufous Motmot. It's a long-tailed, crow-sized bird with a color scheme embracing red, orange, yellow, green, blue, indigo, and violet. (Wait, isn't that all of them?) Its tail takes the form of an absurdly long-handled tennis racket, and when perched the motmot ticks that tail back and forth like the pendulum of a clock. Mr. Darwin wrote many chapters on how we got around to birds like this. The first of our party to spy the motmot was Lily, who tried to describe the unlikely creature she'd seen: it was like something a little kid would draw with a whole box of crayons. My husband suspected motmot, and soon his infallible ear caught out its plaintive hoot. Then we all traipsed after the wondrous bird, seeing and not seeing as it disappeared in the branches of a huge ficus tree, then suddenly reappeared with its mate. The two of them languidly jumped around in the branches, conducting their connubial life with no regard for their own flamboyance. One of them abruptly dropped to the ground near us, snapped up a big black scorpion, flogged it a few times, and gulped it down. Dad lowered his binoculars, rubbed his eyes, and looked at me with an expression of rapture. *Thanks for this*, I whispered to him. *For birds.* It's possible we've never been happier as father and daughter than we were right then, with the motmot.

I think maybe everyone needs birds, at least a little. For a quotidian measure of wonder and a glimpse of how life goes on completing itself, whether we're watching or not. It's a useful enterprise to size up a day's work against the fastidious care of a hummingbird nest, or a family with an insatiable appetite for lizards. The birds should be introduced to others gently, as a gift rather than a duty. But when all is said and done, they are serious business, not just background music to a more important human agenda. They are the whistling breath of the place where we live, a thing that itself is alive, and when that voice goes quiet, merciful heavens, we ought to worry. When it sings, that is something to notice. It could sing us awake.

OPPOSITE Perched above a Louisiana bayou, a Belted Kingfisher scans nearby waters for small fish. This species has evolved to feed exclusively by plunge-diving into the water headfirst to capture aquatic prey with its daggerlike beak. After capturing a fish, the bird flies back to a perch where it may pound its prey against the perch to immobilize it before swallowing.

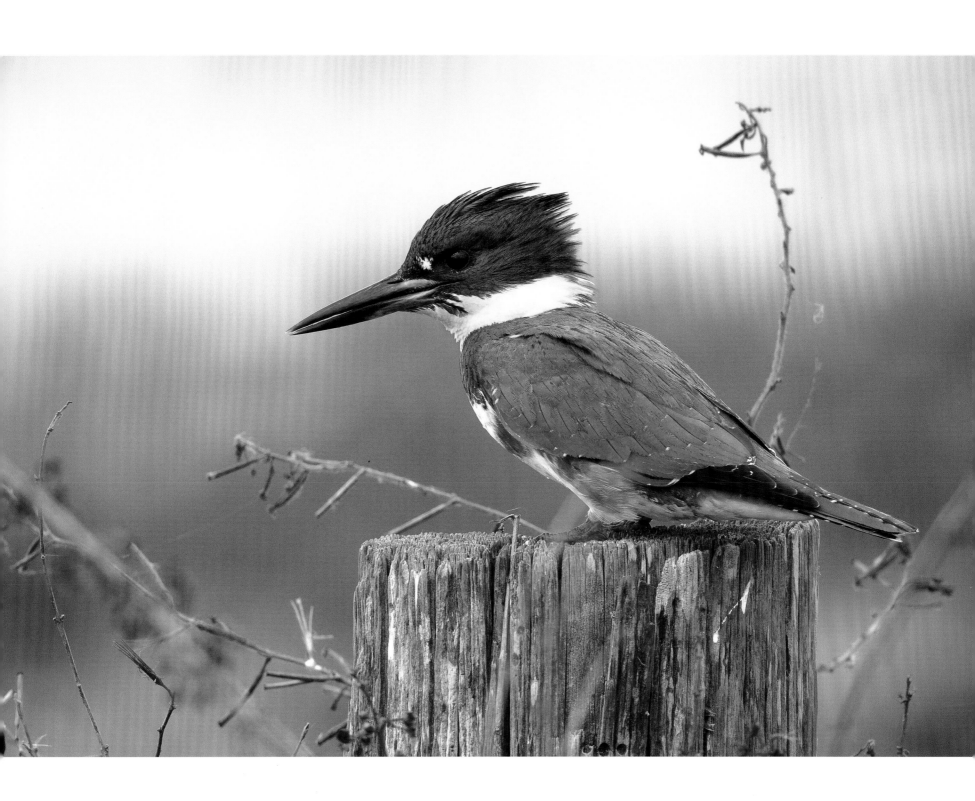

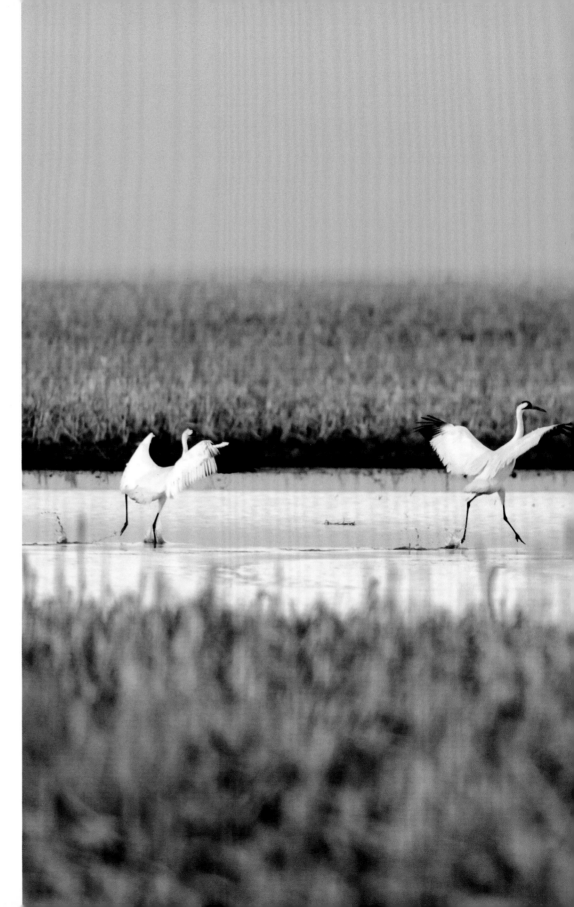

Five critically endangered Whooping Cranes touch down briefly in a South Dakota cornfield during their spring migration from coastal Texas to northern Alberta. Whooping Cranes were hunted down to the last twenty or so individuals in the 1940s, but protections and intense recovery efforts have helped populations slowly climb. Around 450 Whooping Cranes exist in the wild today, but their populations remain vulnerable to habitat loss, collisions with powerlines, and some illegal shooting.

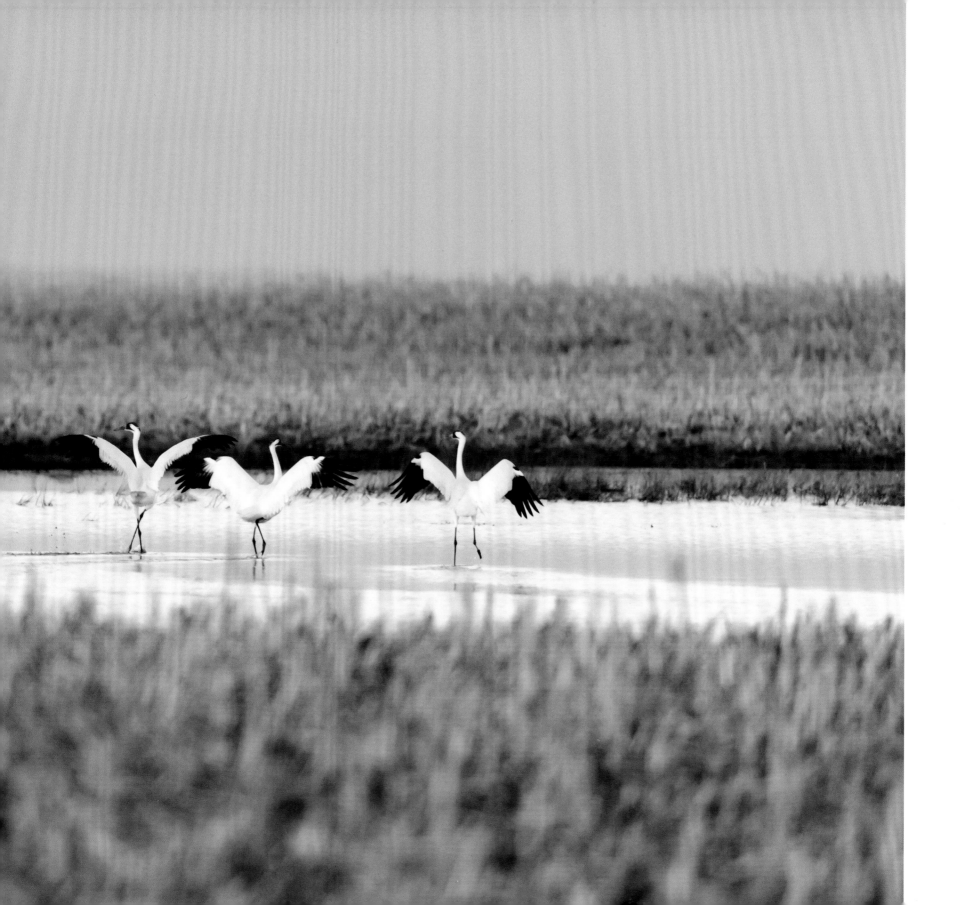

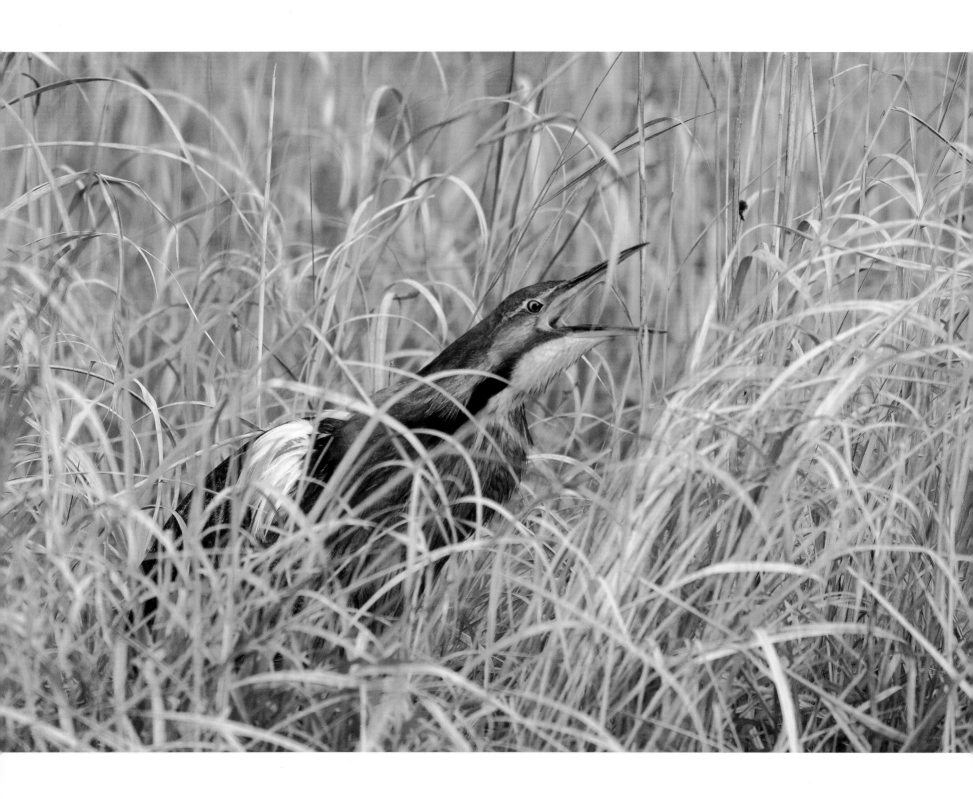

HOW BIRDS CAN SAVE THE WORLD

John W. Fitzpatrick

OPPOSITE An American Bittern, surpassingly well camouflaged and usually reclusive in its marsh habitat, must advertise its presence to mates and rivals for a brief period each spring. It does so with one of the most unlikely sounds in nature.

FOR ONE HUNDRED YEARS, ornithologists based at Cornell University have followed, studied, researched, and loved birds. Birds are superb models for scientific study, and they also capture our hearts and souls, connecting us emotionally with the beauty and mysteries of nature.

Their diversity of color patterns range from the subtle delicacy of a Lincoln's Sparrow to the gaudy brilliance of a Painted Bunting. From the power dive of a Peregrine Falcon to the incomparable hummingbird hovering at a flower, bird flight connects us with the angels. So, too, do their songs. The now-extinct Kauai O'o sang with jazzlike phraseology. Diminutive Pacific Wrens pierce the soggy temperate rain forest with an extraordinary series of musical warbles and trills. Other birds offer melancholy whistles, raucous Bronx cheers, ethereal flutelike notes, and even vocal duets as complex as those of a Verdi opera.

All over the world, birds have the universal power to connect us with nature in ways that no other organism can. We love them, we want to live with them, and—perhaps most important in today's rapidly changing world—we cannot bear the idea of living without them.

But it is birds' ability to help us gauge the state of the natural world that takes our simple wonder to another level. Birds can tell us how well—or how poorly—we have managed the world in which we live. Because many birds are closely adapted to the conditions of specific habitats, their populations can serve as "barometers" for the condition of their landscape. Like the canary in the coal mine, birds give us early-warning signals when habitats become degraded.

Take the Spoon-billed Sandpiper. Now among the rarest birds in the world, this diminutive shorebird sports a unique spatula at the tip of its bill, tactilely locating prey under the soupy surface of tidal mudflats. Once numbering in the tens of thousands, today they are down to a few hundred individuals, perhaps headed to zero in just a few more years. Birds like the Spoon-billed Sandpiper warn us that the earth is at a cusp. As the human population approaches eight billion, and our environmental impacts multiply, we must decide

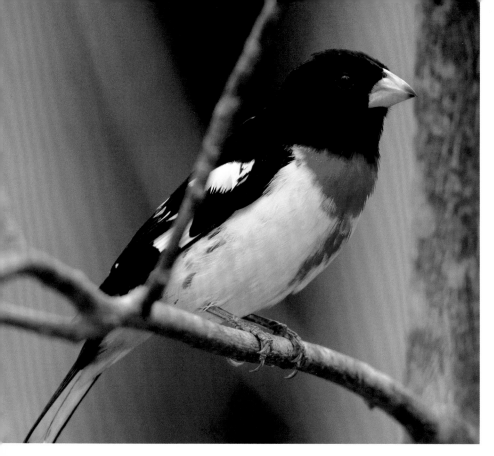
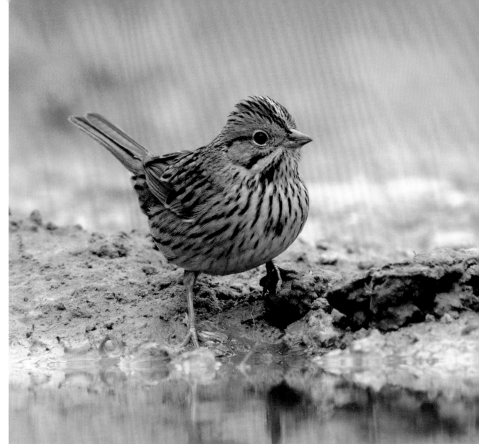
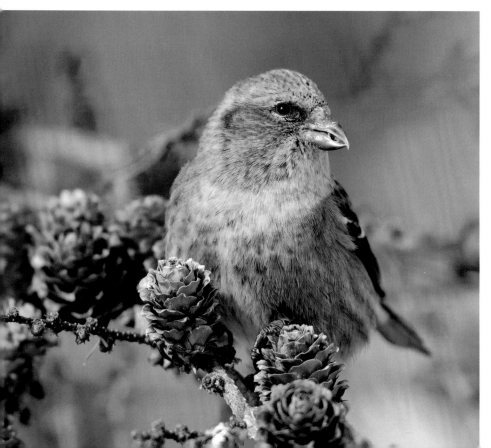
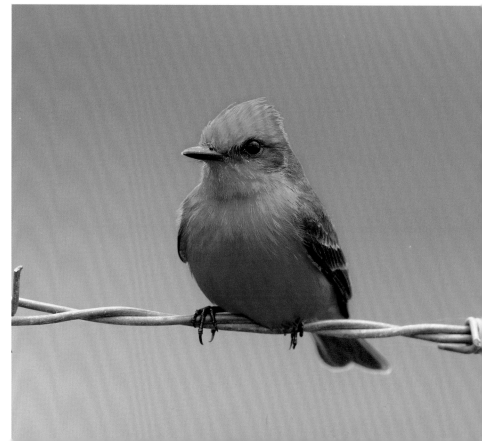

whether we want a future that promotes functional and intact natural systems living side by side with our own cultures.

Fortunately, birds also show us that if we pay attention and work to change our behavior to improve habitat conditions, their populations rebound dramatically. Birds are, after all, remarkably resilient. In the early twentieth century, because of unregulated hunting, the Wood Duck was predicted to be the next species to go extinct after the Passenger Pigeon. But we changed our behavior and passed effective new laws to control hunting. With public and private funds, we began a systematic effort to protect and restore wetland habitats all across North America. Today, the Wood Duck and dozens of other waterfowl species have rebounded to robust population sizes. Spectacular recoveries of Peregrine Falcons, Bald Eagles, Ospreys, and other raptors following the banning of DDT provide another example of how our changes in behavior can restore environmental stability.

Birds motivate us to keep the world healthy for them, and they teach us what we have to accomplish in order to do this. In short, *birds can help us save the world.*

Dramatic population recoveries such as those of Wood Ducks attest to the power of scientifically informed ecological restoration. But how can we know how well we are doing without having a reliable measure to gauge our results? After all, environmental degradation can be subtle and gradual, often occurring over time scales that render these changes invisible to humans. The answer, of course, lies in the birds, whose numbers help us detect insidious long-term changes before their cumulative effects are irreversible. Indeed, birds are such accessible indicators of ecological health that many national governments have formal procedures for using birds to assess environmental well-being.

Sometimes, whole communities of birds speak to us with a single voice about the earth, and about environmental threats. At least a third of the world's bird species are migratory, moving from one place during their breeding season—where their job is to make as many babies as they safely can—to another place, where their job is to stay alive and replenish their bodies' fat and nutrient reserves. Hundreds of species traverse mind-boggling distances, making extended, self-powered journeys that span huge fractions of their hemisphere—and they do this twice a year! Other species make more intricate and short-distance movements back and forth between locations that experience alternating conditions, such as rainy vs. dry, leafless vs. flowering, barren vs. fruiting, or foggy vs. sun baked.

It is both fun and informative to recognize that each one of these mobile individuals represents a tiny but extraordinarily fit warm-blooded creature that treats the world as a single, interconnected place. Together, these hundreds of millions of migratory birds represent a true "heartbeat" of our planet's natural cycles. Their annual arrivals and departures provide poetic signatures of our own seasonally variable emotions. In addition, their migratory timing precisely reflects the annual planetary clock, capable of revealing subtle details about local environmental dynamics. Today, well-documented shifts in the timing of bird migrations provide ironclad evidence of a changing climate. Birds teach us about the unity and connectedness of our planet better than any other organism on earth.

Birds are so ubiquitous, so variable, so easily visible, and so darn charming that they will always be among our most important models and sources of information for how nature works. Darwin's theory of evolution by natural selection is only one of many examples. For hundreds of years, the most influential articles and textbooks in ecology, evolution, biogeography, animal behavior, life-history theory, demography, communication, natural-resource management,

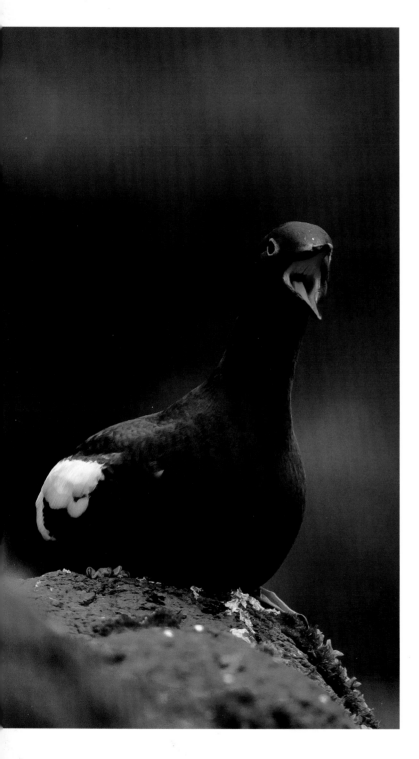

and conservation biology have used data gathered from the study of birds to demonstrate bedrock principles in the life sciences. As humans work toward the ideal of a stabilized planet, careful study of birds will always be in the forefront of this effort.

Inspired by a century of bird study, and sensitized to both their perilous position and unique ability to reflect the health of our planet, this book, *The Living Bird*, provides opportunities for both inspiration and reflection. It is an ode to birds, a celebration of everything we love about them. It is also a plea for action, a call to arms.

Scott Weidensaul's essay, "The Secret Lives of Birds," provides a wonderful survey of the amazing diversity of birds and what they can do. In Lyanda Lynn Haupt's captivating essay, "Inspiration Aloft," she reminds us that we need not be experts or travel across the world to appreciate birds. Anyone can enjoy the mockingbird outside their window, the Carolina Wren in the hedgerow, or the thrasher on the treetop. My own essay, "Beacons of Our Planet," explores examples of how birds provide detailed portraits about the health of our precious earth. And throughout, incomparable Cornell Lab photographer Gerrit Vyn's stunning images and penetrating insights reveal both the majesty and the hidden beauties of birds in their wild environs.

Once you get in the habit of listening to and observing the amazing birds found in your own backyard, you might very well become hooked. Pretty soon you're likely to get curious about what they're doing. How many are there? How do they interact with one another? What's that little hawk that occasionally tries to take one of your smaller visitors for a meal? Where do so many of them disappear to in the winter? Perhaps you'll find yourself participating in a Christmas Bird Count, or even taking a bird-watching vacation of a lifetime.

LEFT Recent dramatic declines of some seabird species around the Northern Hemisphere are clear signs that the oceans are changing. Long-term climate change in marine habitats is altering the distribution and availability of prey species, which in turn affect the behavior and populations of seabirds like this Pigeon Guillemot.
OPPOSITE The Spruce Grouse, a resident of boreal forests throughout the north, meanders through a fall tapestry of blueberry and dwarf birch.

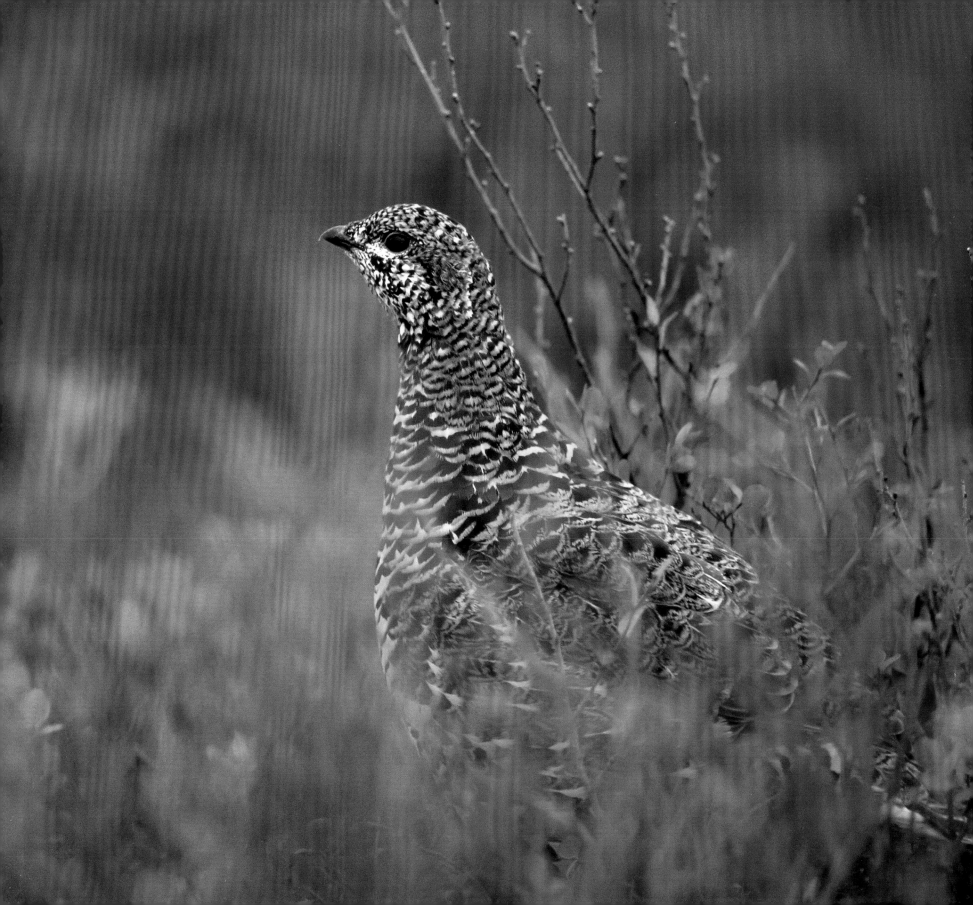

You'll know when you're hooked, because you will no longer be able to look away. You'll notice birds on the utility wires as you drive to work. You may even look for special "airport birds" outside the aircraft window as you take off or land. After all, birds are extraordinary at attracting our curiosity, at drawing us into their lives. Once we begin to appreciate their needs, we start understanding that our place is also their place. As a result, we begin to recognize the importance of saving all their places.

Many of us who love birds see new opportunities when we combine the ancient powers of birds with the powers of modern communication. For the first time, earth has a way of measuring itself because humans can act as distributed sensors around the planet. Millions of daily observations now can be communicated via the internet, organized into databases and maps for instant distribution, and analyzed by sophisticated technology to detect patterns and changes. All this is nothing short of revolutionary. We now have the power to measure in real time how our landscapes are faring, how they are changing as a consequence of our actions, and eventually how they are improving as a consequence of our new knowledge.

Our success at living side by side with stable natural systems across the world will not occur by chance; it will require commitment and planning. To achieve this goal, two things will need to be true: First, every generation and culture must embrace this ideal, because the goal cannot be limited to a few people, a few places, or a few years. And second, we must have real-time proxies for how we are performing—some way of measuring how well our earth's landscapes are faring—as our efforts to live in harmony with them proceed. As unrivaled ambassadors for our relationship with the planet, birds have the unique capacity to accomplish both of these requirements. They inspire us to enjoy and protect them, and they are beacons of environmental conditions around us. Our goal should be nothing short of a new relationship with the earth. Happily for all of us, we can rely on our beloved backyard birds to help us get there.

OPPOSITE, CLOCKWISE FROM TOP LEFT White Pelicans; Western Sandpipers; Brant; Heermann's Gulls. Flocking provides advantages to birds; there can be safety in numbers and, in some cases, an enhanced ability to find food. White Pelicans increase their catch by herding fish into shallow water as a group. Other birds flock to increase their chances of spotting predators and dilute their individual risk of being preyed upon.

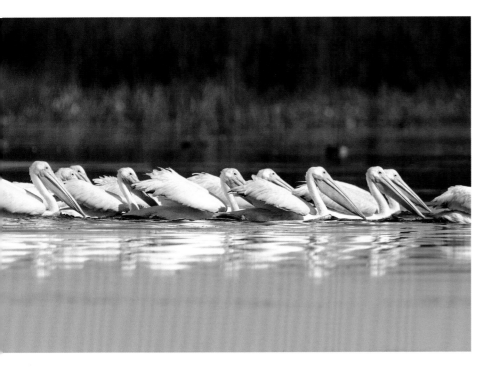

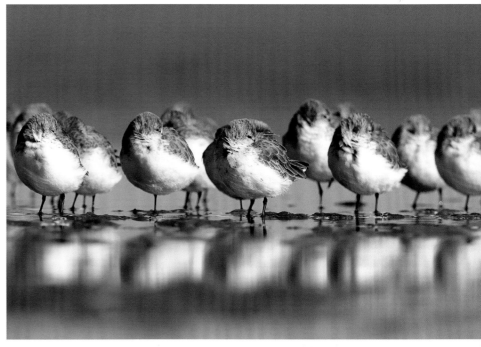

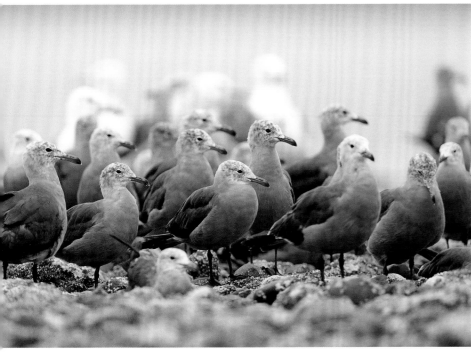

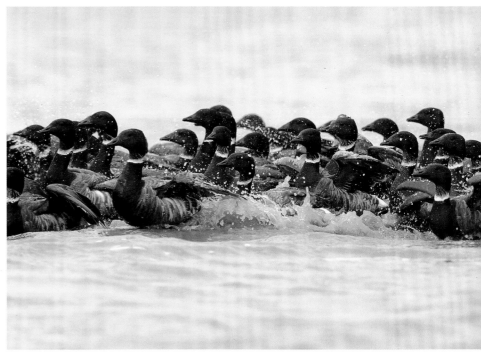

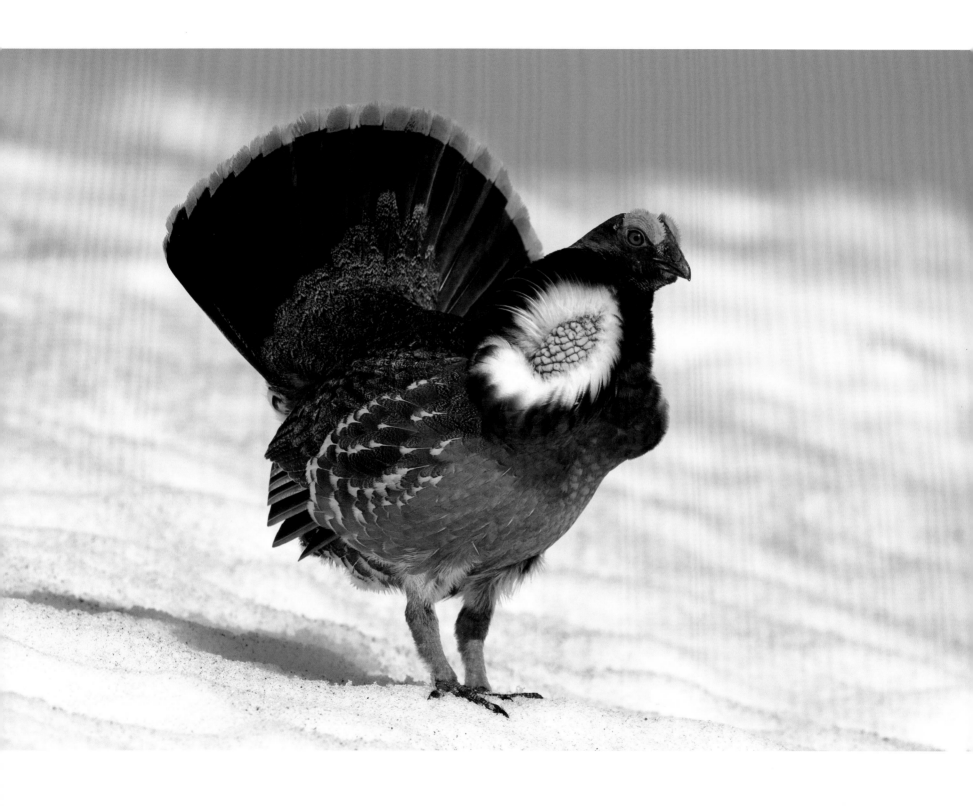

THE SECRET LIVES OF BIRDS

Scott Weidensaul

OPPOSITE Males, such as this Sooty Grouse, attempting to attract mates, perform some of the most intriguing bird behaviors and fantastic plumage transformations in the bird world.

THERE IS ALMOST NOTHING about birds—their physiology, their behavior, their movements and migrations—that is not simply and utterly wondrous.

I know this, perhaps better than the average person, because I have the great good fortune to study birds. During their migrations, I work with them on an intimate level—catching them, detaining them harmlessly for a brief time, and then releasing them with a lightweight leg band or miniature tracking device to follow their travels. Whether I am holding a Snowy Owl from the Arctic or a Ruby-throated Hummingbird that just flew forty hours nonstop across the Gulf of Mexico, the feeling of awe never diminishes.

Once, when helping other researchers, I pulled from our nets a Red Knot—a plump, rusty-brown shorebird the size of a robin. The knot was midway on its annual journey from the southern tip of South America, where it had spent the winter, to its breeding grounds in the Canadian Arctic. On its leg was a metal band, so old and worn and thin that the stamped numbers were nearly illegible. When we deciphered them, we realized that the knot had been banded

fifteen years earlier in Brazil. In the intervening years it had flown some 270,000 miles—the distance from here to the moon and most of the way back.

COLOR

Birds do amazing things and are, themselves, amazing beings. Their coloring is a dramatic and often flamboyant example of this. There is the brilliant, tiger-hide orange of a male Blackburnian Warbler high in a North Woods spruce; the dazzling iridescence of a springtime Wood Duck in a quiet backwater; or the chartreuse, lemon, and blue of a Green Jay hopping through the south Texas thorn scrub.

But the plumage and coloration of birds are not just gaudy; they are wonderfully complex, using light in unexpected ways to dazzle the eye and confound watchful enemies. The colors that catch our breath may even be illusory, a trick of optical physics at the cellular level. And some of the most remarkable colors aren't even visible to the human eye.

Owl coloration is all about subtlety; their soft, intricately patterned feathers have evolved in ways that break up their

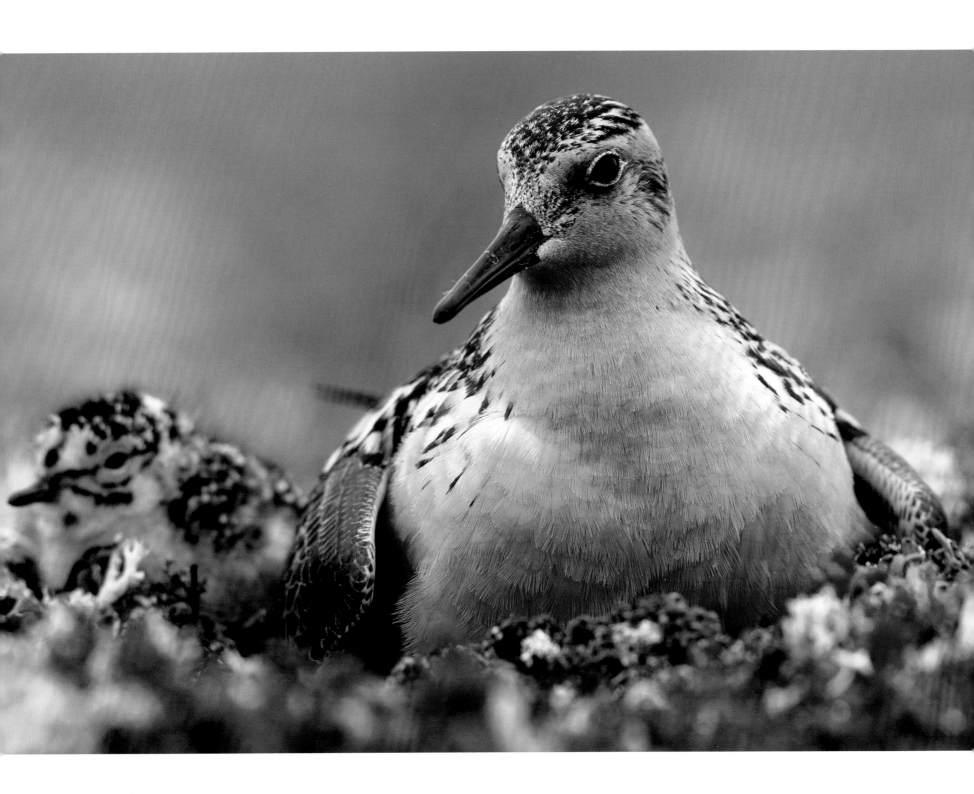

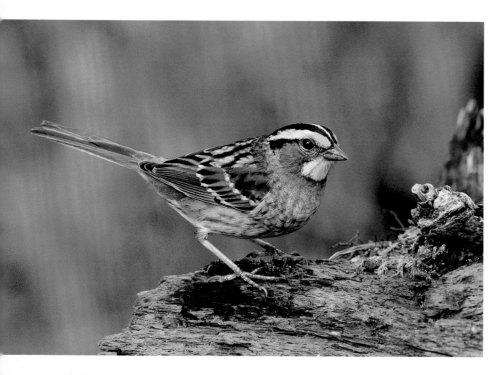

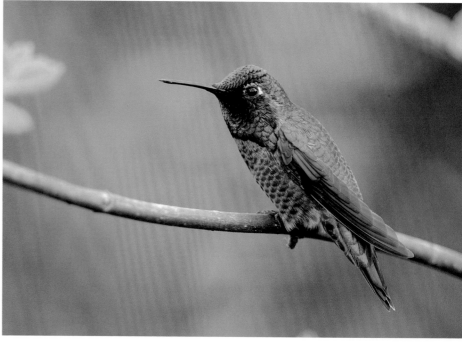

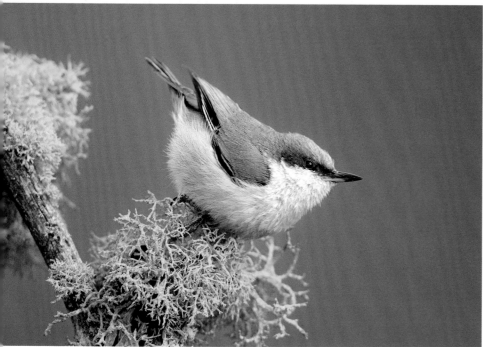

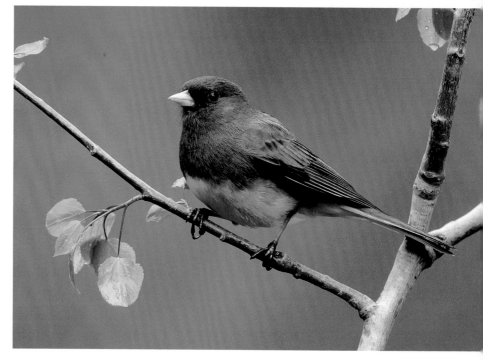

For birds that nest on the ground, the importance of camouflage and staying still cannot be overstated. For these tundra-nesting Red Knots, danger lurks above in the form of aerial predators, gulls and jaegers, that scour the ground visually and readily prey on chicks and eggs. When a parent spots a potential threat, it gives a unique call that tells the chicks to freeze.

OPPOSITE, CLOCKWISE FROM TOP LEFT The oldest recorded White-throated Sparrow was almost fifteen years old; the heart of an Anna's Hummingbird may beat 1,200 times per minute during flight and slow to 50 times per minute at night when it enters a mini-hibernation; the Dark-eyed Junco is one of the most common and familiar North American songbirds with a population estimated at 200 million; like some other social birds, Pygmy Nuthatches will crowd into a single tree cavity to maintain their warmth on a cold night.

outline to allow them to blend with the background. An Eastern Screech-Owl basking in the weak winter sun at the entrance to its roost hole seems like another anonymous burl on the side of an oak tree, its gray-brown feathers merging with gray-brown bark.

Sensing an intruder, the owl's bright yellow eyes close to slits, and its "ear" tufts—mobile clumps of feathers controlled by muscles—rise to further disrupt the owl's shape. (The velvety surfaces of the owl's feathers also help to muffle sound that might alert its prey as it flies, as do the downy edges of its wing feathers and a comblike fringe along the leading edge of its outermost flight feathers.)

The most astonishing example of camouflage rests with another group of nocturnal birds, the nightjars. A Chuck-will's-widow resting along a branch or an Eastern Whip-poor-will lying on a bed of fallen leaves merges seamlessly with its background. Because the nightjars all nest on the ground, camouflage is serious business. When a Common Nighthawk scrapes a shallow depression in the gravel of an old riverbank (or, more often these days, the gravel of a city rooftop), it has nothing but its plumage to protect its two eggs from the prying eyes of crows and other predators.

Most bird coloration is a function of pigments whose manufacture is genetically regulated within the growing feather. Blacks, browns, and some yellows come from melanins. Pigments known as porphyrins, usually recycled from amino acids like hemoglobin, produce browns, pinks, some reds and greens that a few orders of birds use to pigment their feathers.

A class of pigments known as carotenoids produces many of the brightest reds, oranges, and yellows in bird feathers, but birds can't produce these pigments on their own. Instead, they come from the bird's food. The carotenoids are extracted and repurposed by the bird's body and deposited into the

growing feathers. Cedar Waxwings' signature bright-yellow tail tips, for example, are produced through a carotenoid known as canary-xanthophyll that comes from the berries the birds eat. In the 1960s, birders began noticing waxwings with brilliant *orange* tails. The culprit was an invasive Asian honeysuckle whose berries appeal to the waxwings but contain a red carotenoid known as rhodoxanthin rather than the canary-xanthophyll carotenoid.

Pigments produce color by absorbing some wavelengths of light while allowing others to bounce back and hit the eye. But not every color on a bird comes from a pigment. Feather coloration is also created through manipulation of light—and the results, known as structural color, are dazzling.

The iridescence in a male hummingbird's gorget, for example, is the result of stacked layers of hollow, microscopic structures called platelets, which break apart the light hitting the feathers. This reinforces some wavelengths and cancels out others to produce vivid, shimmering hues that appear and disappear as the angle of the sun changes. Blue Jays, bluebirds, and many other species also use structural color, but in a completely different way than the hummingbird. These birds employ what is known as light scattering. Microscopic rods of keratin and minute air pockets within the otherwise blackish feather diffract the light hitting them, producing blues and violets that range from the intense cobalt of a male Indigo Bunting to the ethereal cerulean of, well, a Cerulean Warbler.

Amid so many gorgeously arrayed birds, it's hard not to feel a little sorry for the drab species. But those birds may be drab only to our eyes. While we can't see light in the ultraviolet range, birds can. Scientists are learning that many—perhaps even most—of the species in which males and females look alike to us actually have very different plumage patterns in the UV range. The crow or catbird that

seems dull to us may not be so dull in the eyes of other birds.

Even your pet budgie is more colorful than you might think. Like many parrots, budgies have patches of ultraviolet pigment on their faces, which they can see but we can't. They choose their mates based on these patches. Baby birds of many species also have bright ultraviolet colors inside their mouths—creating a handy target for a parent with food.

CHANGING FEATHERS

A bird's appearance can change dramatically from season to season or year to year. These plumage shifts are usually the result of molt—the predictable replacement of old feathers with new ones. In some birds, the process of molting can take years, like the slow, five-year shift of a young Bald Eagle from dark-brown immature plumage to the white head and tail of an adult, after which the eagle's appearance never changes again. In other species, the change can be swift, dramatic, and regular as clockwork.

A female Red Phalarope's breeding plumage, which she wears in the Alaskan summer, is a rich rufous with a black cap, white cheeks, and black-and-white checkerboard back. But once the breeding season ends, those worn nuptial feathers drop and are replaced by blood-engorged quills encased in protective sheaths, which then quickly slough off to reveal a very different winter plumage. By the time the phalarope reaches her pelagic wintering grounds off the Pacific coast, she is battleship gray above and pearly white below—a pattern she will wear until spring molt restores her breeding colors.

The White-tailed Ptarmigan, which inhabits the frigid alpine zone of western mountains, does the phalarope one better. Its winter plumage, which replaces a camouflaging piebald mix, is immaculately white, right down to the densely feathered toes that act like snowshoes.

Acquiring a new set of feathers twice each year is physically draining, and some birds manage a costume change without the physiological expense. A male Bobolink in winter is a streaky, yellow-brown bird the color of dead grass. But as the winter wears on, the intentionally weak, yellowish tips of the feathers break away, revealing the Bobolink's rich black-and-cream breeding plumage, which had been hiding beneath for months.

ON THE WING

Feathers are not only for insulation and color—they permit that most essentially avian of actions, flight. Although other animals fly—from bats to insects—and not all birds take flight, there is no group of organisms so tightly bound to the air, nor any that fly with the speed, grace, and efficiency of birds.

Speed. A Peregrine Falcon can famously dive at speeds exceeding two hundred miles per hour, making it the fastest creature on the planet. (Though the larger, stronger, more powerful Gyrfalcon of the Arctic may exceed even that mark.) But even beyond these icons, almost every bird that takes to the sky does so in ways that astonish and confound. Hummingbirds, their stiff wings flapping up to two hundred beats a second, employ highly flexible shoulder girdles to twist those wings nearly 180 degrees to hover or fly backward.

Grace. Consider a Wandering Albatross, one tip of its eleven-foot-wide wings, narrow as a sword's blade, barely clearing the heaving surface of the wind-raked Southern Ocean. An albatross may fly almost unceasingly for weeks or months at a stretch, rarely flapping its immense wings but using an exquisite fusion of wind and gravity known as dynamic soaring to remain aloft with virtually no exertion. When the albatross banks across the ceaseless sub-Antarctic

OPPOSITE Each spring, male Greater Prairie-Chickens gather on traditional courtship grounds called leks, where they perform an elaborate display, fight, and, if they are especially strong and attractive, mate. Females clearly favor males that win the battles and that are able to maintain positions at the center of the lek. Usually, only a few males end up mating with the majority of the females in the area.

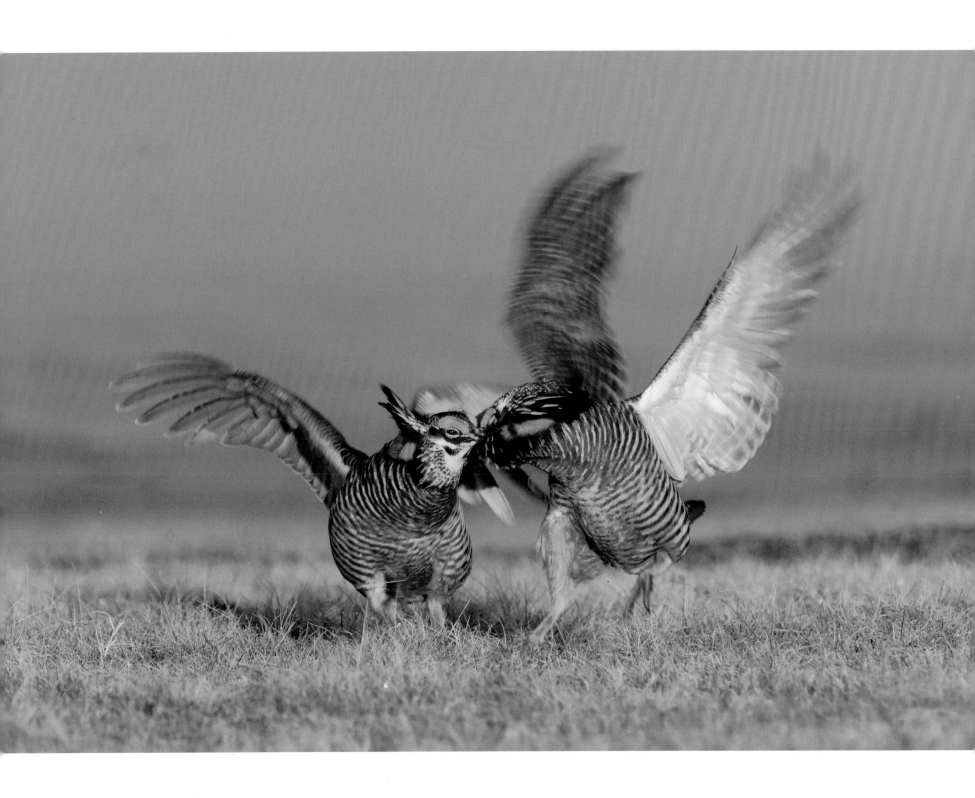

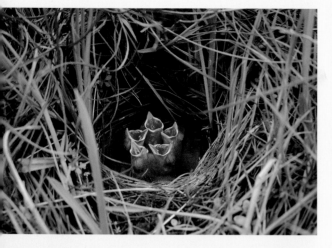
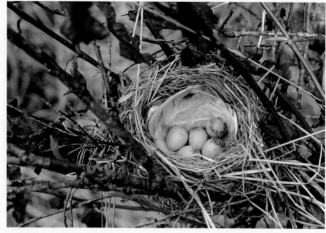
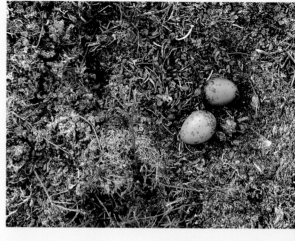
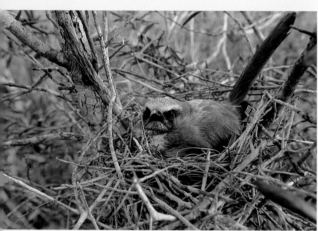

NESTS

The intricate craftsmanship that birds use in constructing their nests is inspiring to behold. Nest shapes and construction techniques vary as much as the birds that build them. CLOCKWISE, FROM TOP LEFT Savannah Sparrow chicks; Common Redpoll eggs; Long-tailed Jaeger nest with eggs; Dunlin chicks; Clark's Nutcracker chicks; Rough-legged Hawk incubating; Glaucous Gull chick breaking through eggshell; Florida Scrub-Jay incubating nest

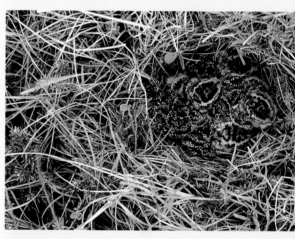
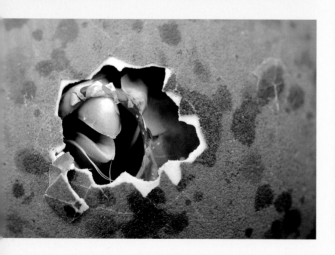
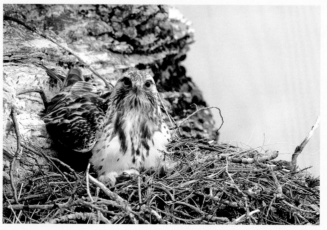
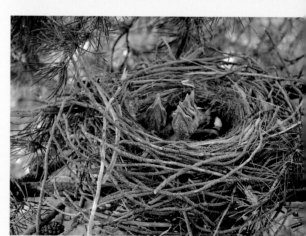

CLOCKWISE FROM TOP LEFT Male bushtit removing eggshell from nest; Golden Eagle with chick; Lewis's Woodpecker in nest cavity; Sage Thrasher nest with eggs; Red-winged Blackbird nest with eggs

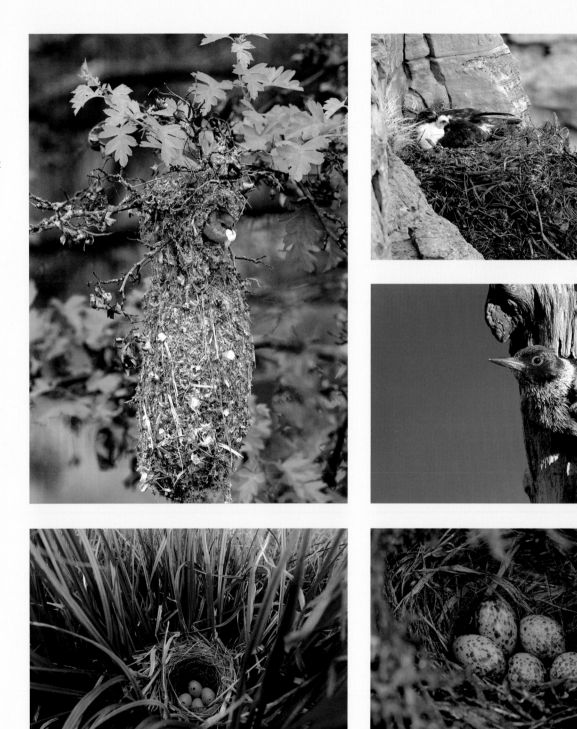

wind, the great bird is lifted high above the water's surface; then the seabird turns into the wind and glides smoothly back toward the sea. Up and down, lift and glide, tack and sail—the albatross can cover thousands of miles of open ocean as effortlessly as we cross the street.

Efficiency. Look up at a soaring hawk or wheeling vulture and you will see them milk the bubbling thermals of heated air that rise above the sun-warmed earth, their fingerlike primary feathers stretched wide to catch the updraft. But for true efficiency, consider the well-named swifts, their bodies like torpedoes and their wings in constant motion.

Few birds spend as much of their lives on the wing as swifts, yet it appears we have underestimated just how wedded to flight these birds really are. Recently, scientists tracked Alpine Swifts that nest in Europe and discovered, to their utter shock, that when these small birds leave their nests, they spend the next six months or more on their west African wintering grounds in constant, endless flight. They do not stop for a moment—even sleeping on the wing. Not even the great albatrosses can match that.

Not every bird is a paragon of aviation, of course. There are a surprising number of entirely flightless birds—ostriches, emus, and the other members of an ancient order known as paleognaths. Some island-bound rails and cormorants have lost the ability to fly through the fullness of evolutionary time; and the penguins, which have cast their lot with the sea, have even fashioned flippers from their wings. Others just barely fly, having made an awkward compromise between air and water. The alcids—the family of seabirds that includes puffins, murres, and guillemots—have split the difference between hydro- and aerodynamics, with wings that are just big enough to bear them in flight, but thin enough to move in the far more turgid medium of water, allowing them to "fly" beneath the waves to hunt.

SOUND AND SIZZLE

Landing on its nesting island, a puffin waves its multicolored bill and growls like a chainsaw—all to good effect, because that's what other amorous puffins like. Birds communicate in a host of ways both familiar and bizarre, especially through their voices. It's for good reason that birdsong has attracted human attention for millennia; bird voices transcend what we think is possible. For example, each side of a songbird's syrinx (the avian equivalent of the human voice box) can produce a different note, allowing a bird like a Wood Thrush to harmonize with itself, creating a one-bird chorus of unearthly dawn music.

Songs are mostly the work of males, fulfilling twin functions as both mating advertisements and territorial boundary markers. In some birds whose songs are fairly simplistic—an Olive-sided Flycatcher's *hic-three-beers!* or a Mountain Chickadee's *fee-bee-bay*—the melody is hardwired into the bird's brain at birth. But for species that sing more complex songs, both genetics and learning play a role. A young male is born with a programmed musical template within its genes, but he must hear the proper song sung by an adult of his species within a narrow window of time just after leaving the nest. Otherwise, he will never sing his species' song in all of its glory.

Because of this mix of genes and learning, many songbirds develop regional dialects. This phenomenon has been most closely studied among White-crowned Sparrows on the West Coast, whose dialects shift with the isolating effects of river valleys, mountain ranges, and coastlines, much as does human language.

There are other birds that never sing an original note of their own but borrow liberally from all around them. The Northern Mockingbird is most famous for this, but its close relative the Brown Thrasher is the largely unacknowledged

OPPOSITE Cliff Swallows are the ultimate colonial nest builders. Large colonies contain thousands of gourd-shaped nests, and each nest is composed of 900–1,200 pellets of mud, each collected, carried, and placed by the bird's mouth. Social behavior at a colony is complex. Males mate with females other than their own mates when possible. Females look for unattended nests in which to lay an egg or will carry one of their own eggs to another nest. Once nests are constructed, owners defend their nest by sitting in the tubular entrance and lunging at passing swallows. Sometimes an intruder forces its way in, and a fight ensues.

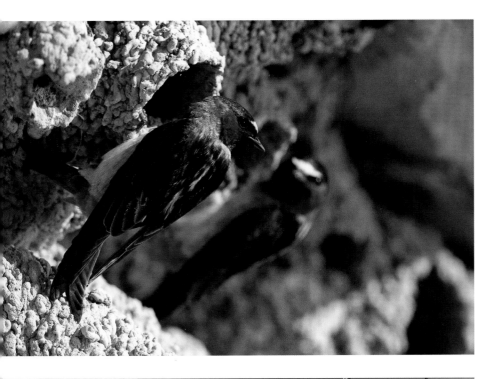

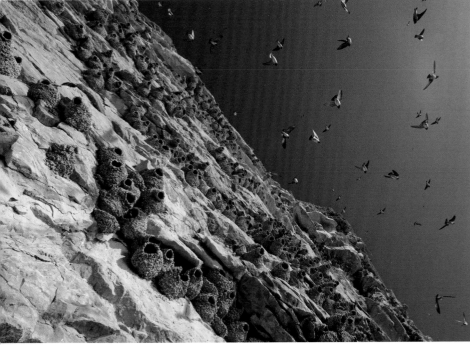

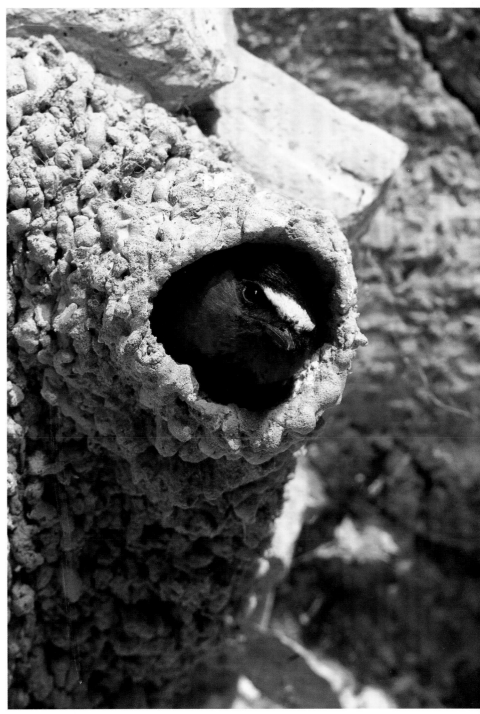

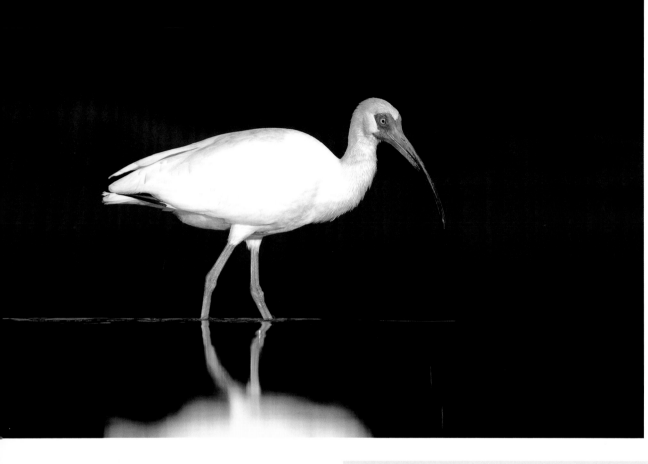

LEFT White Ibises use their long, curved bill to locate crabs and crayfish in the mud where they feed. Probing in mud causes a pressure wave, and a change in the current, detectable by sensory pits in the bill tip, betrays the presence of a prey animal. White Ibises are very social birds. They usually feed in flocks, and some breeding colonies contain more than 10,000 pairs. Their white color facilitates social interactions by making them stand out against any background.

RIGHT Loggerhead Shrikes are predatory songbirds with the habits and beak of a raptor. Although their primary food consists of large insects, they extend their dietary preferences to vertebrates of all kinds, from lizards to small birds to mice. When a shrike captures a bird or mammal, it immediately bites it behind the head to cut its spinal cord, so even large prey do not struggle for long. If the prey is too large to be consumed at one meal, the shrike hangs it up on a thorny twig or barbed wire fence for another day.

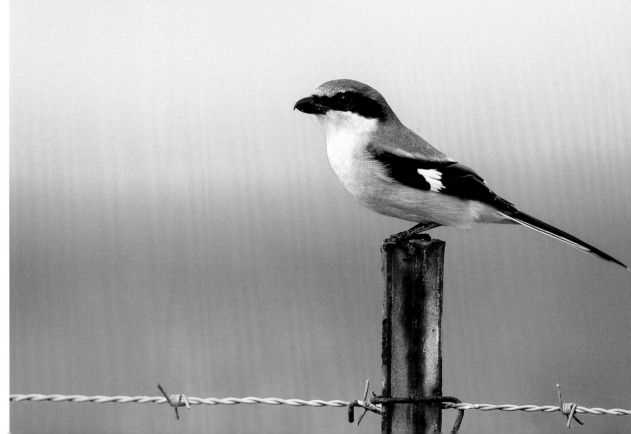

champ. A male mockingbird may learn to sing several hundred song snatches stolen from other birds, but a thrasher may command seven thousand or more—and the ability to sing without repetition for days, a feat that impresses females and intimidates rivals.

Almost every songbird displays unexpected complexity in its music, if we stop and listen critically enough to hear it. Many borrow elements from the songs of their closest neighbors (of the same species), remixing them in original ways and lobbing these musical challenges back into the air again. Listen closely to a Song Sparrow, and you'll notice that while the basic song is the same—a few high notes, some warbling, and a trill—the cadence, structure, and details change repeatedly as he and the other male Song Sparrows within earshot constantly fine-tune their repertoires in melodic battle.

Wood warblers also sing different melodies depending on their audience. A male Black-throated Green Warbler sings a song with an accented ending—*zee-zee-zee-zo-ZEE!*—to catch a female's ear; and one with an unaccented ending—*trees-trees-murmuring-trees*—to warn off other males.

Forest-dwelling warblers pick song perches high in trees for maximum volume and exposure, but what about birds that live on the open grasslands or the Arctic tundra, where perches may rise only a few inches? Then the sky itself becomes the concert hall. Many open-country birds spill out their songs while in flight, which is often a spectacular display in its own right. In the far north, the American Pipit flies high into the air and then spirals down to the tundra, its wings open and tail spread, all while repeating its lively *twjee-twjee-twjee-twjee* song.

You needn't go to the Arctic to see one of the most remarkable song flights, though. Any chilly spring dusk in eastern North America, as the sun sets and the shadows lengthen, a weird call echoes across soggy meadows close to damp woods—the froglike *peent* song of the American Woodcock. This pudgy male shorebird launches into the twilight on twittering wings (the sound made by specialized flight feathers), circling higher and higher until it is a speck against the purple sky—then it tumbles to the earth while gurgling like a stream, only to resume its *peents* the moment it lands.

LOVE AND RELATIONSHIPS

A bird does not *need* song—musical or atonal—to communicate. Woodpeckers accomplish the same goals of mate attraction and territorial defense by hammering away on hollow, resonant limbs, while male Ruffed Grouse beat their wings against empty air, creating a rolling series of minisonic booms that echo through the forest like an engine stuttering briefly to life.

Other grouse have far more elaborate courtship displays. Dawn on the Great Plains sees some of the most spellbinding avian exhibitions in the world, when several species of prairie grouse gather at traditional communal display sites known as leks. Males of one species, the Greater Prairie-Chicken, lean forward, raising specialized feathers that poke up like horns on either side of their heads while inflating bright-yellow air sacs on their necks. Dancing and leaping at one another, they make loud, booming noises that carry half a mile or more across the grasslands.

Males of another species, the Sharp-tailed Grouse—their neck sacs bright purple—fan their wings and raise their pointed tails, pirouetting in foot-stamping dances. Greater Sage-Grouse males fan their wide, spiky tails, inflate air sacs beneath huge white ruffs that look like outsized feather boas, and strut among the sagebrush—all while making rolling, bubbly, popping sounds like water gurgling out of bottles.

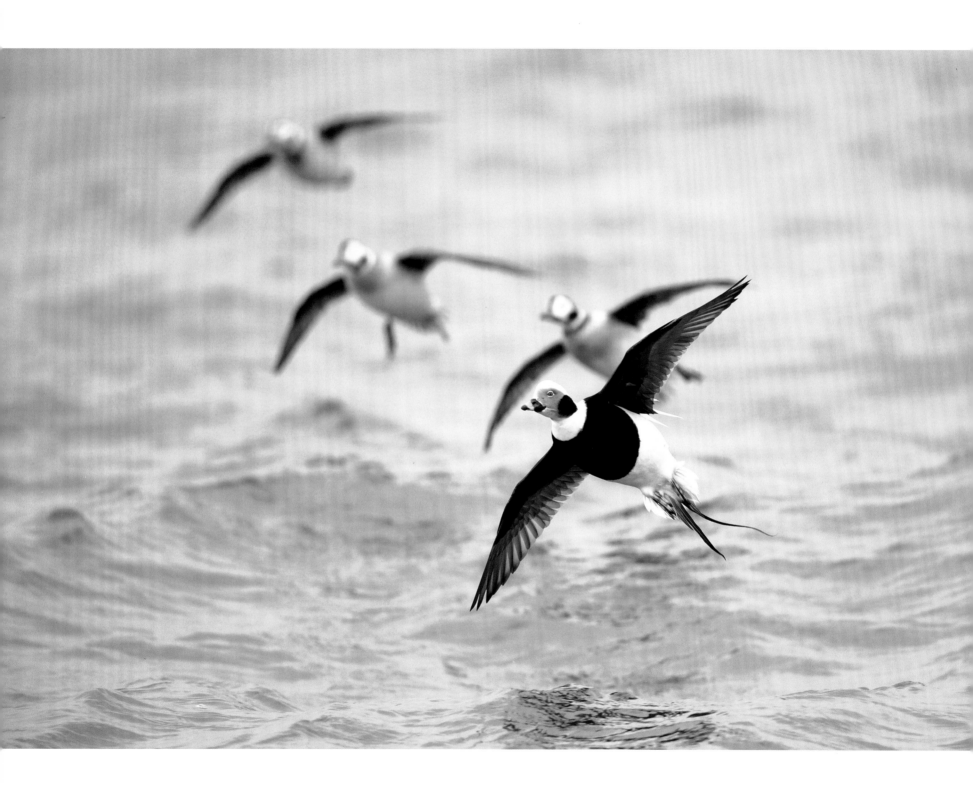

The male Buff-breasted Sandpiper simply stands in place on the Arctic tundra, his wings spread wide, while a gaggle of females peers intently and critically at the fine vermiculated markings on his wing linings—somehow divining, perhaps from their uniformity, whether or not he's the one for them.

The elegant waterbirds known as Clark's Grebes, gliding across the surface of western lakes, rise in tandem display and, legs churning like paddle wheelers, race across the water with their necks arched in perfect synchrony. And hummingbirds, which do everything fast, are true to form in their displays. Male Anna's Hummingbirds make sweeping, pendulum-swing flights that are punctuated with an explosive buzz created when the male opens his specialized tail feathers for just sixty milliseconds at the bottom of his dive.

The point of all this flash and dazzle is, of course, sex and babies—and the breeding biology of birds offers an equal number of surprises. Scientists once assumed most birds were monogamous homebodies. Some—such as large raptors, swans, and cranes—generally are; the pair bond among Golden Eagles, Trumpeter Swans, and Sandhill Cranes, to name a few, is usually for life. But as for the rest of birds, DNA tests have shown that most are messing around like characters in a soap opera, even when they appear to have paired off. "Extra-pair copulations," as such trysts are politely known, are actually the norm among almost all songbirds.

Nor are pair bonds as simple as they may at first seem. Polygyny, in which a male pairs with more than one female at the same time, helping each with her nest, is not uncommon among birds. Some Harris's Hawks in parts of the Southwest, though, practice polyandry, in which a female may keep multiple males—all of whom tend her nest together. And the Smith's Longspur, an Arctic songbird that winters on the Great Plains, practices polygyandry, a fluid situation in which some

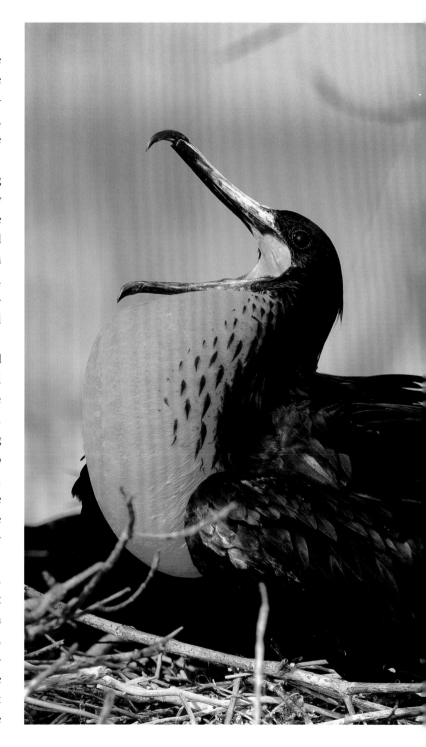

males pair with more than one female, and some females with more than one male.

Phalaropes invert the usual gender stereotypes altogether. Among these needle-billed shorebirds, it is the female that is the gaudy, promiscuous gender. The males are more dully plumaged and they are the ones that tend the nest and raise the chicks alone.

NEST ARCHITECTURE

For phalaropes, a nest is just a depression in the tundra, sparsely lined with grass and lichen, but nest architecture is one of the greatest wonders of avian life.

Open cups, whether built in shrubs and trees or on the ground, are the most common nest type, but nests run the gamut, as does construction material. Swifts use their sticky saliva to glue small twigs into a half cup on the insides of chimneys, hollow trees, or cliffs. Many seabirds—including many auks, shearwaters, and storm-petrels—dig burrows. Belted Kingfishers manage to chip an indentation into a streamside bluff and then spend a week or more excavating a burrow that may extend six or eight feet into the bank.

Orioles are justly famous for their tightly woven pendulous nests, which the female builds from strong natural fibers like milkweed stems (and sometimes yarn, string, and other manmade materials). Vireos are less famous but equally adept at the task, creating a hanging cup in the fork of a limber branch, using grapevine, grasses, fine roots, plant down, and spiderwebs.

Hummingbirds are noted for their use of spider silk, bound with soft plant down, to create a soft, flexible cup-shaped nest that insulates the tiny hatchlings and stretches as they grow. (The shingled covering of lichen that the female glues to the outside of the nest is such perfect camouflage that it may easily be overlooked from just a few feet away.)

Raptors generally pick high places for their nests—there are the cliff aeries of falcons and eagles, and many hawks build their nests in the limbs of tall trees. But the small, mostly diurnal Burrowing Owl goes deep—the world's only subterranean owl. In most of the North American West it uses empty prairie-dog burrows to nest. In Florida, the owls may use gopher tortoise holes or dig their own tunnels in the sandy soil. Wherever they nest, Burrowing Owls often festoon the entrance and tunnel with bits of dried manure and other junk, for reasons still unclear.

One of the strangest nests is that of the little-known Kittlitz's Murrelet, a rotund little seabird that hunts the turbulent tidal rips in deep fjords along the Alaskan coast. When she's ready to nest, the female murrelet flies up to fifty miles inland and thousands of feet up into the mountains, until she finds an isolated rocky outcrop among immense glaciers. Here, sometimes surrounded by hundreds of square miles of ice, she lays her single large egg, usually in the lee of a boulder that provides a little shelter from the constant danger of rock- and icefall. Day after frigid day for a month, she incubates the egg. Once the chick hatches, she flies off to the sea. For another month thereafter, both adults make half a dozen trips from the distant ocean every day, carrying fish in their stomachs for their baby. The payoff for such arduous labor is a nest site secure from virtually all land predators.

Of course, the easiest approach is not to make a nest or raise a chick at all. A few birds are brood parasites, dumping their eggs in the nests of others. This is common among ducks, in which one female surreptitiously lays her eggs in the nest in another of the same species. But Brown-headed Cowbirds take this approach to an extreme—they never rear their own young. Instead, they slip their eggs into another songbird's nest, often first tossing out the host's eggs.

OPPOSITE, CLOCKWISE FROM TOP LEFT Dunlin: Two compete for a small bivalve; one roosts among a flock of Western Sandpipers; probing beneath water and mud for invertebrates; nearing the peak of its breeding plumage. Many species that migrate long distances rely on critical locations in order to complete their long journeys. For Dunlin and Western Sandpipers on the West Coast, Grays Harbor, Washington, is one of the most important. Each May, half a million individuals converge on the estuary's rich mudflats to feed on abundant invertebrates before moving north to breed.

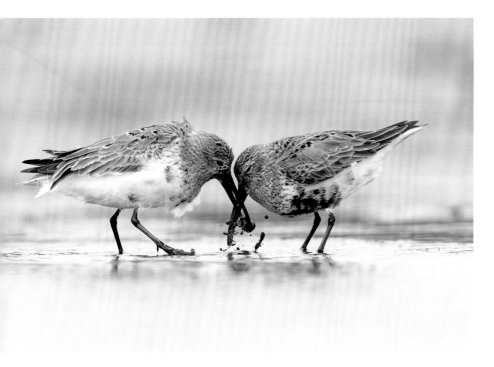

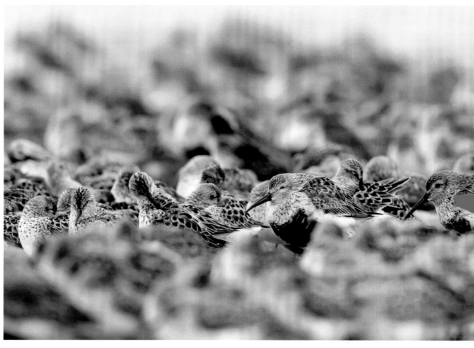

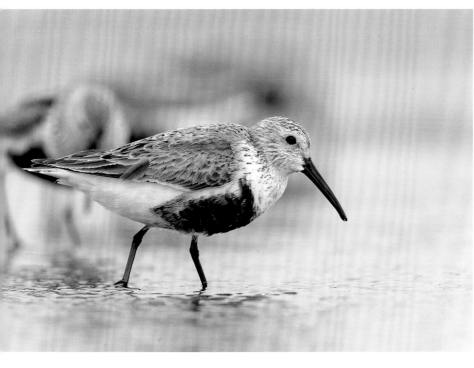

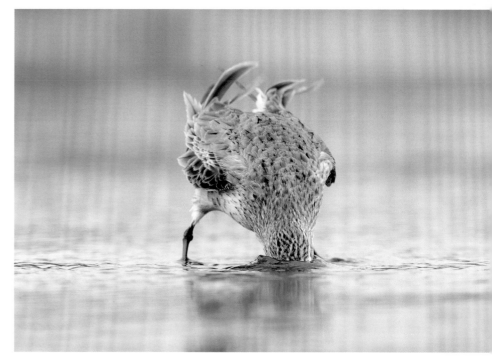

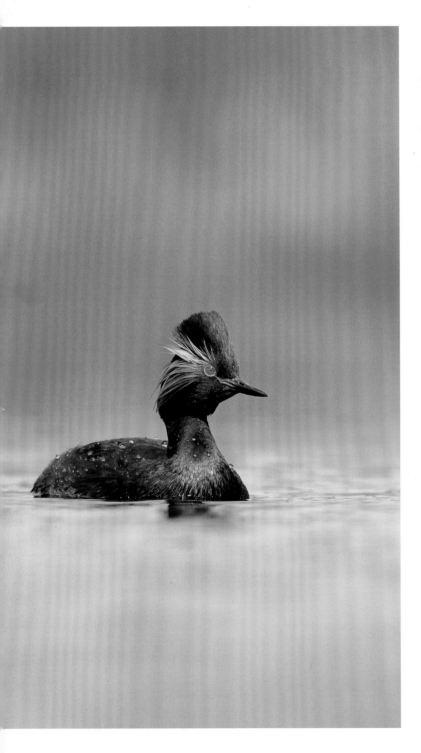

Because the Brown-headed Cowbird was originally a Great Plains species, naturalists assumed this behavior evolved to "free" the cowbirds—which today often forage for bugs among grazing herds of cattle—to follow the once-huge bison herds. Unfortunately for this old story, DNA has shown that Brown-headed Cowbirds evolved from South American species that had already developed brood parasitism far from any buffalo herds. Apparently, abandoning your kids has been a good strategy for a long time.

MIGRATION

Abandoning your home can also be a good strategy. Because the earth is tipped on its axis, the high latitudes undergo profound seasonal changes, setting the scene for that greatest of avian phenomenon: migration.

It is in migration, perhaps, that birds can truly stagger us. The notion that tiny animals weighing barely more than air can circumnavigate the globe in the face of winds and storms, powered only by millions of strokes of their fragile wings, is humbling and almost unbelievable.

And yet they do. Immense migrations are not only the purview of large and powerful birds but also the smallest. An Arctic Warbler from central Alaska, barely five inches long, will fly to the Philippines or Borneo for the winter, while an even smaller Wilson's Warbler from the same Alaskan willow thicket will migrate to southern Mexico. The Northern Wheatear, a thrushlike bird also of the Arctic tundra, has two populations in North America. Those nesting in the eastern Arctic migrate east across the Atlantic to western Africa, while those from the western Arctic migrate the other direction, crossing all of Asia and the Middle East to reach eastern Africa.

Each evening in spring and fall, multitudes of birds—even those normally active only by day—rise into the night sky, traveling under the sheltering cover of darkness. Pull up the

LEFT Eared Grebes go through dramatic seasonal adaptations. After breeding, they migrate to large, saline lakes where their flight muscles atrophy and their digestive organs greatly enlarge while they feed on superabundant brine shrimp and alkali flies. After several months of flightlessness, they reverse these changes, catabolizing their fat deposits to increase heart size and flight muscles, and then take to the air again to fly to their wintering grounds.

OPPOSITE To attract females, male Ruddy Ducks have an impressive "bubbling display." They also have a copulatory organ that is as long as their body, furnished with spines to hold it in place as they mate. A brushlike tip may remove sperm deposited by other males.

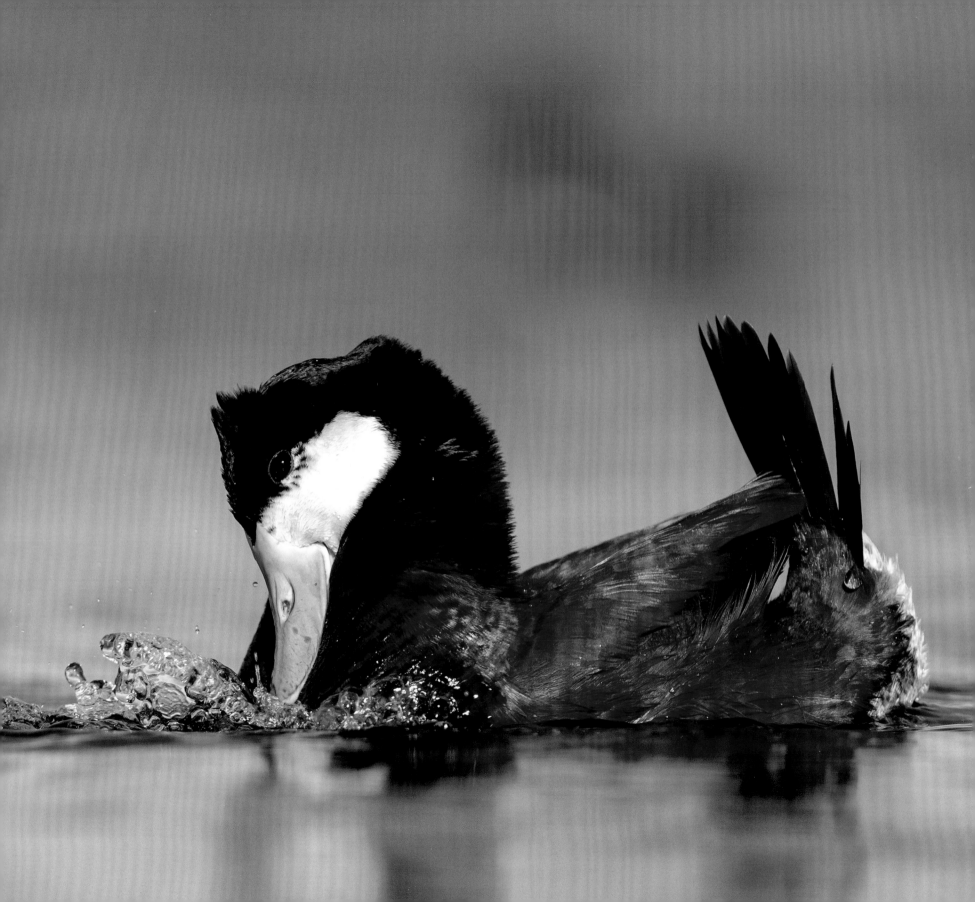

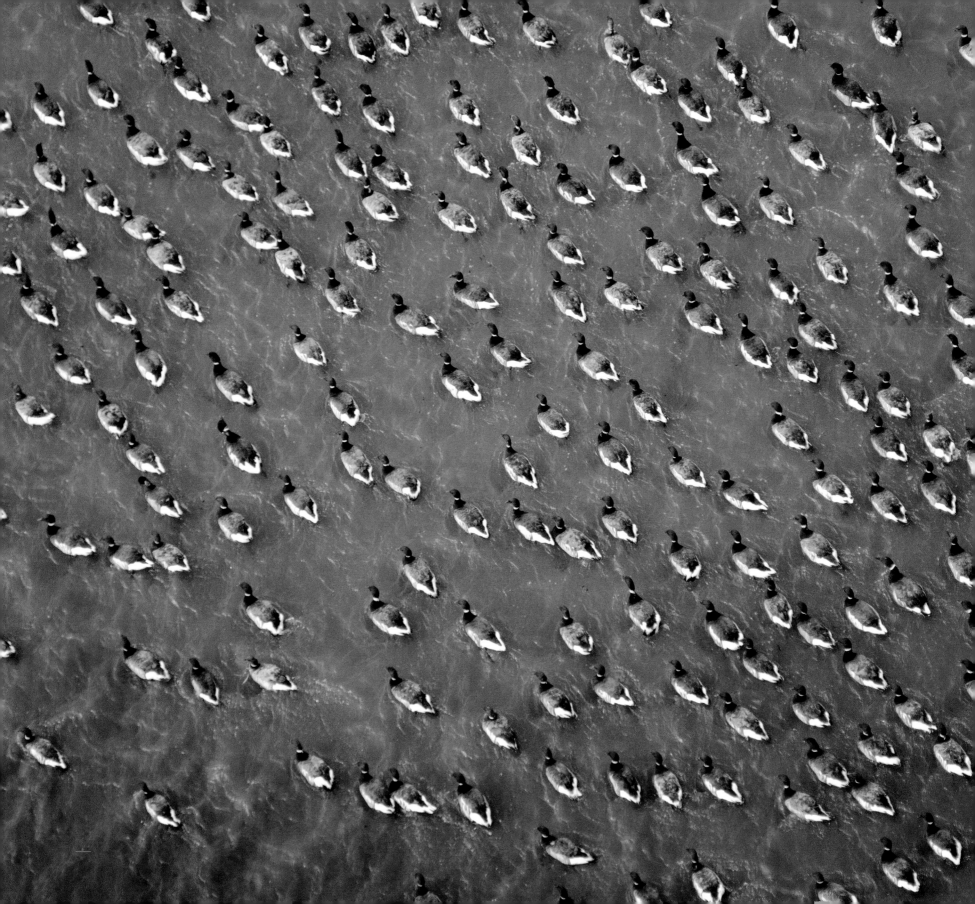

local Doppler radar feed on a night in April or May with a mild south wind, or a September or October night with a north wind blowing, and you can see them for yourself—great blossoms of pale blue and green on the radar screen that are not rain, but the radar signatures of hundreds of millions of birds pouring across the continent. It is one of the greatest wildlife spectacles—occurring in almost perfect secrecy. These bird migrations are not, however, entirely hidden from view. On such nights, if you focus binoculars or a spotting scope on the full moon, you can see the birds passing across the white disk in a fraction of a second, their silhouettes etched for a breathtaking instant on your retina.

On North America's northeast coast in autumn, millions of these small travelers head straight out into the western Atlantic. Birds such as Blackpoll and Connecticut Warblers fly 80, 90, or 100 hours nonstop to the coast of South America, burning fat with an efficiency equal to getting 720,000 miles per gallon of gasoline. Along the Gulf Coast, Ruby-throated Hummingbirds that weigh slightly more than a penny take off on a direct flight to the Yucatán Peninsula, crossing 600 miles of open water, while Pacific Golden-Plovers fly halfway across the Pacific from Alaska to Hawaii every year.

Seabirds make even greater journeys. The waters off both coasts of North America are alive every summer with shearwaters, petrels, storm-petrels, and (in the Pacific) albatrosses that journey tens of thousands of miles every year. On small islands from New England to Newfoundland, millions of Leach's Storm-Petrels nest in burrows dug into the peaty soil. These chocolate-colored, swallow-sized seabirds spend their nonbreeding season in the Southern Ocean around Antarctica and travel perhaps 20,000 miles back and forth each year. (While the Leach's Storm-Petrel is nesting in the north, its southern counterpart, the Wilson's Storm-Petrel, is in the North Atlantic. The latter spends its nonbreeding

season on the open water just offshore, feeding on plankton. Six months later, the roles reverse, with Wilson's sitting on nests on the Antarctic coast and Leach's feeding in the cold southern waters.)

Seabirds cover staggering distances. Tiny tracking devices placed on Arctic Terns have shown that some from Europe travel 51,000 miles a year, while those tagged on the coast of Maine migrate back and forth between South America and Africa in the southern Atlantic. Some even round the Cape of Good Hope and spend part of the winter in the Indian Ocean before returning to New England.

On the North American west coast, seabirds gather from the farthest corners of the Pacific to feast on the food brought by cold, rich ocean currents. Short-tailed Shearwaters fly 40,000 miles a year in looping figure-eight patterns between their nesting grounds in Tasmania or New Zealand and their feeding grounds in the Bering Sea. There, they encounter critically endangered Short-tailed Albatrosses that breed on just one volcanic island near Japan, and Laysan and Black-footed Albatrosses from remote atolls in the central Pacific.

We are still learning what birds are capable of. Bar-tailed Godwits, which make the longest nonstop flight we know of—7,200 miles from Alaska to New Zealand, a journey of seven to nine exhausting days—do so by radically altering their internal anatomy twice each year. After feeding voraciously for weeks on marine invertebrates, doubling their weight and laying on sufficient fat reserves for this astounding flight, the digestive tracts of these large shorebirds atrophy in a matter of days—saving weight because they are no longer needed. At the same time, the birds' flight muscles and heart mass, which will be critical for the journey ahead, increase dramatically.

The Bar-tailed Godwits time their departure from Alaska with the passage of ferocious autumn gales, which rake the

North Pacific with hurricane-force winds—and provide the godwits with a powerful push as they set out across the widest part of the ocean. A week or more later—having flapped their wings without surcease the entire time—they land in New Zealand, regrow their shriveled digestive organs, and spend the austral summer feeding. When it's time to return to Alaska, they again take advantage of prevailing winds, this time making a nonstop flight to the Yellow Sea coasts of China and the Koreas. After another long refueling stop, they complete the journey to Alaska. In the process, the birds cover some 18,000 miles a year.

Whether a Bar-tailed Godwit crossing the ocean or an American Robin migrating a few hundred miles across the Midwest, birds use many cues to find their way through the skies. They use celestial orientation, marking the apparent movement of the stars rotating around unmoving Polaris; they somehow tap into the earth's magnetic field, use landmarks like coastlines and mountains, listen to the low-frequency rumble of distant ocean surf and mountain winds, and—in the case of seabirds—sniff their way home.

Of course, not every bird needs to migrate. Migration isn't driven by the cold; birds are superbly insulated creatures. Instead, the motivational force behind migration is the predictable lack of resources, either foods such as insects, fruit, and nectar that are only seasonally abundant; or seasonally available habitats, notably open water for ducks, geese, and other waterbirds.

Species that can make do with winter's limited larder needn't migrate, and many do not. Others are more highly migratory in the most northerly parts of their range, and less so (or not at all) farther south. Recent tracking research has shown that some Snowy Owls actually go *north* from their Arctic breeding grounds. These rugged birds spend the perpetually dark Arctic winter hunting sea ducks at permanent openings in the pack ice, known as polynyas. The temperatures and wind chills can reach terrifying depths, but the owls are fine. Snowy Owls are so well insulated that they have shrugged off experimental temperatures as low as -135 degrees Fahrenheit—far colder than it ever gets in the wild.

No other bird seems as delicate and fragile as hummingbirds, and yet some of these tiny creatures have shown an astounding ability to tolerate frigid winter conditions too. Rufous Hummingbirds from Alaska and the Pacific Northwest normally migrate to Mexico for the winter, but since the 1970s, a rapidly growing population has been wintering in the eastern and southeastern United States—probably the result of a genetic error in their instinctive orientation. While the Southeast is a fruitful place for the new migrants to winter, many of them linger into December or January as far north as New England, and they sometimes get caught in dangerous cold snaps.

How can they manage? A Rufous Hummingbird simply turns down the thermostat every night, drastically reducing its energy needs by essentially going into hibernation for fifteen or sixteen hours. Its body temperature drops from about 104 to 50 degrees Fahrenheit, and the bird goes rigid and unresponsive. In this suspended state, wild Rufous Hummingbirds thrive in subfreezing conditions and can even survive temperatures below zero, emerging hale and healthy at dawn to feed on cold-hardy invertebrates, tree sap, and other natural foods.

INTELLIGENCE

With each migration, a bird learns the best route to take, the safest stopover sites with the richest food, and the unique dangers of its distant wintering lands. The more scientists study birds, the more they appreciate the surprising intelligence that underpins many of their actions. Birds are not

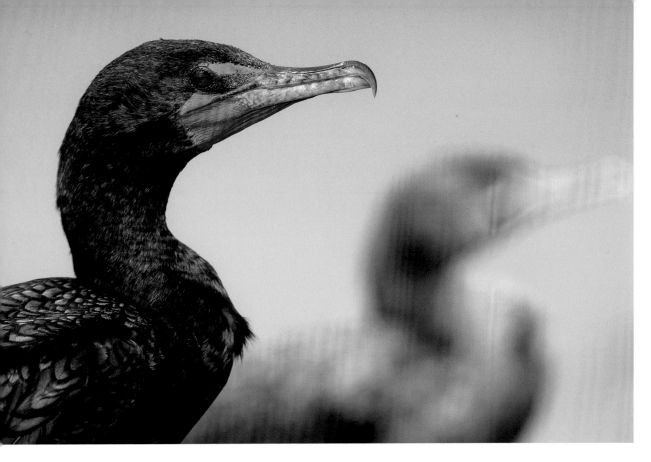

LEFT Not usually known for its good looks, the Double-crested Cormorant has sparkling emerald eyes that are among the most beautiful in the bird world.

RIGHT For a brief period each year, Long-tailed Jaegers visit the Arctic where they nest on tundra and consume a diet of lemmings, voles, insects, chicks, and eggs. They spend the remainder of their year at sea, generally out of sight of land. They winter over the open southern oceans.

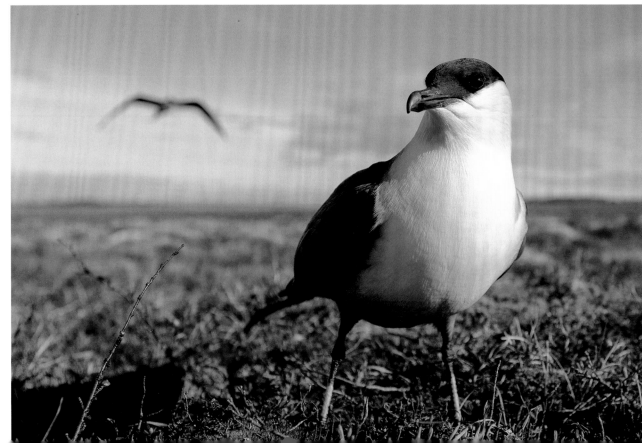

the simple stimulus/response automatons they were once considered.

Measuring intelligence is a tricky task, of course. We are reasonably good at measuring human intelligence, but crossing the species barrier and assessing organisms radically different from ourselves is fraught with biases and miscalculations. What appears to be raw intelligence may, in fact, be a highly evolved behavior that functions in a way fundamentally different from how human brains work.

Take spatial memory. Many birds cache extra food against lean days to come, and remembering where they stashed the goodies is critical. This is hard enough for a chickadee or titmouse that is squirreling away a few dozen sunflower seeds and returning for them the next day, but the western corvid known as Clark's Nutcracker takes this task to an almost unimaginable level.

Late each summer, as the cones of pinyon and whitebark pines ripen in the high elevations of North America's western mountains, the nutcracker begins prying them open and removing the large, nutritious seeds. Over the coming months, the bird may cache as many as 98,000 seeds, burying a few at a time an inch or two deep and memorizing the spot based on the position of nearby rocks, logs, and other landmarks. The nutcracker may range up to twenty miles on foraging expeditions, carrying collected seeds back to its home territory in a special throat pouch.

As winter weather begins, the highest caches are buried deep in snow, and the nutcracker may move to progressively lower elevations, caching as it goes. In spring, as the snows begin to melt, the bird migrates upslope again. As the drifts recede, the nutcracker uses its uncanny memory to find and uncover thousands and thousands of its old caches, using the stored seeds to feed itself and its chicks through the summer breeding season. A single nutcracker may make—and then relocate months later—more than five thousand separate caches. Scientists have found that the birds rarely forget a stash, although a cache may go unrecovered, often because the nutcracker died—in fact, this is the primary means by which whitebark pine seeds are dispersed.

Whether it is ingrained instinct or something more, the hunting behavior of the Harris's Hawk is strikingly unavian. These large, dark raptors with chestnut-colored patches on their wings are found from Arizona and south Texas into Central America. They are oddballs in many respects; their sometimes polyandrous mating habits have already been mentioned. In some areas they also form extended families with wolf-packlike hierarchies, an alpha female at the pinnacle.

A breeding group of up to eleven hawks will gather in so-called assembly ceremonies, where they perch together in a tight bunch. They then set out on a cooperative hunt—again, much like wolves or a pride of lions or a band of predatory chimps. By hunting together, they can tackle prey such as jackrabbits, which would otherwise be too large or strong for a single hawk to subdue. Sometimes one or two pack members will scuttle into thick cover to flush a rabbit into a waiting circle of other hunters. At other times, the hawks will pursue a jackrabbit in staggered relays, allowing some hawks to break off and rest while others of the pack take up the chase, eventually wearing down the prey.

However, once the kill is made, there is a sharp difference between these cooperative hawks and mammalian pack hunters. Among lions and wolves, the most dominant individuals eat first. Harris's Hawks usually allow the youngest and least adept members to feed before the rest have their share.

The peak of avian intelligence rests with two unrelated groups—the corvids (jays, crows, and ravens, the group to

OPPOSITE Ring-billed Gulls are the ultimate flying machines. A flick of the wings, and up the bird rises from the beach. A crook of a wrist just so, and the bird makes a 90-degree turn. By adjusting each of the joints, the wings and the spread tail hold the bird perfectly steady in the air as it hovers, sharp eyes searching for food below.

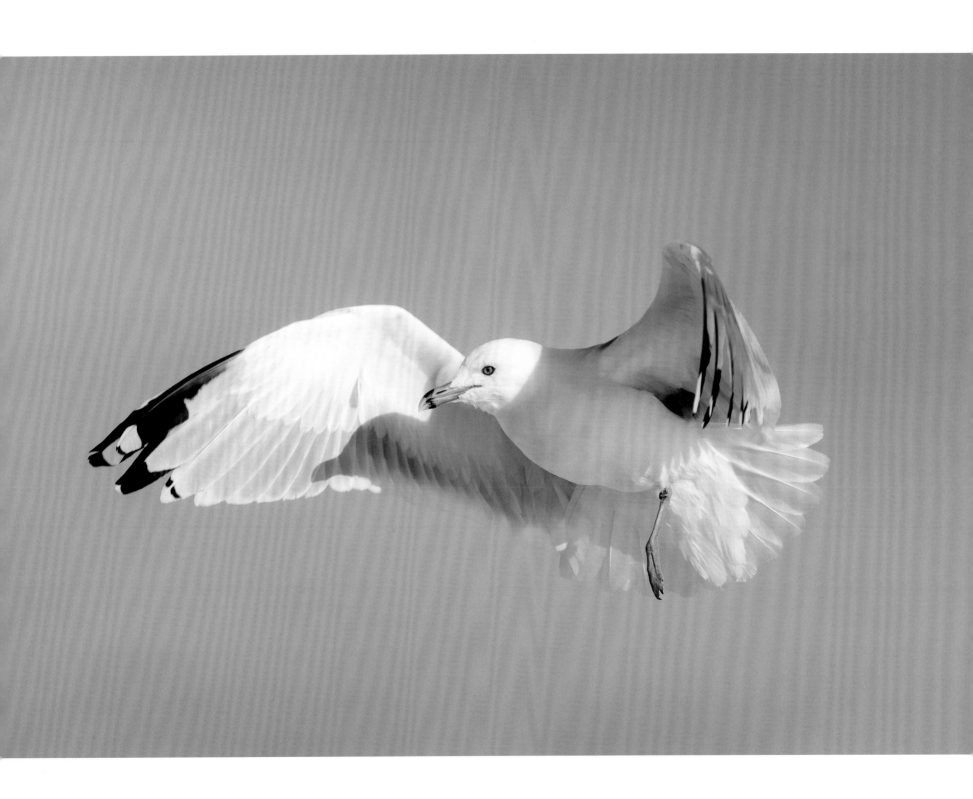

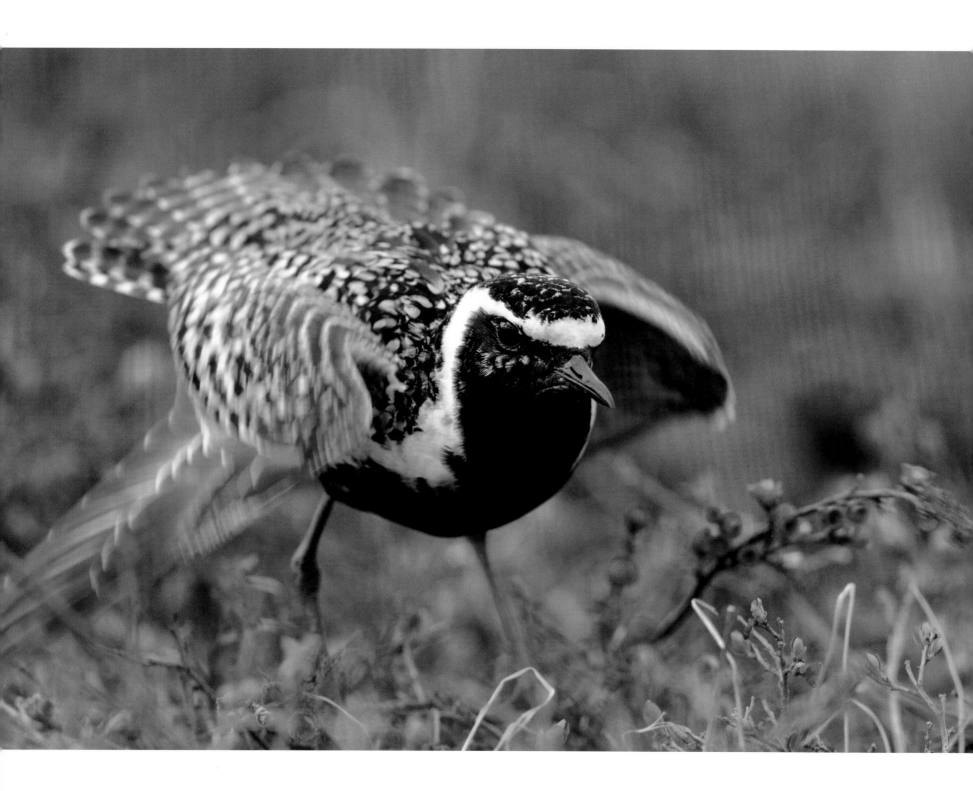

which nutcrackers belong) and parrots. Experiments with Common Ravens and African Gray Parrots have shown that both perform logical reasoning at about the same level as a four- or five-year-old human child. They are the only animals in the world other than humans and the great apes that are capable of such a feat.

THE SECRET LIVES OF BIRDS

But as much as birds astonish us, there is still much more to be discovered. There are enormous gaps in our knowledge of even the most common species, and those birds whose lives take place in remote places or out of easy human sight are often little more than a cipher with feathers.

We have only the vaguest notion where many migrants go when they leave their northern breeding grounds, for example. How far and how fast they travel are mysteries—and we know little or nothing about their ecology and behavior in the areas where they go.

Nocturnal birds, not surprisingly, are an especially tough riddle to solve. For almost twenty years I have studied one such species, the Northern Saw-whet Owl—a raptor the size of a soft-drink can with wide, yellow eyes and a remarkably confiding nature when in the hand. Saw-whets breed in the cool forests of northern North America, the Appalachians, and the western mountains and are so infrequently encountered that even an avid birder can go a lifetime without spotting one. When we started banding them in the mountains of Pennsylvania, they were thought to be so rare that the Saw-whet Owl was the symbol of the state conservation fund and they were listed as a species of conservation concern.

But other researchers discovered that if you play the mechanical, tootlike call of a saw-whet at night, you can lure the migrating owls down from the sky and into fine, soft mist nets to catch and band them—a lot of them. We quickly learned that saw-whets were not rare at all, just rarely seen. Some nights we captured them by the dozens; one exciting season, we banded nearly four thousand of these supposedly threatened birds.

Along the way, we learned that saw-whets travel south on the same chilly autumnal winds that hasten other migrant birds. When we affixed tiny radio transmitters to some of them, we discovered where they hide in the daytime, what kinds of habitats they prefer, and how wide an area they hunt after dark, chasing mice through the shadowy forests. We used new tracking devices that allowed us to follow their movements across several years, and we learned that the owls are among the most nomadic of raptors, nesting one year, perhaps, in Quebec, and the next in Pennsylvania.

We also used radar and infrared cameras to peel back the cloak of nocturnal darkness, hoping to trace the flight of these small owls. One night in the windy aftermath of a November cold front, we sat on a ridgetop in the Pennsylvania hills, aimed our equipment to the sky, and gasped. The air was full of birds; we could see the distinct silhouettes of loons and ducks, geese and herons, owls and thrushes, and countless smaller birds. They passed overhead in waves, their warm bodies glowing white against the black, cold sky on the infrared monitor. On the radar screen they showed up as fast-moving blips.

The waves kept coming. Counting off the minutes and tallying up the passing birds, we made some rough calculations. We realized that along our thirty-mile stretch of ridge, birds were passing us at a rate of nearly *two million* per hour.

To us, it was jaw dropping. For the birds, it was just an average night. Just an average miracle, you might say—the sort birds routinely perform, whether we notice or not.

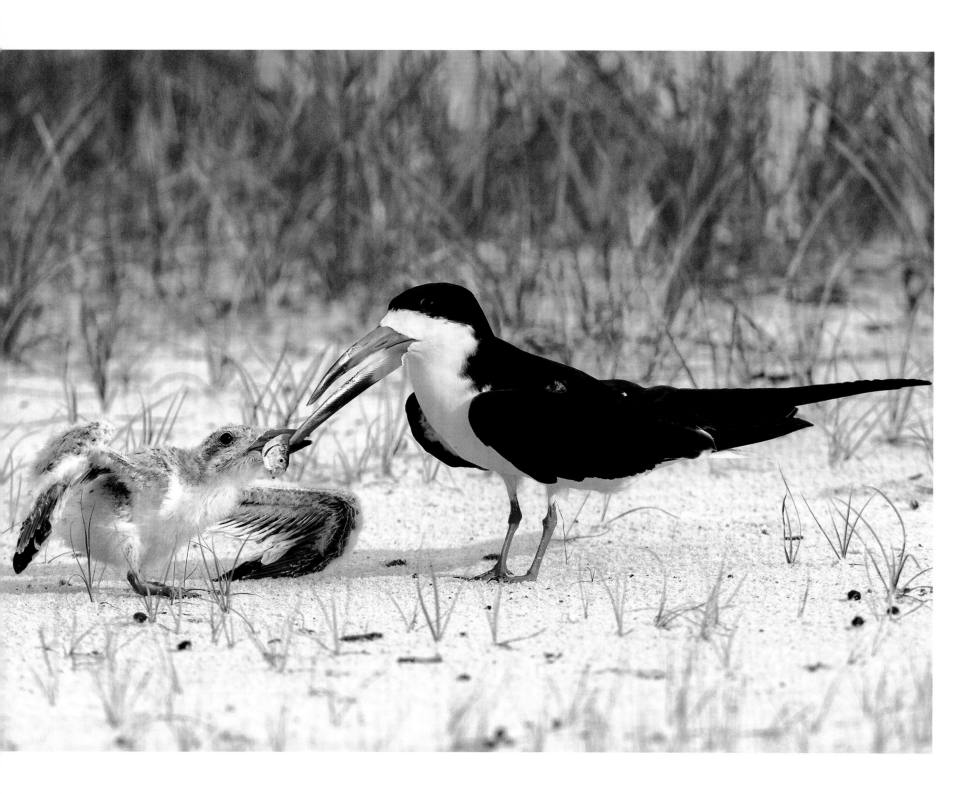

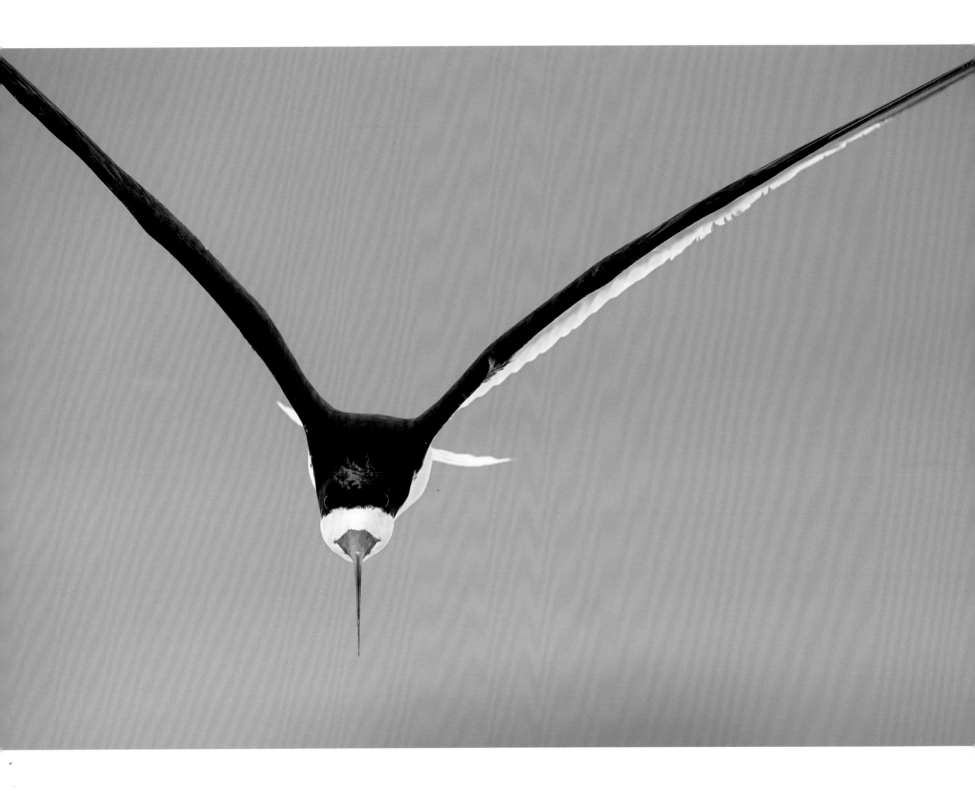

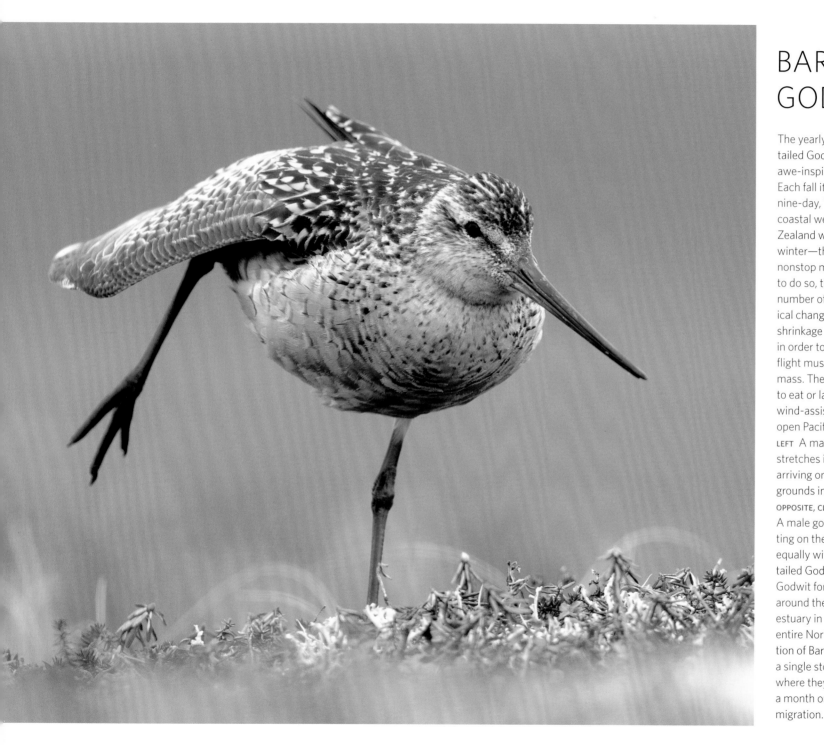

BAR-TAILED GODWIT

The yearly migration of the Bar-tailed Godwit is among the most awe-inspiring in the bird world. Each fall it makes a seven- to nine-day, 7,200-mile flight from coastal western Alaska to New Zealand where it spends the winter—the longest known nonstop migratory flight. In order to do so, the bird undergoes a number of dramatic physiological changes including a rapid shrinkage of its digestive organs in order to make room for more flight muscle, fat, and heart mass. The godwit does not pause to eat or land to rest during its wind-assisted journey over the open Pacific Ocean.

LEFT A male Bar-tailed Godwit stretches its wing shortly after arriving on its tundra breeding grounds in Alaska.

OPPOSITE, CLOCKWISE FROM TOP LEFT A male godwit takes his turn sitting on the nest, a task he shares equally with his mate; a Bar-tailed Godwit nest; a Bar-tailed Godwit foraging on the mudflats around the industrialized Yalu estuary in China; virtually the entire North American population of Bar-tailed Godwits make a single stop at these mudflats where they refuel for about a month on their northward migration.

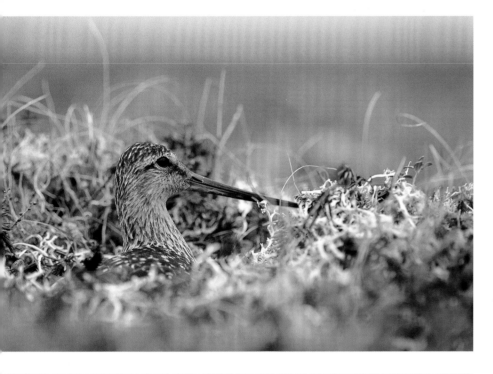

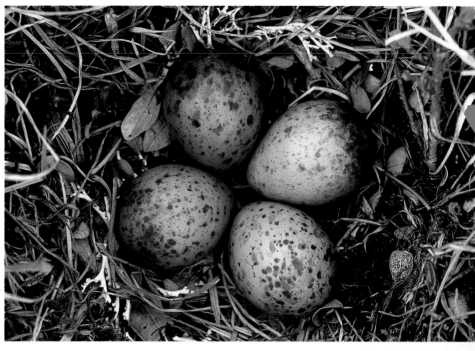

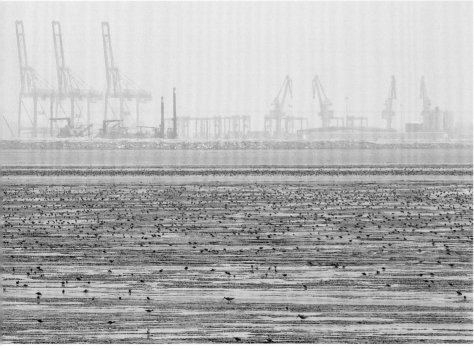

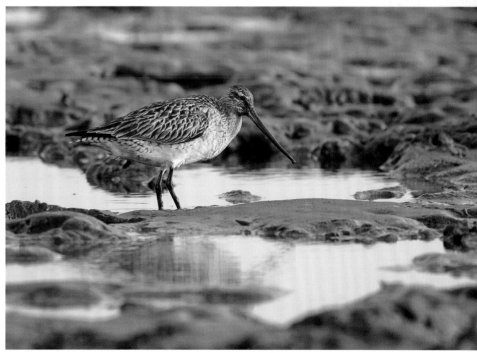

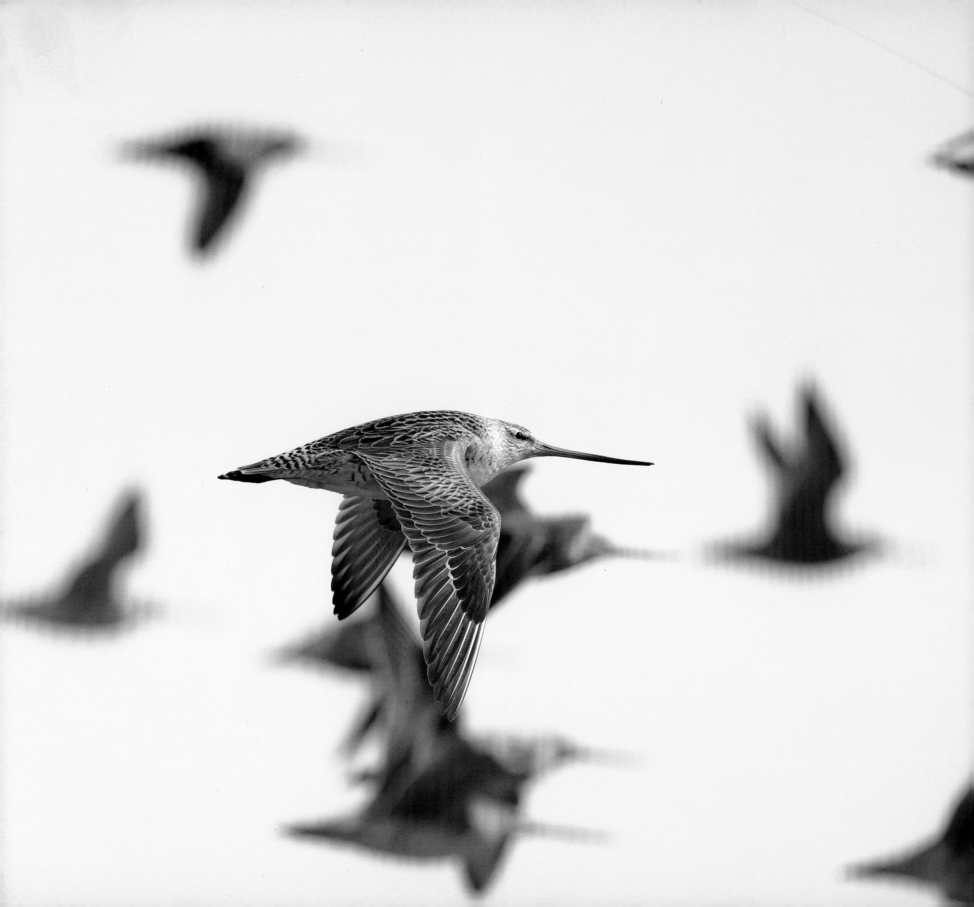

OPPOSITE AND RIGHT Migrant godwits; a godwit foraging at dawn. On its return flight to Alaska from New Zealand in spring, the godwit takes a different route, stopping once to refuel on the mudflats of China's Yellow Sea coast. In all, the godwits migrate 18,000 miles each year—more than seven times the distance from New York to Los Angeles.

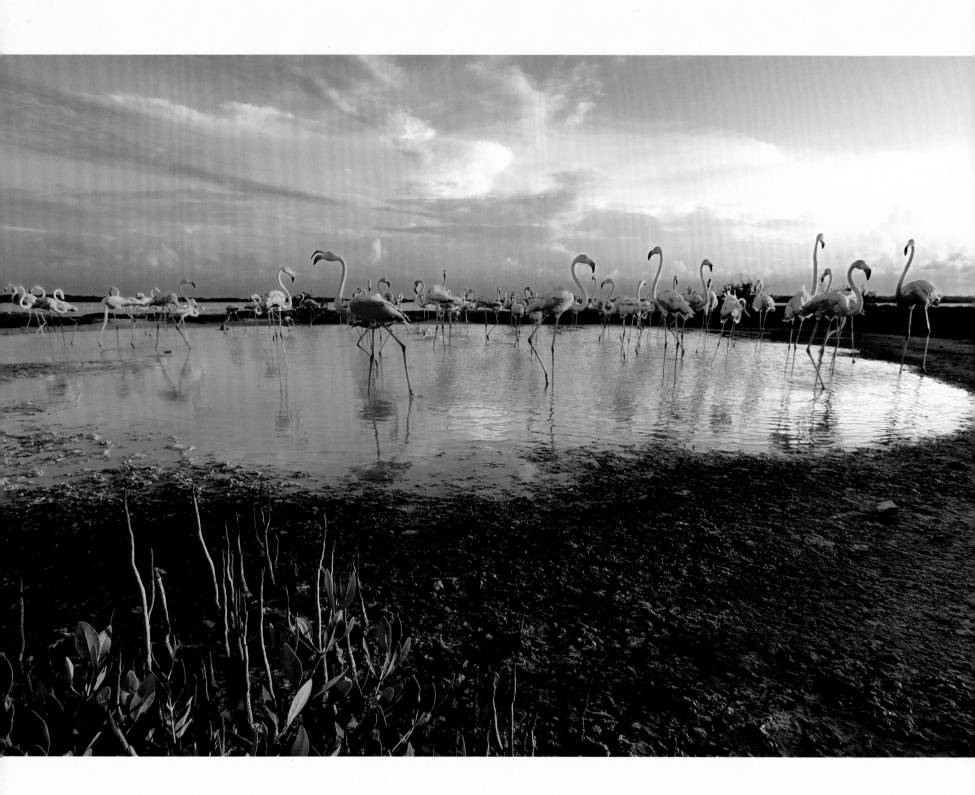

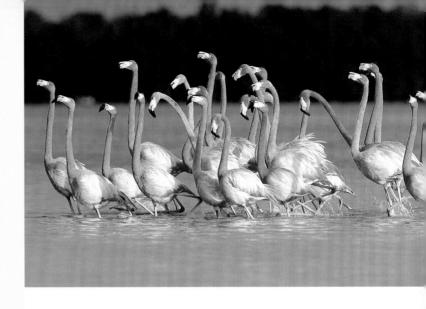

IN THE FIELD
Among Flamingos

Gerrit Vyn

Ría Lagartos Biosphere Reserve,
Yucatán, Mexico, August

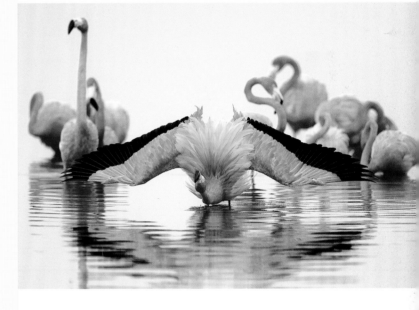

OPPOSITE Flamingos often flock to springs and places where rainwater collects to drink and bathe.

RIGHT, FROM TOP Flamingos perform elaborate group courtship displays like marching and wing salutes that help individuals assess and select potential partners for breeding; Adult flamingos feeding.

WE LEFT FOR THE FLAMINGO COLONY long before dawn. Barely awake and already sticky from the thick, salty Yucatán air, we traveled down the coast on the long, sandy road that separates the Gulf of Mexico from the great estuary Ría Lagartos. My local guide, Chucho, tried to avoid the large tomato-red crabs that littered portions of the road. "Cangrejos" he said—and I repeated it—each time we encountered another group. *Crabs.* It was one of the few words in Spanish we both knew. Eventually, we parked the truck, applied layers of sunblock and bug spray, and quietly snaked our way through a narrow band of mangroves to the estuary's edge. From there, it was a long shuffle, perhaps a mile, through shallow saline waters to the flamingos.

When my toes first touched the still water, it was warmer than the morning air. Sunlight and algae had conspired to render the bottom's surface as slippery as ice. One false step and a lot of expensive camera gear would be lost to the corrosive salt water. I slid one foot ahead of the next, never lifting a foot, feeling my way across the black, liquid expanse. Above me, the Milky Way was in full force, with the stars appearing large and vibrant, as they often do in the tropics. Midway, I stopped to turn 360 degrees.

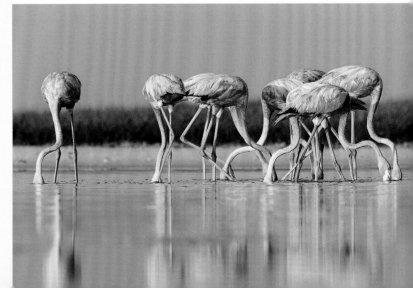

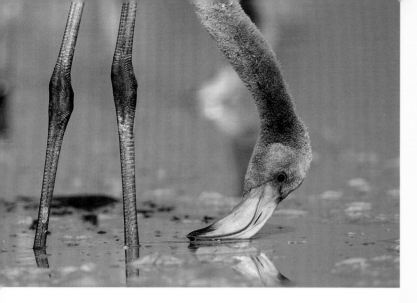

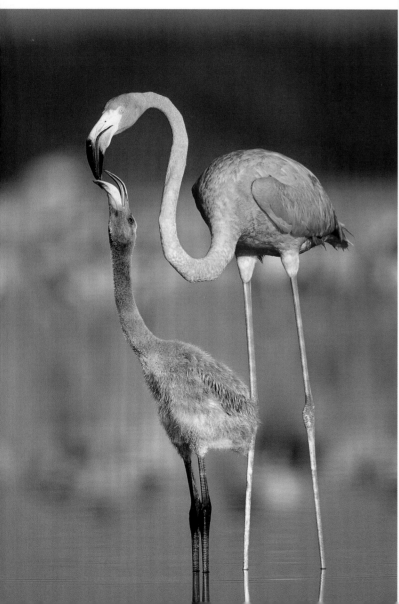

With the dripping stars perfectly reflected in the still water, I felt like I was floating in space.

As we neared the muddy island where the colony was located that year, the occasional gooselike honks of adult flamingos and the din of thousands of murmuring chicks guided our steps. In hushed tones Chucho helped me ready my gear, and then I set off alone for the last hundred yards. On hands and knees, and then on my belly, pushing my camera gear ahead of me, I slithered through the cool mud to a tiny blind we had built near an area of shallow water where the chicks would feed as the day warmed.

The American Flamingo—or any flamingo for that matter—was not a bird I had ever given much thought to. It was a cliché: a lawn ornament, a C-list attraction at a zoo. Like a few other fantastical birds, peacocks come to mind, there is a prejudice attached to it, as if the flamingo has chosen to lower itself by deserting its proper place in nature and showing off for humanity. As the deep, starry night turned a dark powdery blue, and a pinkish hue appeared on the horizon, I saw the flamingo anew.

In the growing light, I peered through my camera. Stretching for several hundred yards were the packed bodies of thousands of fuzzy, gray chicks—the crèche. There were sixteen thousand of them, and the noise they made was growing. The chicks called out emphatically, vying to be heard by parents that might arrive from distant foraging grounds to pour streams of blood-red liquid called crop milk—rich in protein and fat—into their open beaks.

Though each chick's individual calls sound almost identical to our human ears, they are different enough that parents and chicks quickly reunite in a noisy flock of thousands of birds. As the adults began to arrive, terminating their powerful flights with graceful running stops, some walked to the edge of the crèche and called, waiting for their chicks to hear their calls and work their way to the edge to be fed. Others marched right in to the melee, where a game of Marco Polo ensued and eventually united the pair.

LEFT Young flamingos quickly learn to feed themselves but rely on adults for most of their nourishment when they are young. OPPOSITE Like adults, young flamingos are highly gregarious, more comfortable in dense flocks than on their own.

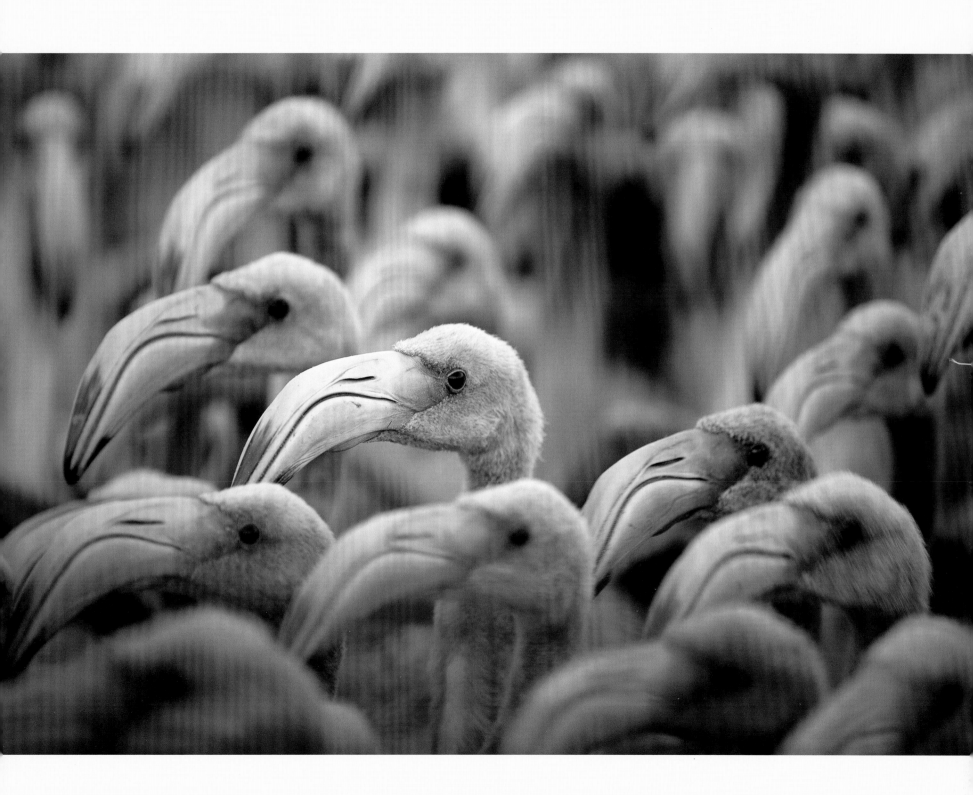

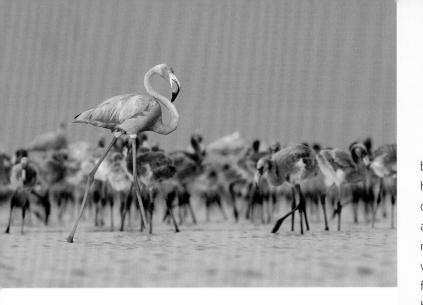

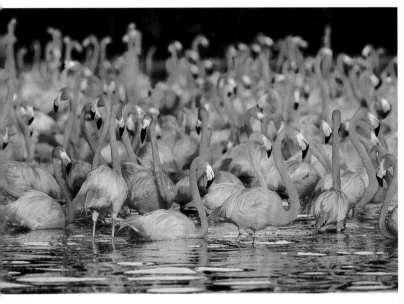

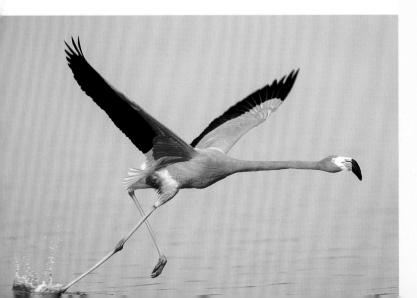

The adults continued to arrive, many of them close to my blind, giving me the opportunity to study them at close range. It is hard to believe the flamingo is real when you first lay your eyes on one in the wild. The birds have glowing crimson and pink plumage. Their necks and legs are impossibly long. Their beaks are like no other—bulbous, drooping, and meticulously painted in black, white, and pink. Their clear yellow eyes are serene and watchful. What twists and turns of evolution and environment possibly added up to produce a bird that looks like this and thrives in some of the harshest conditions on the planet?

As the sun rose, most of the adults departed, leaving only a handful of chaperones to guide the young. The chicks, ranging in size from calf- to waist-high, moved en masse on well-developed, knobby-kneed legs to the shallow waters around my blind to cool themselves and feed on their own. Hunkered down, sweating in the tropical heat and getting muddier by the minute, I was completely surrounded by squealing chicks and the sounds of thousands of beaks and feet working the muddy waters.

Flamingos are filter feeders. Their oddly shaped bill evolved for one purpose: to separate from the muddy substrate the few but abundant tiny organisms that survive and flourish in hypersaline wetlands. They accomplish this by using a repetitive series of tongue and bill movements to rapidly pump water in and out through comblike bristles that line their upper and lower mandibles.

As night began to fall, I was treated again to the arrival of the adults—ten times as many as that morning. Eventually, it was dark enough for me to slip out of the blind and ford my way back through the still water, unnoticed by shoals of pink birds that had gathered in places for the night. I was exhilarated and fascinated. How could I have ever discounted this otherworldly creature? Perhaps flamingos are simply beyond even a bird lover's imagination. Beyond what even a bird could possibly be.

LEFT, FROM TOP An adult flamingo looks for its chick in the crèche; Adult flamingos gathering to roost in the last light of the day; Slow to take off, flamingos must run across the water to get airborne

OPPOSITE Thousands of flamingo nests, made by piling up mud that hardens when it dries, sit dormant between breeding seasons.

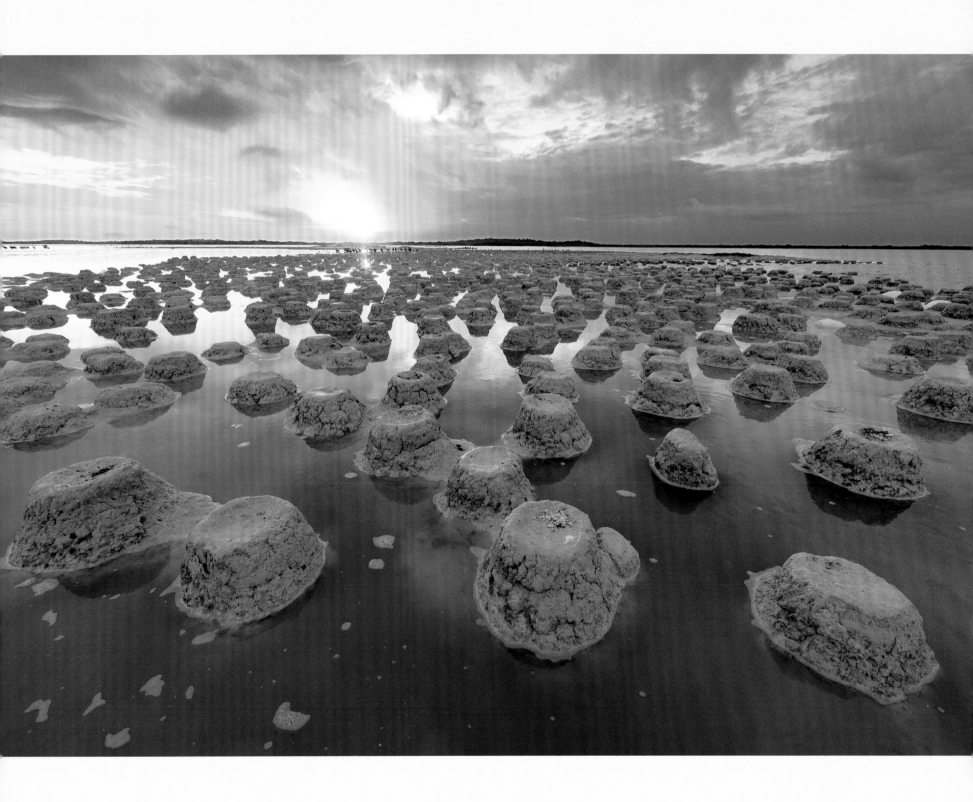

PROFILE

Greg Budney, Audio Recordist

NAME A BIRD, and Greg Budney can probably tell you what it sounds like.

Hermit Thrush?

"Starts each song with a clear tone."

Veery?

"A descending spiral of notes."

Willow Flycatcher?

"Fitz-bew. Fitz-bew."

But words don't come close to capturing the cacophonous glory of birdsong, so Budney would rather you listen for yourself. He knows just the place for it: the Cornell Lab of Ornithology's Macaulay Library.

In his more than three decades at this digital library of animal behavior, Budney helped build what is now the world's richest repository of nature sounds. With more than two hundred thousand audio files, the collection represents 80 percent of bird species living on the planet today—and some, like the Kauai O'o, that vanished decades ago. Budney's own recordings fill nineteen pages in the computerized database, starting with a three-minute clip of an adult Veery he snuck up on near Ithaca in June 1981.

That was a year after Budney hired on at the library as a technician. His job was to duplicate reel-to-reel recordings mailed in by researchers or volunteers. He cut the tapes by hand and spliced them together by species, creating reels that held only robin songs or Snow Goose honks. He took the job to earn money for graduate school and didn't expect to stay long. He never left.

"No day was boring," Budney said. "I always learned something, and working with some of the most experienced field biologists in the world, preserving their life's work and making it accessible to others, is incredibly rewarding." His job description morphed over the years, from technician, to audio archivist, and then curator of audio. His current title is curator for collection development and outreach.

The oldest recordings in the collection date from 1929 and were made on "talkie" film stock. In the 1940s, researchers carted around the apparatus necessary to cut records in the field. During Budney's tenure, reel-to-reel and cassettes eventually gave way to solid-state digital recordings.

He helped orchestrate a twelve-year project, completed in 2013, to standardize the collection by digitizing every file. It was the most ambitious undertaking in the library's history, essentially swinging the doors open to anyone in the world with access to a computer. For Budney, the doors swung open when he first joined the staff at Cornell.

He grew up in Horseheads, New York, just twenty-five miles from Ithaca. His grandparents were backyard birders who brought him to visit the Cornell Lab of Ornithology as a youngster. All he remembers from that visit is straying off the boardwalk that winds through the Sapsucker Woods Sanctuary and ending up muddy and in trouble.

He was always tuned in to nature, though. As a kid he knew where to find spotted salamanders and which rocks hid the biggest crayfish. It was an ornithologist at the State University of New York at Geneseo, where Budney earned his bachelor's degree, who taught him to tune in with his ears as well. "He challenged us to learn twenty or thirty local bird sounds, which seemed like an enormous challenge at the time," Budney recalled.

The more Budney listened, the more he heard. Soon he could tease out distinctive voices in the chorus of birdsong that greets the dawn. He learned to strain at the far range of his hearing, alert for unusual species almost out of earshot.

When he started making his own recordings at Cornell, he was thrilled by the entrée it provided into the intimate lives of birds. With a twenty-pound Nagra recorder slung over his shoulder and a thirty-inch parabolic microphone in hand, he would creep ever closer to his quarry. "It takes all the skill of a hunter," he said. "I want to be able to capture every bit of information, bring it back, play it for someone, and have their jaw drop."

He bagged the library's first good recording of a Least Bittern on a cattle ranch in Florida. Budney spotted the bird across a small pond, sitting in a patch of lily pads. He waded into the tea-colored water, feeling it fill his boots. The tiny heron kept singing its deep-throated *coo-coo-coo*, so Budney moved closer, plunging in over his knees, and then up to his chest, until he was within a few yards of the bird. In Hawaii, Budney eavesdropped on the last wild pair of Hawaiian Crows. He was crouched in a blind, recording their voices, when the male picked up a berry and began rolling it back and forth in his beak to entice the female.

"I couldn't help but feel for him," Budney said. "He was being ignored."

With smartphones and other featherweight tools, the ability to capture the sounds of nature is in more hands than ever before. Part of Budney's job is to tap into that potential to swell the library's collections.

Budney points out that it doesn't take extraordinarily sharp hearing or even a musical ear to become proficient in recognizing and recording bird songs. He says he has neither. "Most people can pick up a telephone and recognize a familiar voice within a few seconds," he said. "We just don't apply that ability to the natural world."

Birds are the perfect place to start, Budney tells audiences when he travels the country as an ambassador for the Cornell Lab. They're all around us. They lead interesting lives. And their songs resonate in such a fundamental way that many scientists believe birdsong is the root of what humans call music.

Budney has heard the voice of the Common Loon dozens and dozens of times, and it never fails to move him. "What a stirring sound," he said. "It just transports you."

All you have to do is listen.

RIGHT A male Common Loon proclaims his territory with a wail call.

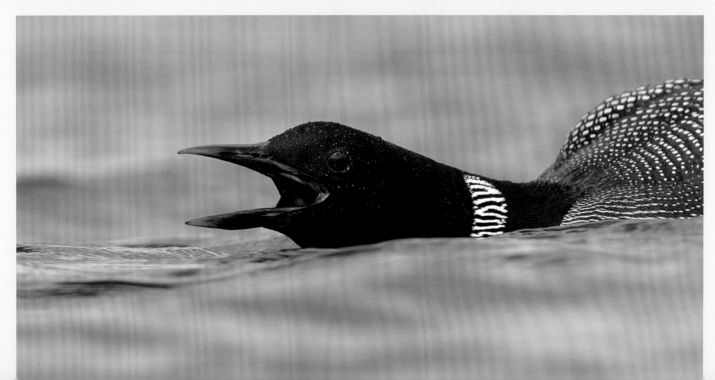

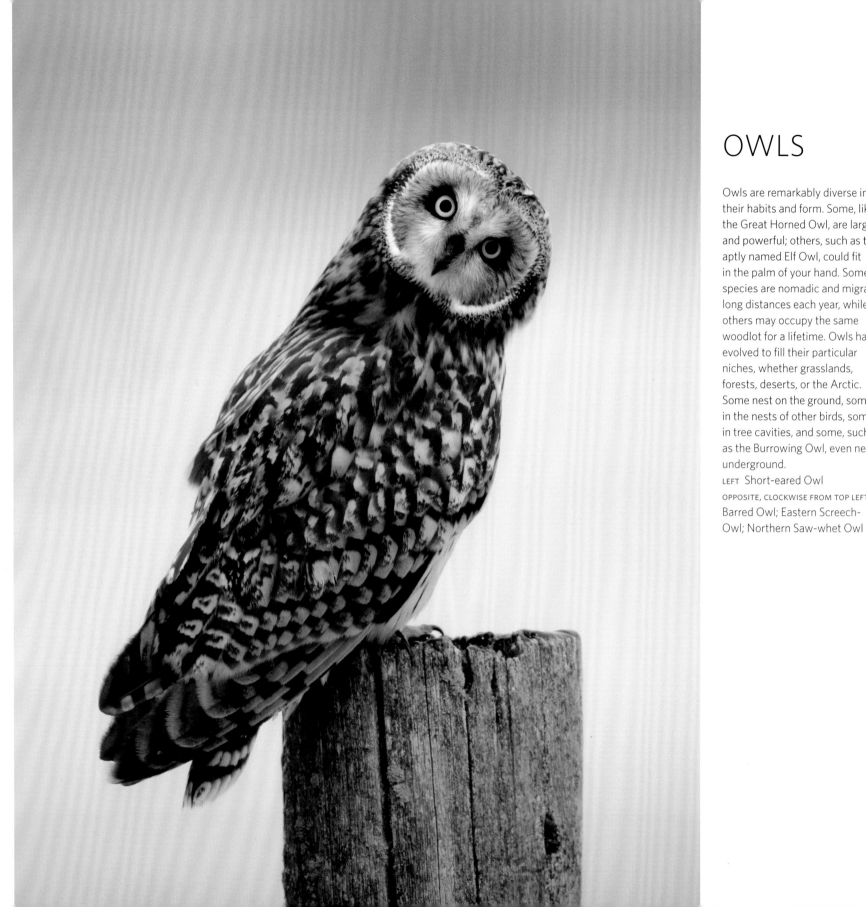

OWLS

Owls are remarkably diverse in their habits and form. Some, like the Great Horned Owl, are large and powerful; others, such as the aptly named Elf Owl, could fit in the palm of your hand. Some species are nomadic and migrate long distances each year, while others may occupy the same woodlot for a lifetime. Owls have evolved to fill their particular niches, whether grasslands, forests, deserts, or the Arctic. Some nest on the ground, some in the nests of other birds, some in tree cavities, and some, such as the Burrowing Owl, even nest underground.

LEFT Short-eared Owl
OPPOSITE, CLOCKWISE FROM TOP LEFT Barred Owl; Eastern Screech-Owl; Northern Saw-whet Owl

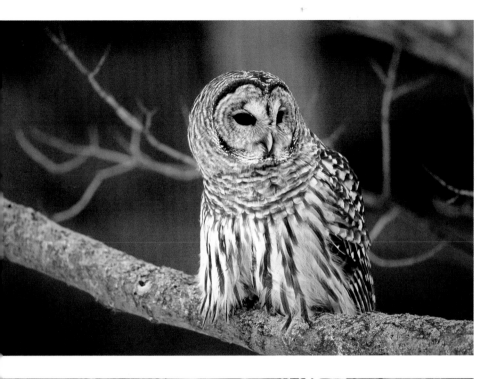

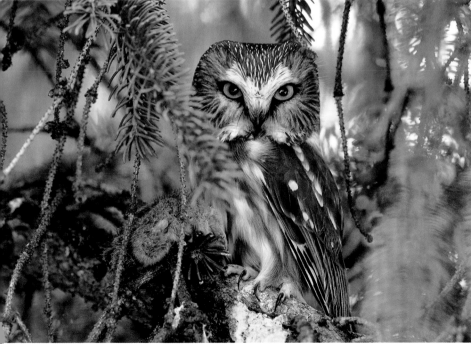

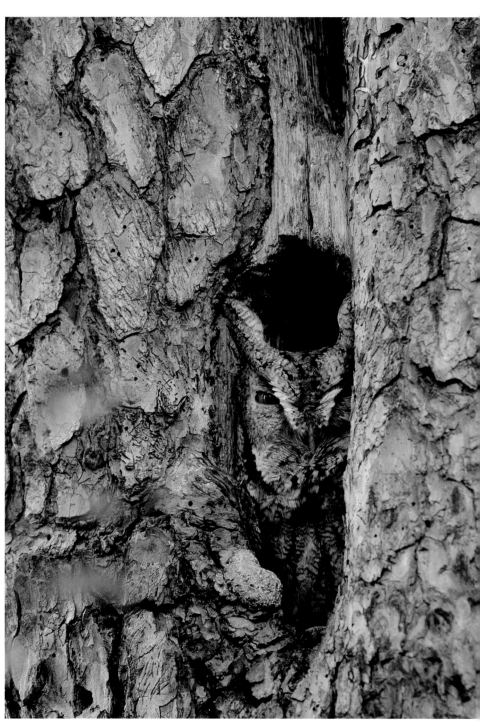

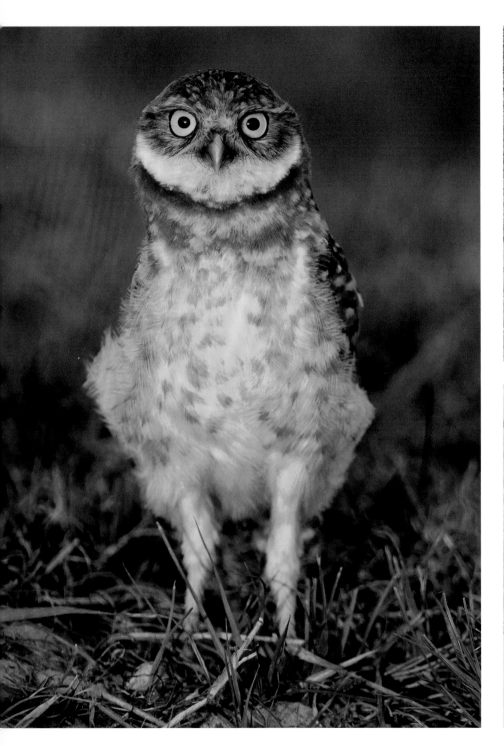

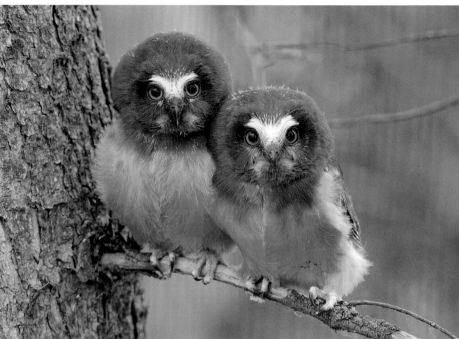

A Burrowing Owl fledgling
ventures outside of its nest
burrow. When threatened, this
species has the uncanny ability
to deter potential predators from
entering its burrow by producing
a call that replicates the rattle of
a rattlesnake; the white brows
of fledgling Northern Saw-whet
Owls make them more easily
seen at night by parents arriving
with food; fledgling owls like this
Great Gray Owl issue persistent
calls when hungry that encourage
their parents to hunt and adver-
tise their locations so they can be
found and fed.

RIGHT A Great Horned Owl fledg-
ling raises its wings in a defensive
posture to make itself appear
larger and more formidable to
would-be predators.

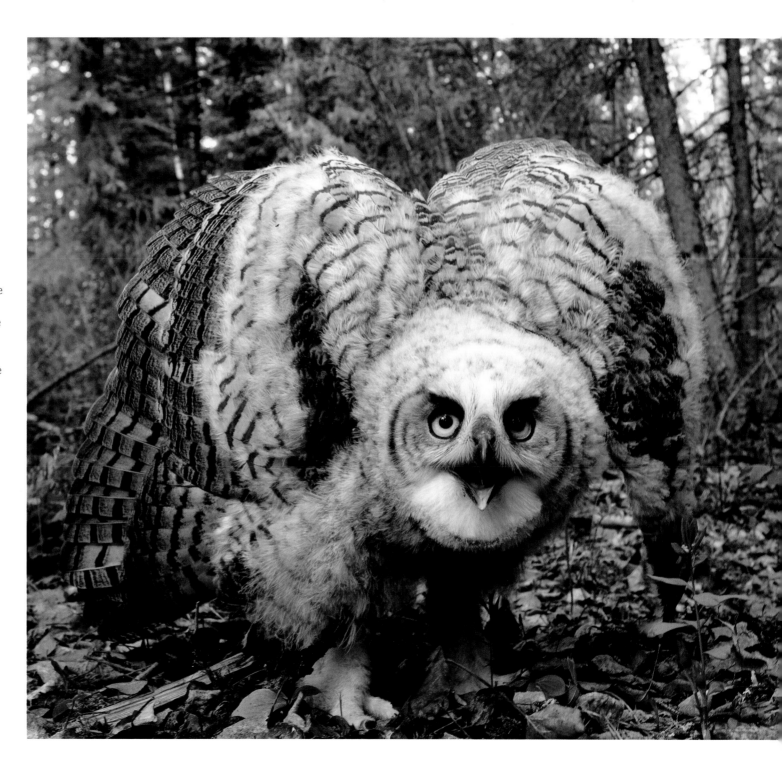

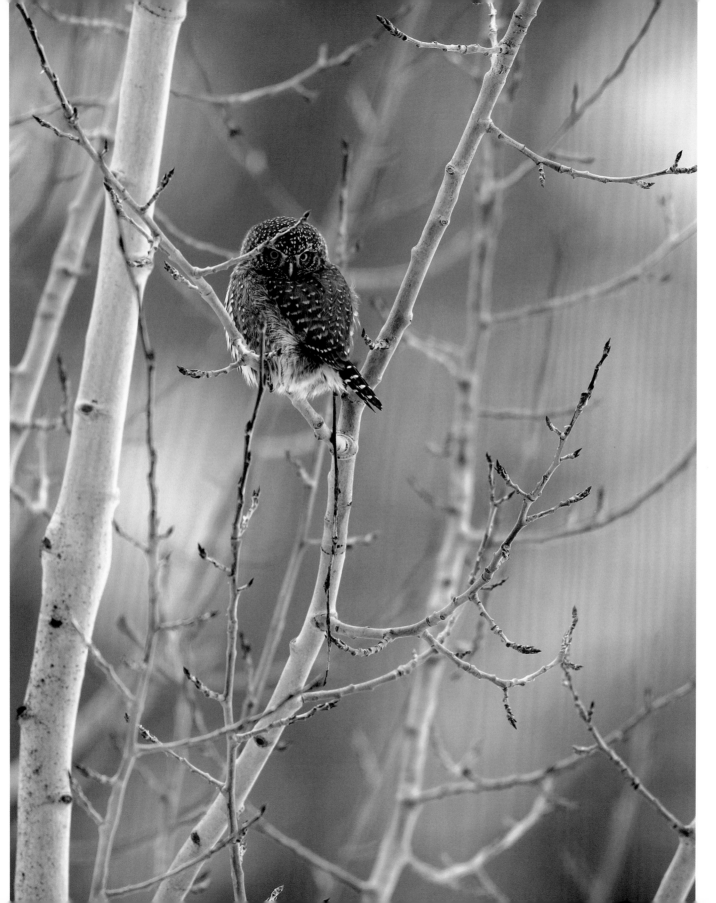

LEFT Small but fierce, Northern Pygmy-Owls hunt visually by day. They take a variety of prey including birds, mammals, reptiles, and insects and have been known to capture birds twice their own weight.

OPPOSITE Despite their large size, Great Gray Owls feed almost entirely on relatively small rodents, primarily voles and pocket-gophers. In winter, their large facial discs enable them to precisely locate and capture prey beneath deep snow cover by sound alone.

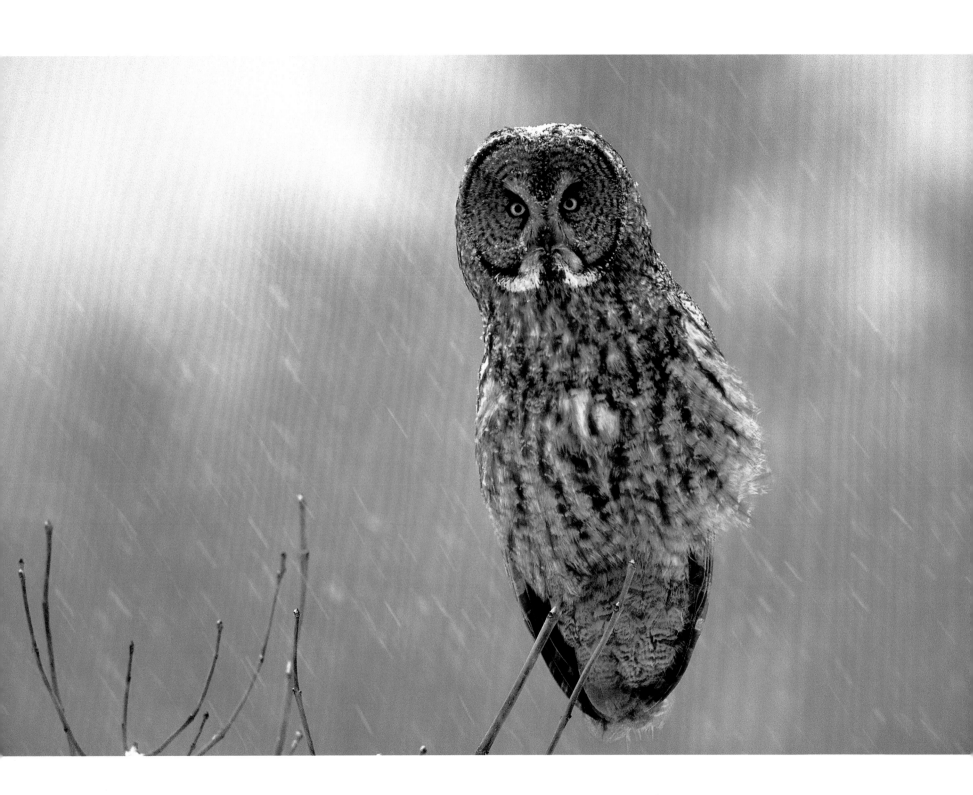

A Great Horned Owl mated pair (female, left; male, right) roosting in an Idaho barn

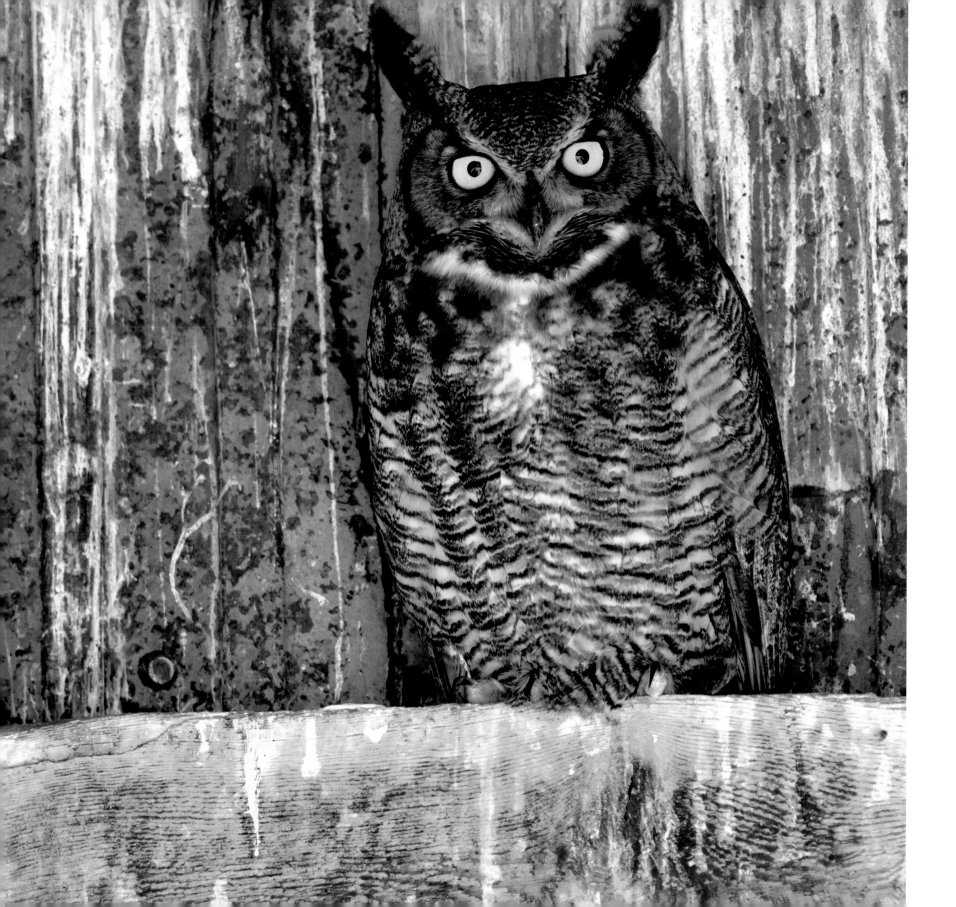

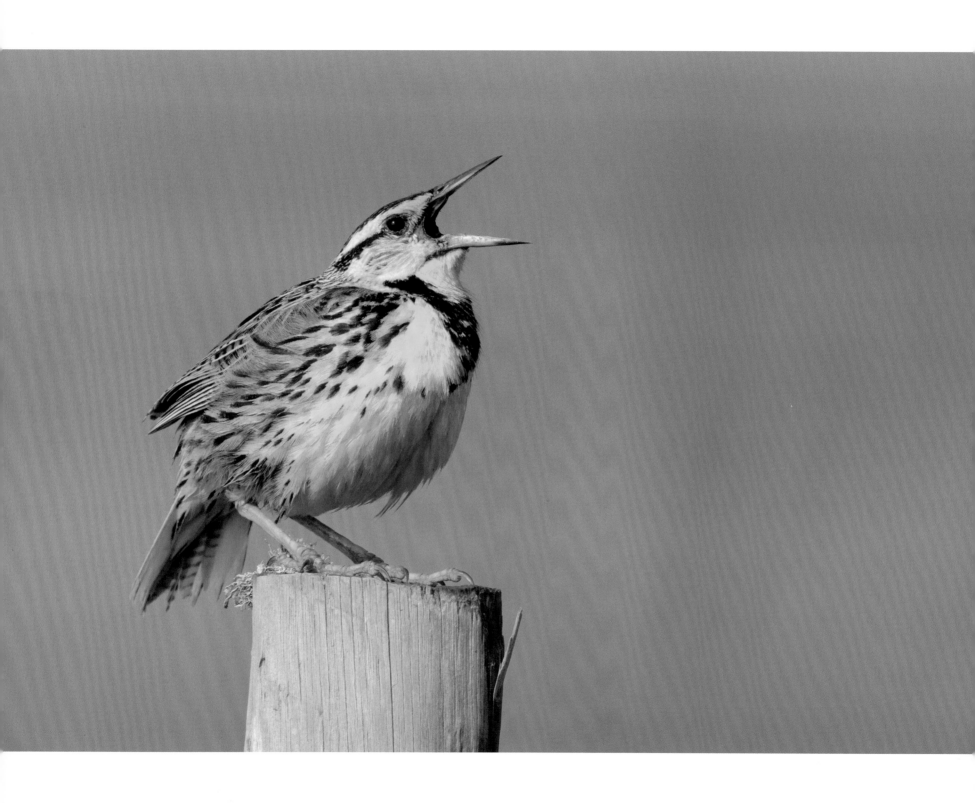

INSPIRATION ALOFT

Lyanda Lynn Haupt

EVERY YEAR I GROW a small forest of sunflowers in the backyard. My vegetable patches are reasonably productive, but unruly and untended. My cottage perennial flowers, which look so fresh and tidy in early spring, quickly wither into a messy tangle of pods and stems and leaves. But I have learned that sunflowers cover a multitude of garden sins. You walk through the curved gate—sunflowers everywhere! The immediate impression is one of flagrant beauty, no matter how many weeds.

And every year there is a day—a moment, really—when the very first sunflower seeds, encased in their black shells, ripen and bulge from the flower's round center. At this moment, a goldfinch will descend, and within minutes there will be three, then seven, then twenty more, and they will begin their monthlong feast, vying with the squirrels and the Black-capped Chickadees until every last seed is eaten and scattered. I love this wild knowing. I rarely see goldfinches in this neighborhood at other times of year. Then one day, a quiet message beneath my hearing is sent from the earth to the air, and they are here.

WILD WISDOM

These birds, and all the birds among us, offer a window into a different kind of knowing—one that is natural, but in modern times is forgotten and unpracticed. If we pay attention, the birds in our lives become mediators between the obvious and the hidden, between the normal way of seeing and a way of seeing that is less common but more beautiful, nourishing, and grounding. We see the Sanderlings cluster along the coastline, filled with an ancient biological imperative as they gather strength for their long-distance migration to the Arctic; between feedings they face northward—energetic, feet stamping with readiness—and we remember the advent of spring in our own veins. We see the Hooded Merganser on the lake, with her downy chicks (merganserlets?) trailing in a line and following in flappy unison when their mother makes a sudden turn, and we remember our own bodies— soft, frail, alive. We hear the Winter Wren sing as we wander the forest trail, and we remember that wherever we walk, in whatever solitude we think we are finding, we are never alone. We see the crow on the city sidewalk, happy with its

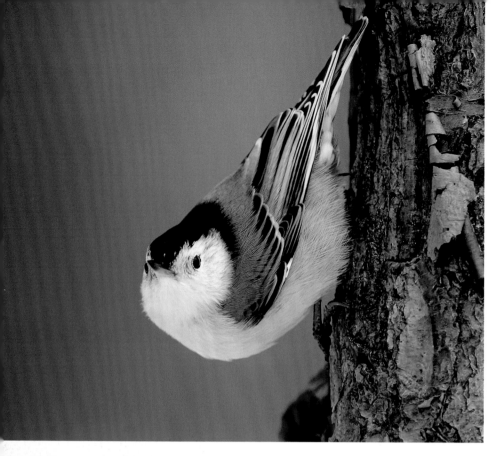
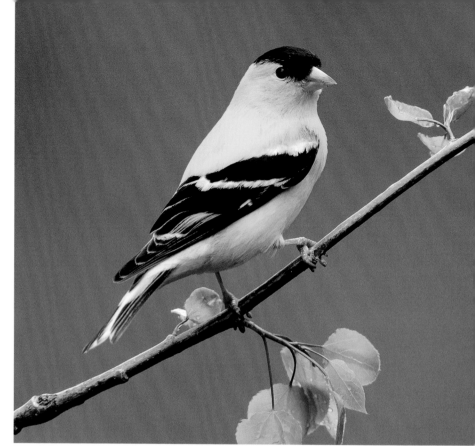
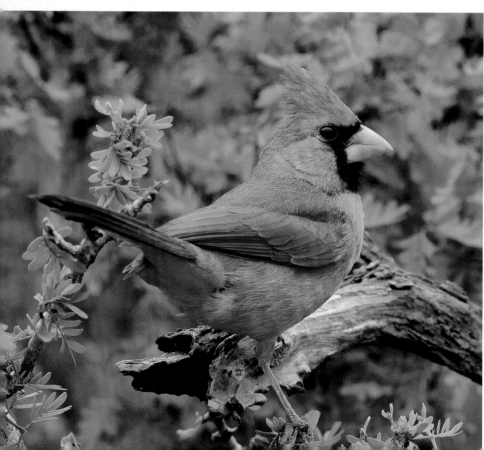
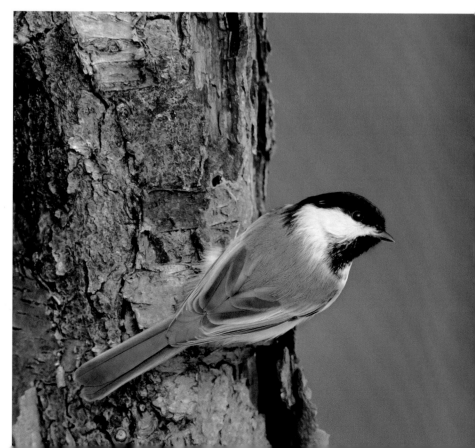

scrap of roadkill, and remember that no matter where we live, the cycles of nature surround and support us. And in winter, when the world is aswirl with holiday mayhem, we clutch our warm lattes while standing at the water's edge and watch the goldeneyes float on the waves, bills tucked under a wing against the cold. We remember what we want most to feel this dark season: simplicity, rest, and peace.

The birds bring us back to the strength of this center, mediators between what we see on the surface, what seems important in modern everyday life, and what is deeper, truer, wilder, more creative, and most alive. Birds move us away from the inertia that draws our eyes downward and inward. They are liaisons from earth to sky, from the distractions of the technologically dependent life we live to the immediacy of nature. In watching birds we are schooled in the most important, elemental teachings: when to harvest, when to birth, when to sing, and when to be silent. When to spread our wings. When to fly.

Birds are unique in offering us ready access to such wild wisdom. They are the most numerous wild vertebrates among us, as well as the most lively and easiest to observe. It is always thrilling to spot a coyote, a cougar, a mountain goat, or even a raccoon, but it is birds that we see every day, that give us the opportunity to observe wild animals closely, that call us into constant enlivened participation with nature—both near and far.

There are many natural entities other than birds upon which we might focus our awareness, with the same sorts of benefits. I am sure that watchers of rodents and marine invertebrates and mushrooms and stars and beetles and fossils might report the same advantages. But from my own biased center, I cannot help but feel that birds are particu-larly well suited to inspiring this connection with the natural world. Birds are everywhere. They are endlessly various,

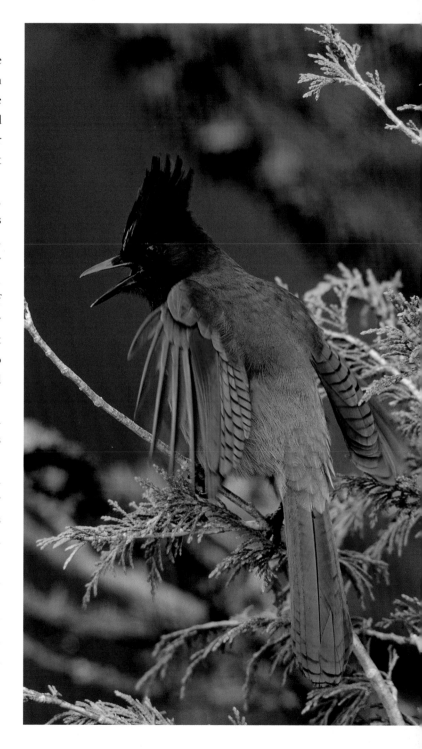

giving ready access to a sense of evolutionary movement and adaptation. Birds are lovely to look at, and the ready, lyrical symbolism of flight and birdsong is lost on only the thickest heads. Even in the most urban setting, the presence of pigeons, starlings, and House Sparrows allows us to learn biological secrets of the avian kind, as they point like a poem to what is missing. Birds fly above our upturned faces—softly feathered, vital, and wild—every single day.

FAR AND NEAR

Birds focus our much-needed attention upon the earth's most beautiful, faraway, and often endangered regions. Committed watchers find themselves in search of trogons, bee-eaters, boobies, and macaws in Kenya, Costa Rica, and Kauai, from the lushest to the most desolate places on the planet. The study of birds can throw us into the far-flung wild, whether we travel in body or by armchair and photography books. All of this watching has value, but it is equally valuable to recognize that we don't have to pack food and water and venture far from home to be bird-watchers. We don't have to leave home at all. Attuning to the most everyday birds reframes the bird-watching endeavor. We train ourselves to find the wild thing, the peaceful presence, the animal awareness in the ordinary moments of our daily lives and places, and in doing so we begin to bridge any disconnection between home and wild nature, to realize the constant interdependence with the more-than-human world that is an essential part of human life, no matter where that life is lived.

Today I write from the desk in my home studio, where I overlook a typical neighborhood sidewalk and the motley mix of native, invasive, and specimen trees that make up most city streets. Above the window box outside this second-story window I have placed a little sunflower-seed feeder. I'm not a big feeder of birds. I don't have the time or inclination to keep feeders as clean as they need to be or to argue with the variety of creatures (squirrels, rats, raccoons, starlings) they attract. This feeder is small, though, and to tend it I just need to lift the window sash. It is supposed to be squirrel-proof, but of course it isn't, so I have come to know the squirrel family that populates the big fir tree by the front door as well as the chickadees, House Finches, nuthatches, and other small birds that frequent the feeder. As I compose this paragraph, I am visited by four Black-capped Chickadees, including one that keeps hopping up on the sill of the wide-open window and looking straight at me, our eyes just two feet apart. Studies reveal that when chickadees tilt their heads to the side and survey a pile of black oil sunflower seeds, they are not just taking their sweet time—they are finding the biggest, fattest seed in the heap. If they don't eat the seed right away, they might cache it for later retrieval—chickadees have one of the best spatial memories of all birds and will relocate their stash through visual cues from the landscape, memory, and orientation by sun compass.

Roger Tory Peterson, who tracked down every possible bird species in North America and much of the rest of the world, saved some of his most rhapsodic comments for common garden birds: the chickadee, which he found endlessly curious, industrious, and cheering; and especially the flicker, the bird that first inspired him into his life's work (he found a dead one, and when he bent to pick it up it burst into life, startling him out of his youthful complacency).

CHOOSING RAPTURE

I am prone to philosophizing about such things, but even without the cerebral overlay (*or perhaps especially* without it), it is easy to find wonder and inspiration in attuning to the lives of birds. They are like us, and so we identify with them (warm-blooded, color-visioned, bipedal vertebrates).

RIGHT Male Hooded Merganser in breeding plumage. When attracting a mate, he will puff out his neck feathers, raise his crest, shake his head and throw it backward onto his back, and then turn away from the female to display his raised crest adorned with white.

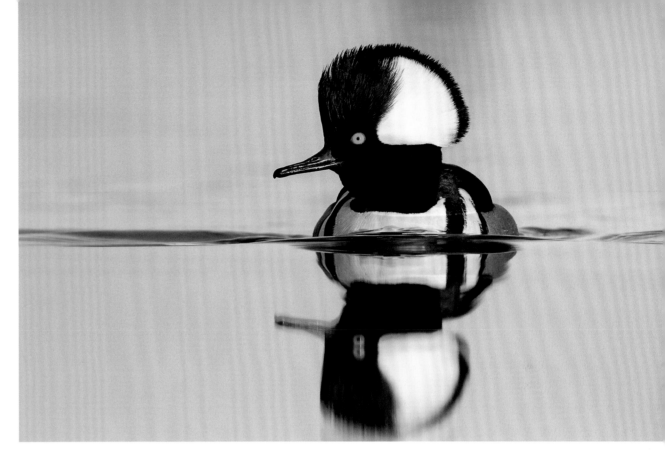

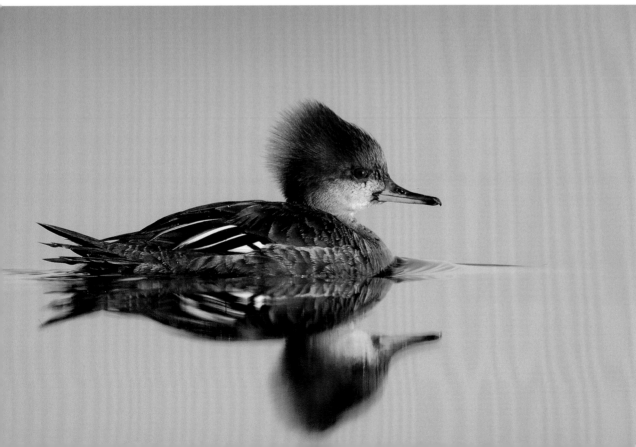

LEFT Female Hooded Merganser. Most ducks form their pair bonds in winter, when they are in large groups, so a male's display must be elaborate and vigorous to compete with other males and attract a female.

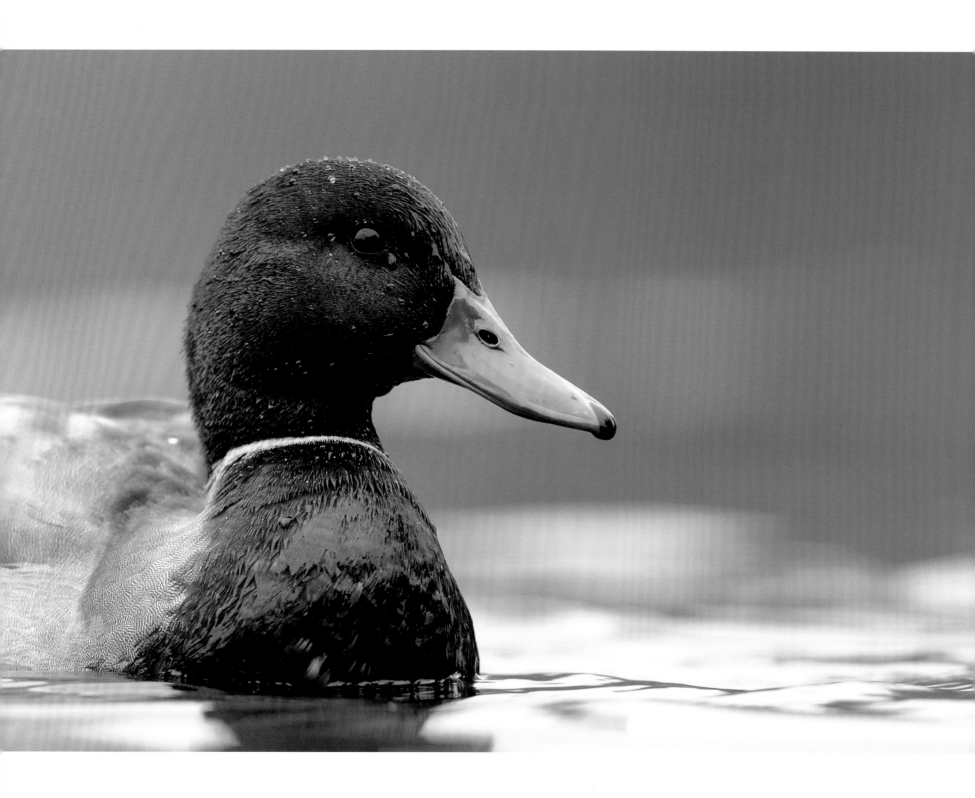

They are unlike us, as well, and so we are fascinated by them (feathered, flying, scale-footed dinosaurs). Thousands of years before the evolution of *Homo sapiens*, birds were able to see the earth from above, the bird's-eye view that humans have always sought but managed in manufactured flight just a century ago. It is little wonder that birds inhabit our imaginations and our poetry, literature, and visual arts more richly than any other animal, signifying vision, soul, wisdom, beauty, the cycles of death and life.

Bird flight carries an easy symbolism: the bearing of flesh heavenward. Who has not looked up with awe, even with yearning? Watching a bird in flight, we are visited by thoughts of freedom, of vitality, of creativity. We feel the lifting of our minds, the release of our thoughts, the flights of our fancy. We think of magical beings—dragons, faeries. We think of the rhythms of life as birds gather and disperse and migrate. Morning, evening, spring, autumn. Sometimes we just think how lovely birds look flying, and how astonishing a world we inhabit. Here are creatures with feet that walk the earth, just like ours, but look what they can do! We think of possibility.

Our deepest connection to birds may rise from the biological and evolutionary attunement to their presence, movement, and language that resides within us. We are wired, in our innate, primal selves, to be attentive to birds' language and to enter into their discourse. Human societies that relied on hunting (and those that still do) had to be keenly aware of the haunts and ways of birds. An agitated bird will fly out of a hunter's reach or alert other quarry—another bird, or a mammal—to the hunter's presence. Humans had to know how to search out birds and how to walk among them without causing alarm. We still feel and respond to this ancestral knowing in our lazy, modern bones. Our attention to birds is visceral—the flash of feather,

the shadow overhead, and we turn, however briefly, even unknowingly, to the winged one who passes over.

It is little wonder that birders are unable to keep up a conversation out of doors. To the annoyance of their friends, they are always darting their eyes from tree to sky to trail to sidewalk, or cocking an ear to identify the smallest pip. When Charles Darwin was a young man wandering the tropics on his *Beagle* journey, every day he encountered birds that he'd never dreamed of. Motmots, trogons, rheas. And hummingbirds! Imagine the discovery of tropical hummingbirds to a student of nature from England, where there are no hummingbirds at all. He wrote in his diary, "It is tiresome to be in a fresh rapture at every turn in the trail, but one must be that, or nothing." We do not need to go to the tropics to live this sensibility. We can go to the ocean, to the forest, to Antarctica, to the city park, the urban skyscraper, the suburban sidewalk, the kitchen window. We can live it through daily observation of ever-present birdlife. And if, as Darwin says, it must be wonder, inspiration, "rapture," or nothing? Then to those who attend birds, the answer seems obvious: choose rapture.

SEEKING

When I was fresh out of college, I packed a few essentials into my old Subaru—binoculars; spinning wheel; barefoot, guitar-toting boyfriend—and drove to Minnesota to begin a life-changing stint as a naturalist at an environmental learning center on the edge of the Boundary Waters. The first morning I was there, I woke early to wander the hardwood forest, which was still new to me. All at once, my foot slipped and I fell into a narrow earthen tunnel, grasping at rocks and loose soil as I spun and dropped. It happened so fast that I couldn't even scream, but in my ears I heard a spiral of music, twisting and following me downward. I

landed with a thud and a gasp and sat up . . . in my cot. Outside my cabin, the music continued to swirl: the first Veeries I had ever heard. In the dawn light, I could not tell if they were near or far or both. I slipped binoculars around my neck and tiptoed outside to find them.

Veeries look very much like their sister thrush of the same *Catharus* genus—the lovely, spotted, fawn-brown Swainson's Thrush of my home forests in the Pacific Northwest. But while the Veery's song trills in a downward spiral, that of the Swainson's climbs as it swirls, the music that would accompany Alice if she were falling up, into Wonderland. Anyone who has tried to find a member of the thrush family by following its song in a woodland knows that it can be a fool's errand. With their complex layered syrinxes, thrushes create the most magical songs and have seemingly ventriloquial voices. Sometimes we catch the bird in the act—neck arched, bill parted, voice emerging. But more often, we think we are on the trail of the song, and where the bird ought to be we find nothing but bare branches and dewy ferns, while the song erupts again from what seems to be the opposite direction, mocking us.

Barely recovered from my Veery dream, I was introduced to that quintessential North Woods sound, the breeding song of the Common Loon—a voice, like the thrushes, that seems to come from everywhere and nowhere, rising from the lakes and filling the forest. There would be plenty of time to find loons on the lakes and watch them build their floating nests: this day I closed my eyes and listened from beneath the warm blankets. So often we hear these songs, the loons and thrushes, in the liminal times, the medial hours between darkness and light. It is during these times that our own psychological edges are softened and our imaginations run a bit wilder. The songs call to us from woods and water, and if we allow it, a part of us will follow where the music leads—in psyche if not in body. Under the influence of this uncommon dislocation we will be made wiser and more whole, even if we can't quite be bothered to unsnuggle from our beds or sleeping bags.

PRESENCE AND ABSENCE

It is fashionable in some scientific and linguistic circles to question whether birdsong is truly *song* according to the human definition of music. The arguments trend back and forth, and the question is a good and meaningful one. But no one needs a scientific study, a consideration of scale and meter and harmonics, to tell us that birdsong, while serving several biological functions in bird lives, is to humans also magical, uplifting, and beautiful. Henry David Thoreau responded in his journal to the voice of a Wood Thrush in the Concord forest: "It is all divine." Thoreau was no traditional theist; his "divine" is a sacred delight, a time that is lifted beyond the ordinary by openness to the wonder of an extraordinary birdsong.

But just as birds get us nicely lost in the field of imagination, they also perform the essential task of locating us, very specifically and very physically, in nature. The presence or absence of a bird can tell us just where we are. Veery east, Swainson's west, to start. Pileated Woodpecker means mature forest; Chestnut-backed Chickadee, the Pacific Northwest coast; Rock Wren, talus slope; American Dipper, rocky stream. This list could go on forever. A seasoned birder-by-ear can wake up to the dawn chorus and tell within a hundred miles or so where in the entire continent she is likely to be. It is a rare intimacy with the landscape, this knowing, and one that can't be found on Google Maps. The presence or absence of particular species also tells us a great deal about the health of the habitat we are exploring, the pulse of the ecosystem.

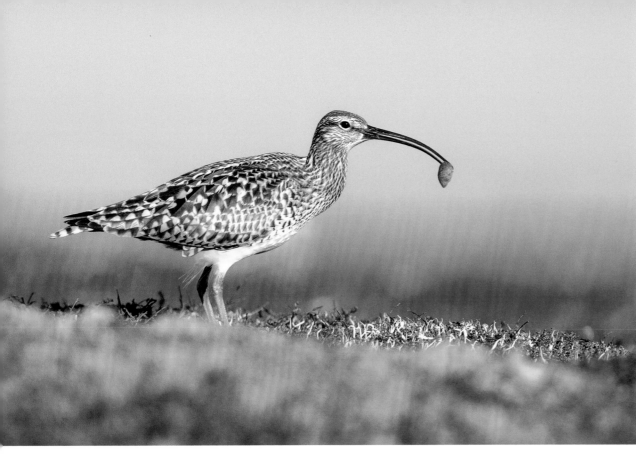

LEFT A Bristle-thighed Curlew holds a cocoon spun by a woolly bear caterpillar. The curlew will give the cocoon a quick shake to extract and eat the pupa inside.

RIGHT A Snow Goose feeds on waste grain in a farmer's field. Adaptation to a diet that includes abundant agricultural food has resulted in an explosion of Snow Goose numbers over much of their range, doing serious harm to coastal marshes where they winter and to their tundra breeding grounds.

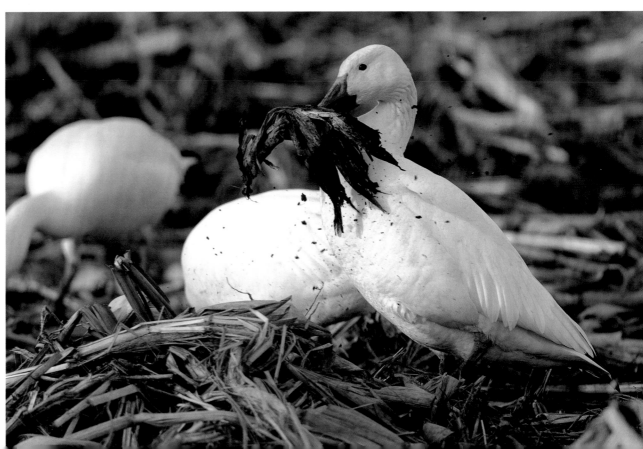

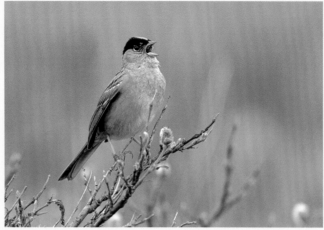

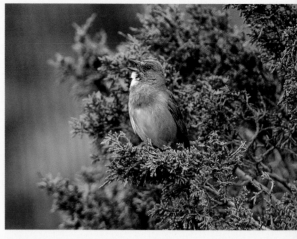

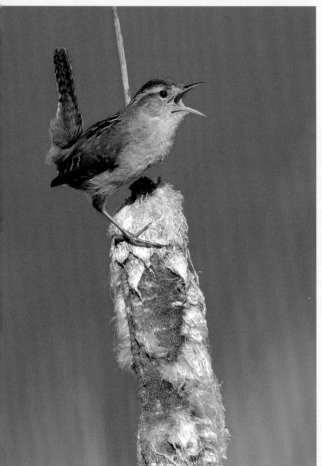

BIRDSONG

We interact with the world as much by sound as by sight. What would the world be without the sounds of birds? CLOCKWISE, FROM TOP LEFT Red-eyed Vireo; Golden-crowned Sparrow; Green-tailed Towhee; Yellow-headed Blackbird; Western Tanager; Marsh Wren

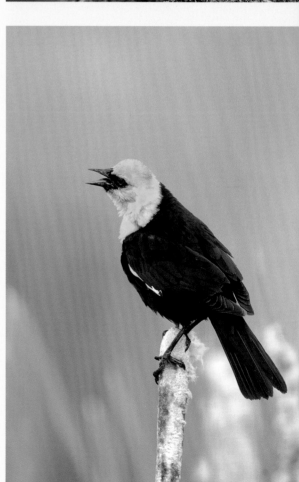

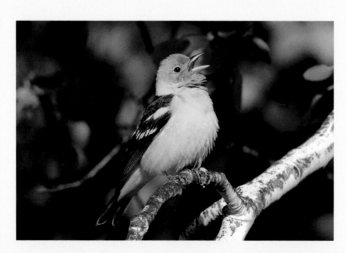

CLOCKWISE FROM TOP LEFT Canada Goose; Black Scoter; Marbled Godwit; Willow Ptarmigan; Herring Gull; Red-necked Grebes

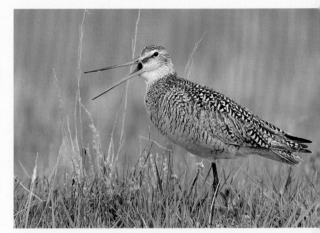

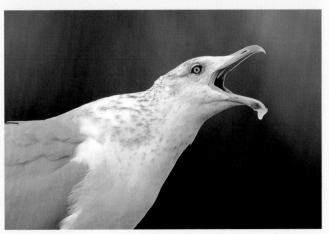

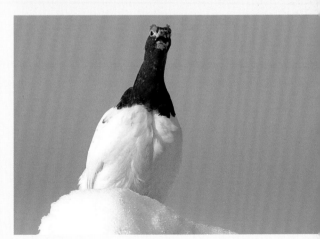

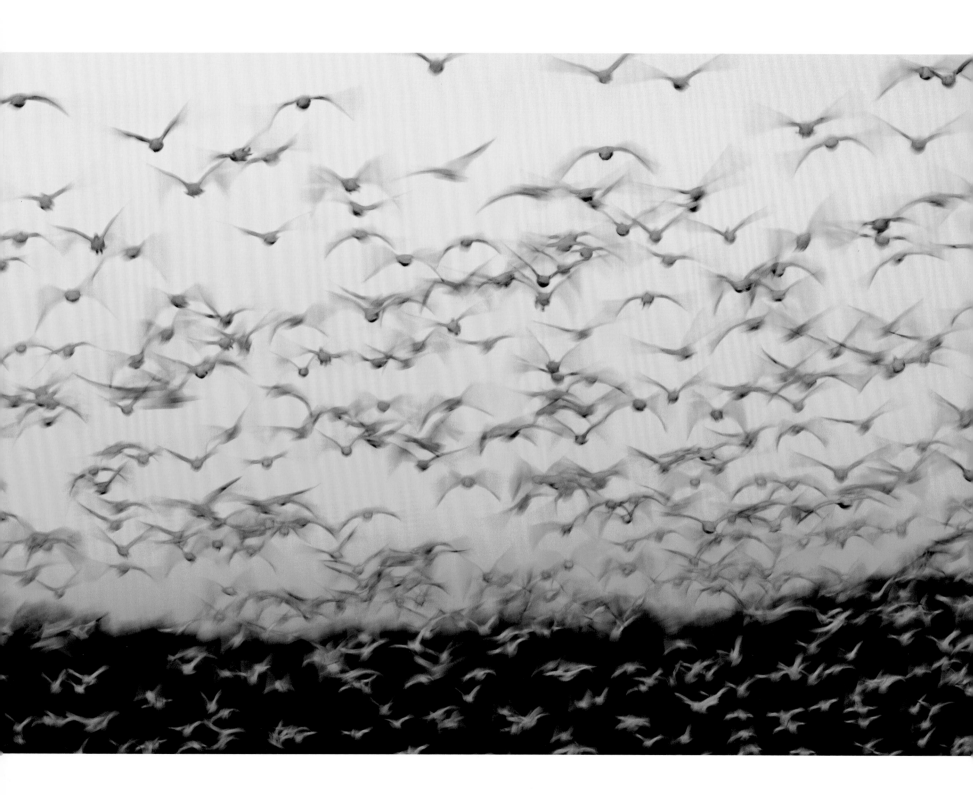

Flocks of geese have long provided inspiration to all who live along their migratory pathways. Waves of Snow Geese travel from the Canadian and Alaskan Arctic south to wetlands across North America and northern Mexico every fall, filling the sky with white birds and the din of thousands of combined voices. RIGHT In the southern plains, the very long black-and-white forked tail of the aptly named Scissor-tailed Flycatcher attracts attention. A closer look reveals the vivid orange and pink feathers on the flanks and underwings. When a crow or hawk flies over, the flycatcher doesn't hesitate to harass the predator, even landing on its back to peck it, until it beats a retreat.

There has been a great deal of research focusing on birds and climate change, and the forecasts are grim. One study suggests that by 2050, nearly a quarter of the approximately 650 species that regularly occur in North America will lose more than half of their climactic range, without the potential to make up the loss. By 2080, the number could grow to 50 percent. Extinctions are all but unavoidable. How many? It is impossible to predict with accuracy, but the number will likely be more than we have allowed ourselves to imagine. Species that are already showing signs of impact include the American Three-toed Woodpecker, the Rufous Hummingbird, the Northern Hawk Owl, and the Northern Gannet. Many species that currently have robust populations will be threatened. Baltimore Orioles may disappear from Maryland. And the song of the loon on the lakes of northern Minnesota? It may be silenced. Scientists hope that the loons will be able to move northward across the border of Canada to find suitable breeding lakes, lakes that are still cold and deep enough, but nothing is certain. In this diminished future, birds that thrive on lawns and concrete will flourish. As overall diversity falters, we will see more robins, more crows, more starlings than ever.

With this knowledge, we remember that the inspiration birds bring to us reaches beyond immediate aesthetic delight, psychological well-being, physical awareness, and natural connection. Bird species hold their end of a thread, a seed within the genetic material of their bodies and consciousness that reaches into the future. This is what Thomas Berry called "the dream of the earth," the vital imperative for *continuance*. It is so basic a part of biological life on earth that we didn't realize until very recently in human history that we have the capacity to interrupt it at all, let alone so fully. We all know the litany of steps we need to take to conserve habitat and reduce our impact on the changing climate; no

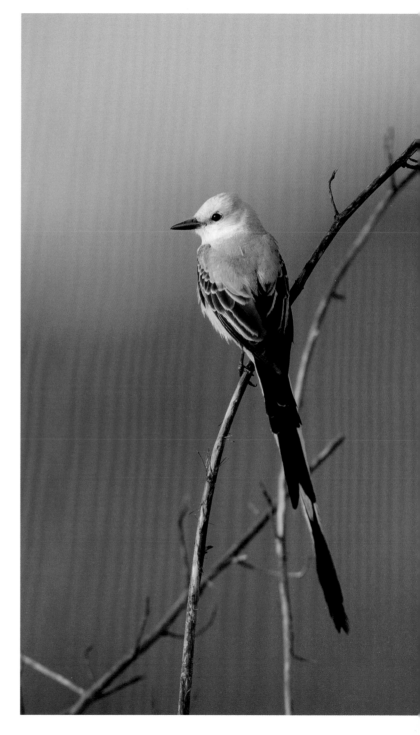

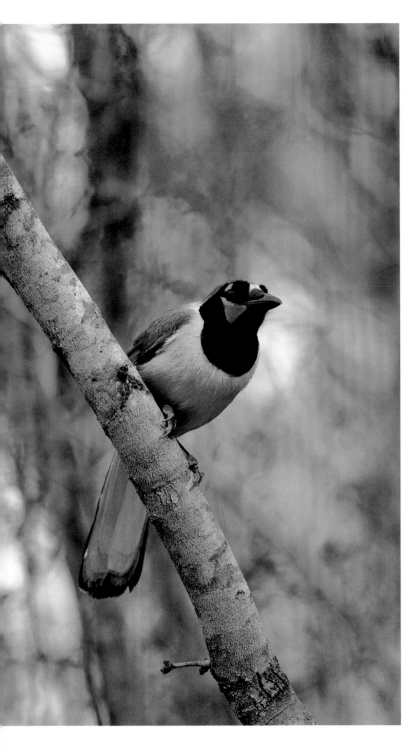

matter how irreversible current trends, right action calls us to do what we can, without hesitation, without laziness—with, even, a measure of joy, a response based in love. In this, we turn to the birds for another kind of inspiration—the inspiration that keeps us, in the face of such desolate ecological awareness, from sinking into despondency and inaction.

KEEPING WATCH

I live in Washington State and have been fortunate to spend time writing at a retreat center in the San Juan islands for artists and scholars. There, the Salish Sea meets an exquisite harbor visited by seals, shorebirds, hawks, gulls, saltwater ducks. Whenever I am there, I rise early and watch the light spread across the water. But no matter how early I get out of bed, I am never quick enough to catch the arrival of another odd little creature—a very small woman in a hooded cloak who travels by electric scooter.

By the time I see her, she will have hobbled to the crest of a grassy knoll overlooking the harbor, and she will be sitting on top of a tattered blanket, sipping some sort of sustenance from an old thermos. At first I thought she just came to the hill to meditate—she is so still. But soon I realized that she is watching the birds. She is silent, peaceful, and seemingly timeless (clearly my elder, but beyond that I cannot say), and everything about her person and her belongings is worn and disheveled, except for her binoculars and her spotting scope; they are of the highest European quality, the brands coveted by top birders. On the side of her little scooter, alongside an oddly shaped basket fastened with twine, is a sticker that proclaims, "Do you eBird?"

Ha! The eBird database is a project launched jointly by Cornell Lab and the National Audubon Society just over a decade ago, and it has since become the central online database for charting avian populations across the globe. I

LEFT Green is a color we most associate with parrots, but one tropical bird, the Green Jay, brings a bit of the tropics north, reaching its northernmost population limits in extreme south Texas.
OPPOSITE On their breeding grounds, Black-necked Stilts stand out due to their conspicuous colors and in-your-face behavior. A pair with eggs or chicks takes to the air on sighting any potential predator, including humans. Their strident calls ring out, alerting every other animal in hearing distance. On the wintering grounds, they gather in large flocks to sample the aquatic life of lagoons and estuaries.

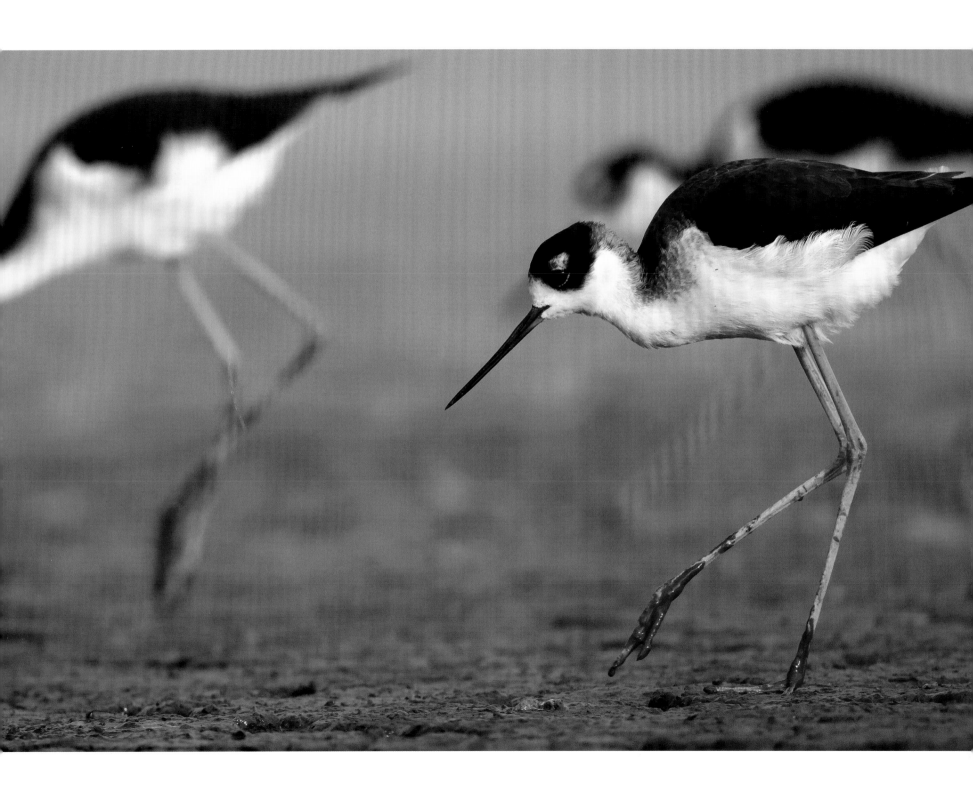

had supposed this ethereal little watcher was copying her observations into some medieval diary made of worn leather and parchment. Now in my imagination, she returns daily to a hobbit-hole hermitage full of velvet cloaks and wooden goblets, lit by candles *and* the glow of her top-of-the-line laptop, into which she daily enters the results of her morning bird counts.

I think about trying to talk to her, to lurk around the scooter and compare bird notes. But she has not once called out to me, and I feel that it would somehow be an intrusion. A meeting might at least ruin the little story I have forged in my mind, and I am quite attached to it. (I am not the only one—I have spoken to other guests who have their own names for her, including the Monkess of Friday Harbor and the Mystical Lady of the Sea.) But because I watch birds too, I like to think we have a special, secret connection.

Birders like eBird because it offers a highly usable interface for recording their own sightings over time and space; but more than this, it offers every person who observes birds an opportunity to give voice to the birds they see and love. Collected data are used in both scientific analysis and conservation decisions, in habitat rehabilitation and preservation. By plotting the sighting of a bird on eBird, we give that bird—as an individual and a member of a species—the chance to say, *I am here.* And we, in turn, are given the chance to respond: *I have seen you.*

Audubon's Christmas Bird Count, now running for over a century, is the longest-standing citizen's ornithology data-gathering project, and the results from these yearly counts—the highlight of the birding year for many—have been valuable in countless scientific studies, including the new study on birds and climate change. The eBird database and other newer efforts make use of accessible technology and rising public interest to offer citizen-science projects that all of us can contribute to, from any place, on any day.

The Cornell Lab's Great Backyard Bird Count, for instance, brings serious ornithological data gathering right to our own homes. In this project, everyone, no matter their age or skill level, is invited to watch birds for just fifteen or more minutes each day over the course of four days and to submit their results online, providing a real-time snapshot of where birds are all over the world. And Cornell's Project Pigeonwatch carried citizen science to the sidewalks, asking observers to report the colors of pigeons in our neighborhoods, schools, and parks. The fact that individual Rock Pigeons are uniquely colored is a scientific mystery. The typical coloration of the species is that nice blue-gray with iridescent purple trim we see so often. But in urban places, while this natural color is the most common, we see all sorts of other pigeon colors as well—whites, browns, gold, pied black-and-whites. It makes no sense. According to the premises of natural selection, anomalies should be either weeded out (meaning errant colors would show up only occasionally) or, if they lead to reproductive success for the birds in some way, propagated (meaning many more pigeons should be multicolored).

The pigeon might seem a homely subject, even for sidewalk watchers, but they are in fact lovely birds with fascinating natural histories. Darwin himself would have been intrigued with the premise of the Project Pigeonwatch. He was a pigeon aficionado who kept a large dovecote, and wrote more about pigeons in his natural-selection studies than he did about the famous Galapagos finches. All of these projects bring us into lively participation with the birdlife around us and the conservation efforts that help to sustain birds, humans, and all of life.

We might think it more poetic to keep our avian observations unplugged, resting in the quiet moment between

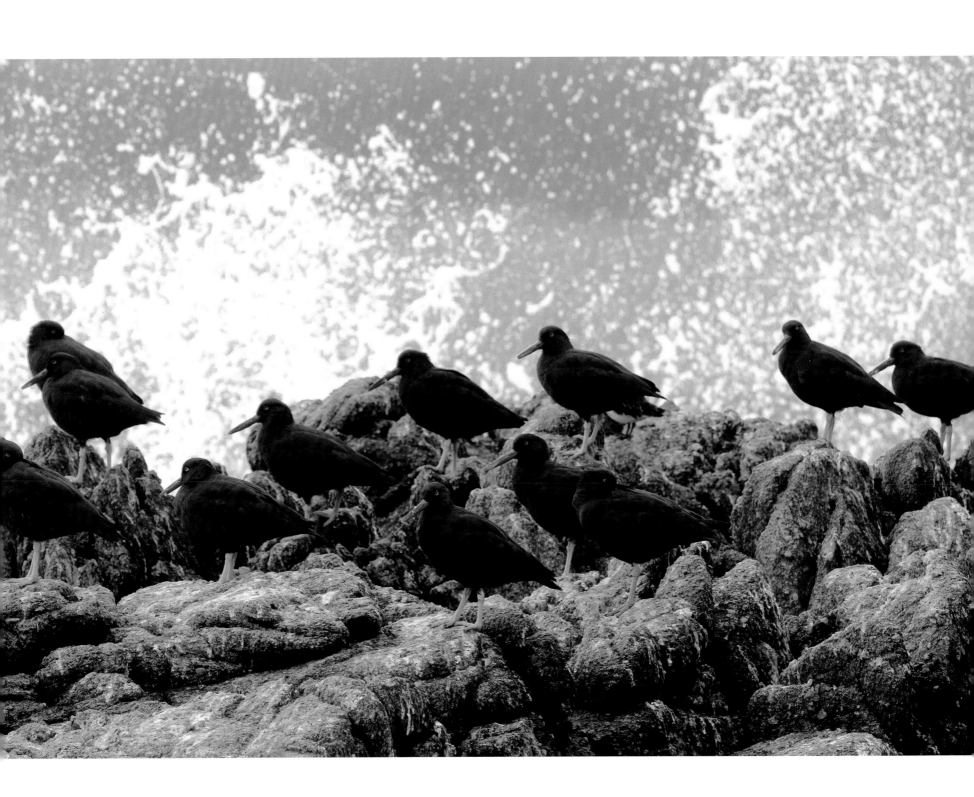

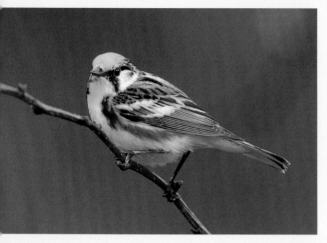

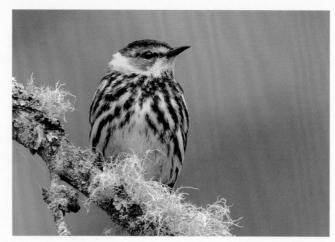

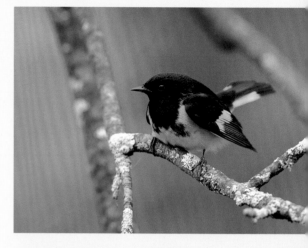

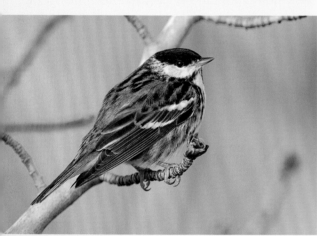

WARBLERS

No group of North American birds shows the diversity of color and pattern to be found among our nearly fifty species of wood-warblers. CLOCKWISE, FROM TOP LEFT Chestnut-sided Warbler; Cape May Warbler; American Redstart; Wilson's Warbler; Magnolia Warbler; Orange-crowned Warbler; Canada Warbler; Blackpoll Warbler

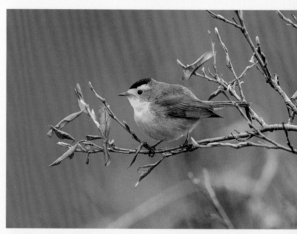

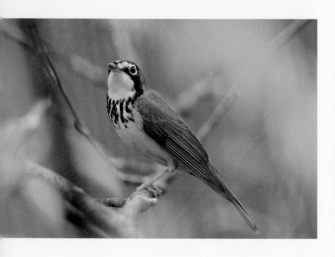

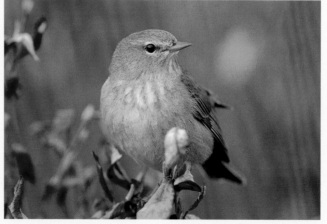

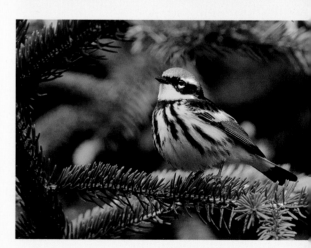

CLOCKWISE FROM TOP LEFT Yellow Warbler; Palm Warbler; Oven-bird; MacGillivray's Warbler; Yellow-rumped Warbler; Black-throated Green Warbler

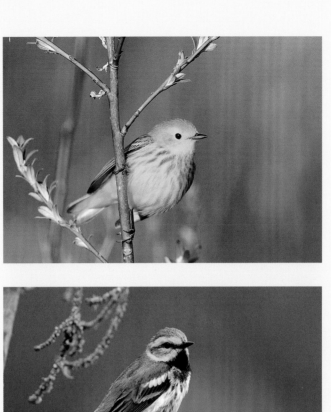

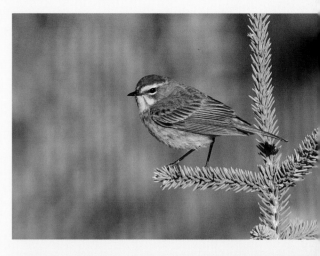

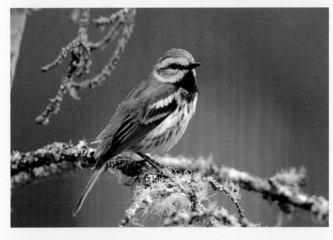

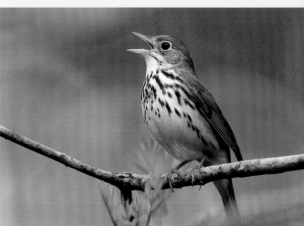

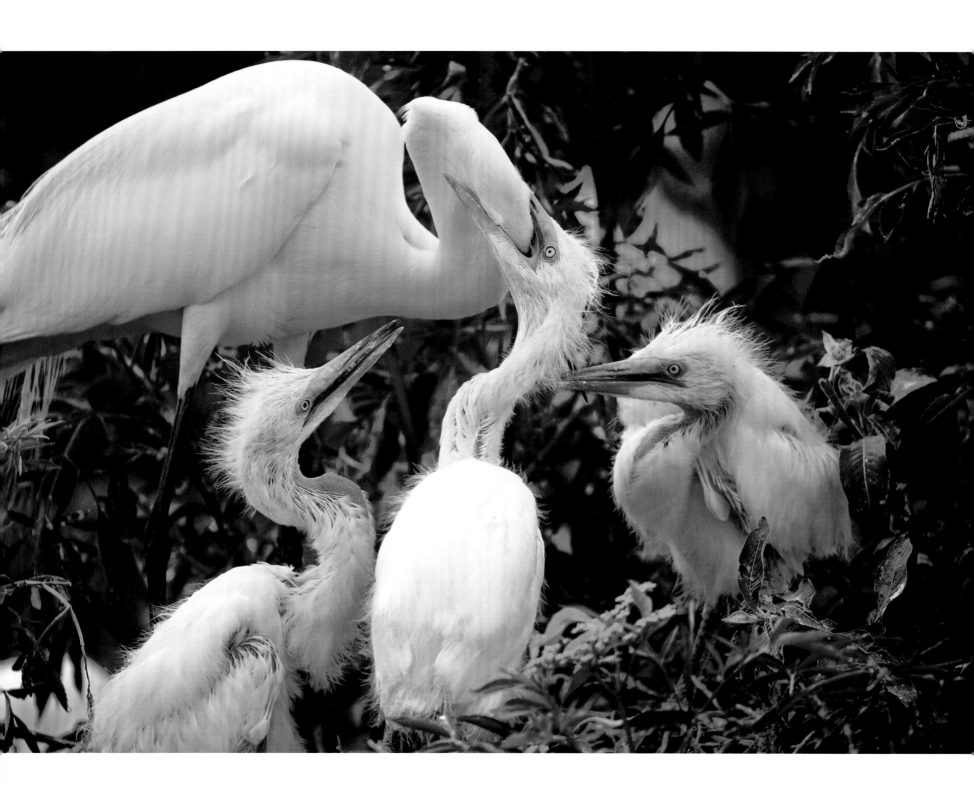

ourselves and that tiny Saw-whet Owl we happen upon, a disemboweled mouse hanging indelicately from her bill. But the electronic form of keeping watch has its own poetry. We enter our data, and our dots spread onto the digital map, which resembles an ever-changing Tibetan sand mandala. We live in a time where bird populations are in dramatic decline, and bearing witness to their presence and absence is among the most meaningful work that we can accomplish, whether or not the rest of our lives have anything official to do with ornithology and conservation. Such participation is a delight, a recognition that we are all bound together in mutual sustenance and fragility. When I am moving too fast to remember this, I think of the small Bird Monkess of Friday Harbor, keeping watch in quiet dedication and absolute peace. And I try to be more like her.

This is the good work of the amateur (most fun to pronounce after the French fashion, *ah-mah-TEUR*). Somehow, in our culture, this word has come to be associated with ineptitude or those less skilled at a given practice. But *amateur* is from the Latin *amator*, a lover. The most knowledgeable birders I have ever known have all been amateurs, following birds not for money or for profession or for recognition, but for pure love.

THE CALL

Soon after returning from Minnesota to the Pacific Northwest as a young naturalist, I discovered one of the books that I would carry with me for life. *Always, Rachel* is a thick epistolary collection of the decade-long correspondence between Rachel Carson and her beloved friend Dorothy Freeman, gathered and edited by Freeman's granddaughter.

The simplicity of the letters is powerful. I love how Carson mingles the messy details of her difficult domestic life, her worsening health, and the challenge of creative effort around the passion she and Dorothy shared for nature—especially birds. The book rests on my nightstand, and I read a letter or two almost every day of every year.

Over time, the Veery became the totem bird of Rachel and Dorothy's friendship; whenever they were together they would sneak off alone at dawn or at dusk, seeking the enchanted song, and they wrote to each other about Veery sightings (or hearings) when they were apart. Later in their correspondence, Rachel and Dorothy discovered a shared love for one of the most wonderfully mystical passages in all of nature literature; they would read it to one another for sustenance when Veeries were far away. It is from the chapter "The Piper at the Gates of Dawn" in Kenneth Grahame's *Wind and the Willows*. Mole and Rat are out all night, searching the wooded riverbank for Portly, the lost baby otter. At the liminal turning of night-into-dawn, and without quite understanding what is happening, they hear Pan's flute. Rat cries: "O Mole! The beauty of it! The merry bubble and joy, the thin, clear, happy call of the distant piping! Such music I never dreamed of, and the call in it is stronger even than the music is sweet! Row on Mole, row! For the music and the call must be for us." Their sense of mystical oneness with the forest dims as the sun brightens and everyday life intrudes. Portly, of course, is safe with the faun. But I agree with Rat—the music and the call are for us. And this music surrounds us every day—if we will listen—in the songs, the calls, the movement, the simple presence of the birds in our midst.

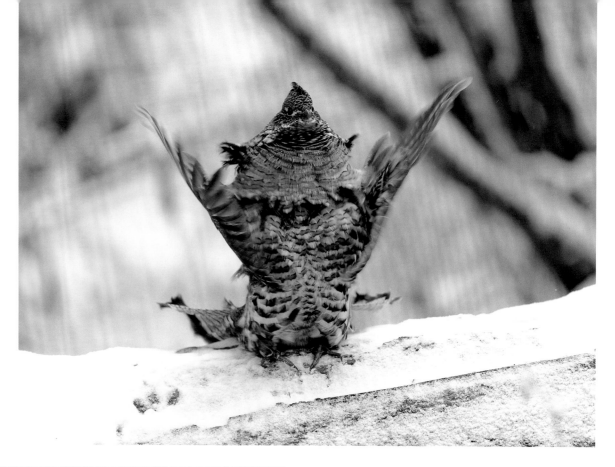

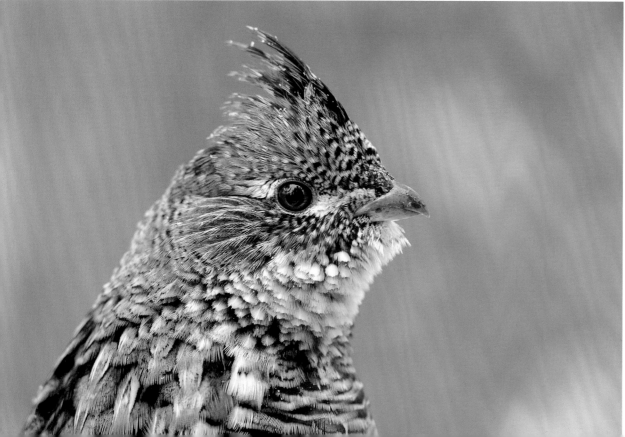

ABOVE, LEFT, AND OPPOSITE Male Ruffed Grouse drumming, and showing ruff. Cornell Lab of Ornithology professors Arthur Allen and Peter Paul Kellogg published research in 1932 on the first investigation of bird behavior using new motion-picture technology, solving a long-standing mystery. They found that Ruffed Grouse beat their wings against the air, not their breasts or the logs they perch on, to produce their drumming sound. Drumming, one of the lowest-pitched bird sounds, is produced by the wings as they rotate forward, then quickly backward. The sudden compression and release of air into a momentary vacuum creates a miniature sonic boom. As the bird repeats the maneuver faster and faster, the wingtips and sound blur to a crescendo.

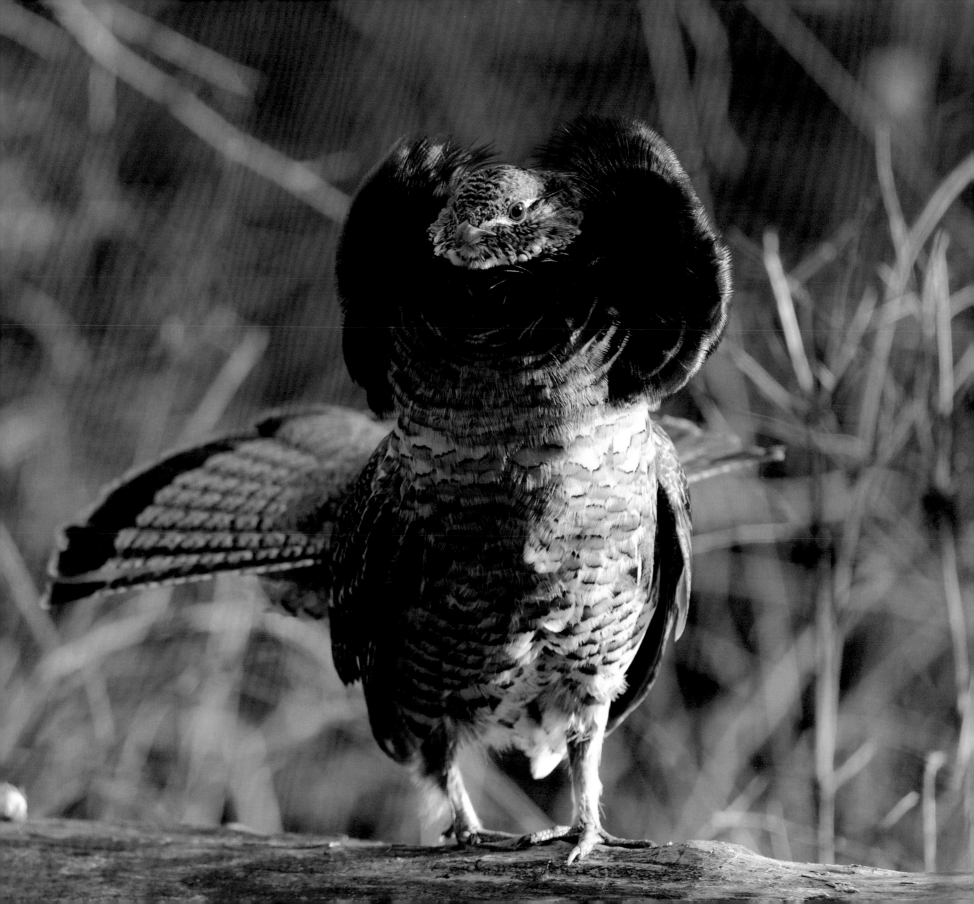

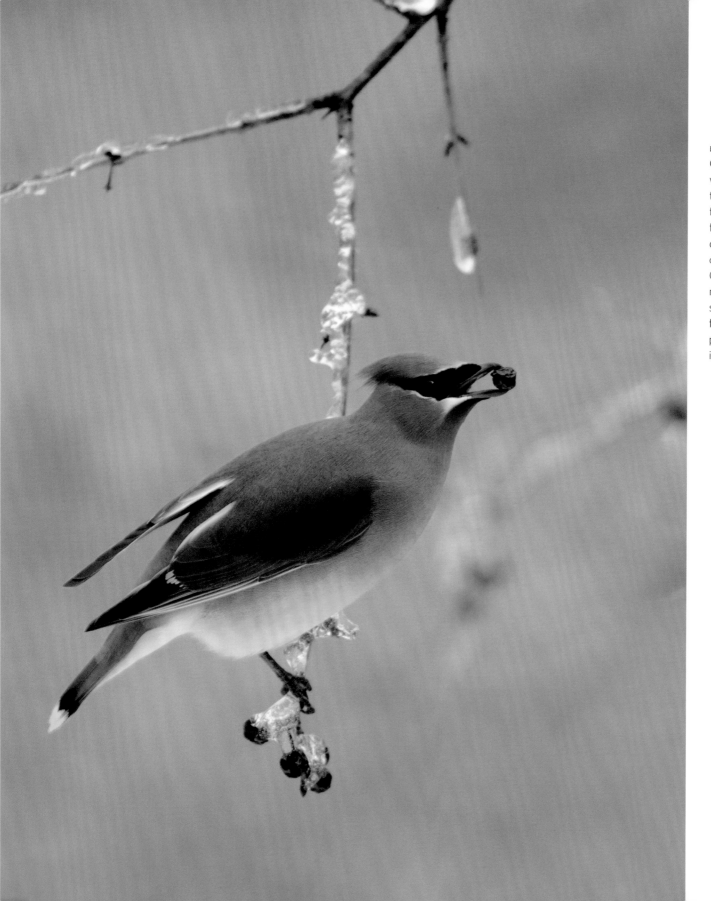

LEFT The "wax" on the wing of a Cedar Waxwing's feathers isn't wax, just highly modified feather tips. The yellow tail tips come from carotenoid pigments in the fruits that make up much of its diet.

OPPOSITE A pair of Barrow's Goldeneyes drift across a mountain pond. Specialized structures in the males' head feathers, rather than pigments, produce the shimmering iridescent purples and blues.

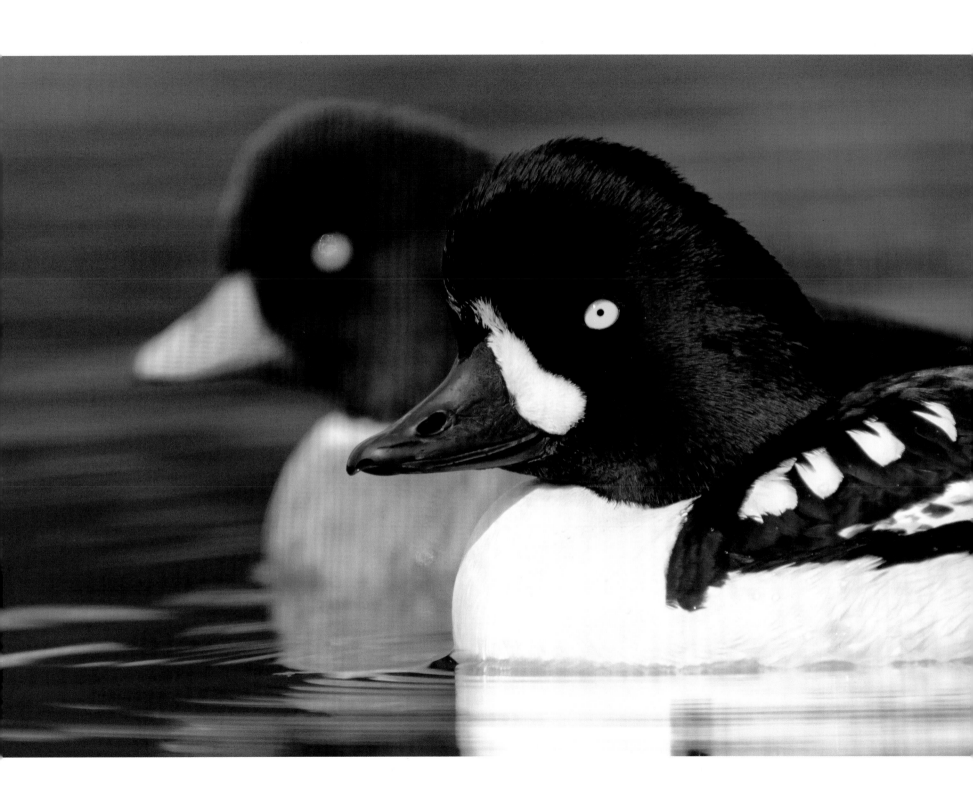

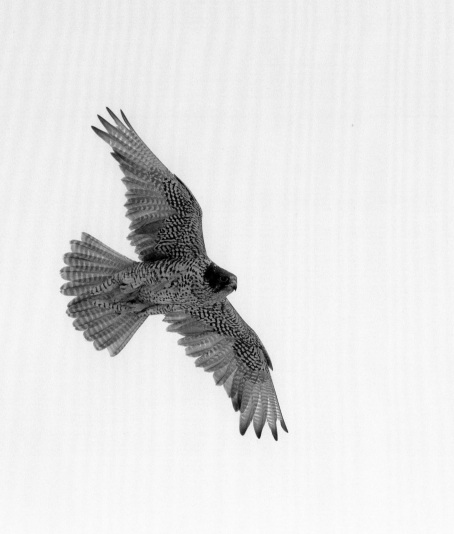

LEFT AND OPPOSITE Some birds, like the Gyrfalcon, are special because of their inaccessibility. They inspire exploration, luring us to the hinterlands of our planet. The largest falcons, swift and powerful Gyrfalcons dominate their remote Arctic habitats of tundra and cliffs. They vary more in color than other falcons, with many birds in Greenland and Siberia being almost pure white.

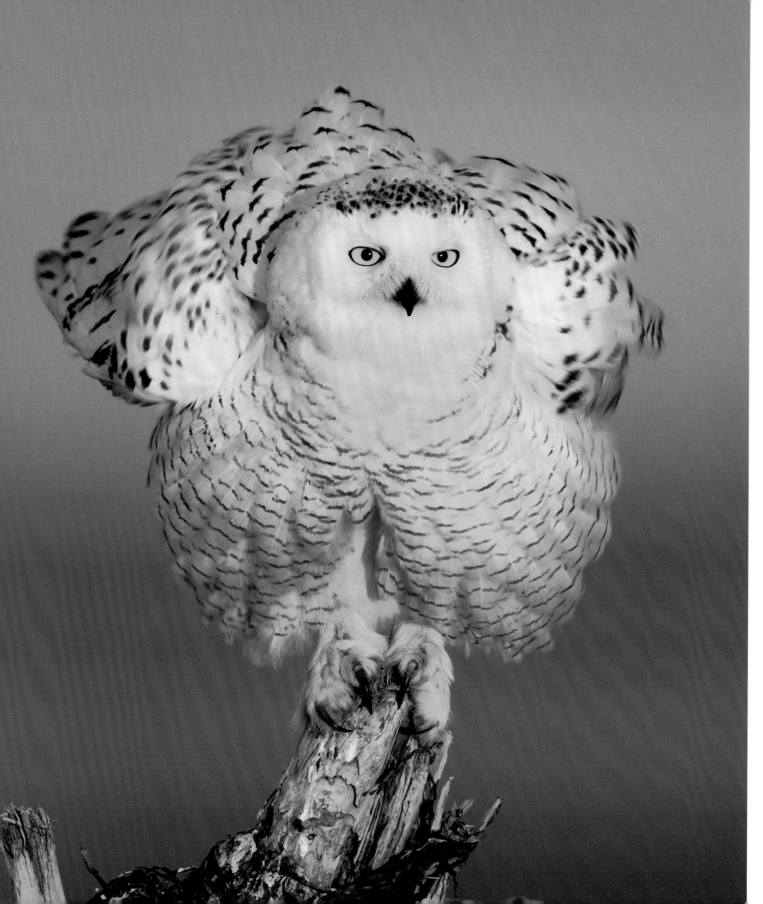

LEFT AND OPPOSITE Snowy Owls are spectacular white birds of the Arctic, birds that normally go unseen by most of us. But every few winters lemmings (on which Snowy Owls feed) reach a high in their population cycle, which results in many more young owls fledging than normal. These young owls must spread out in all directions to find food through the winter, especially if the lemmings begin to decline. When this happens, hundreds of snowies travel south and invade our northern states, giving us a glimpse into the mysterious lives of nomadic birds that have evolved to thrive in the cold darkness of an Arctic winter.

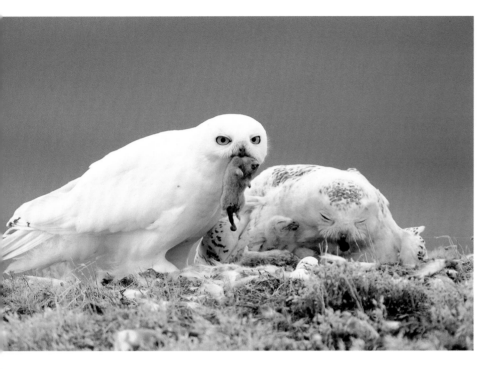

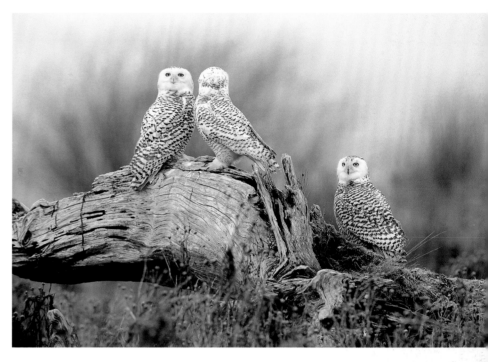

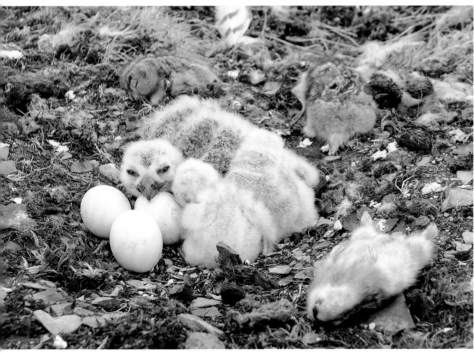

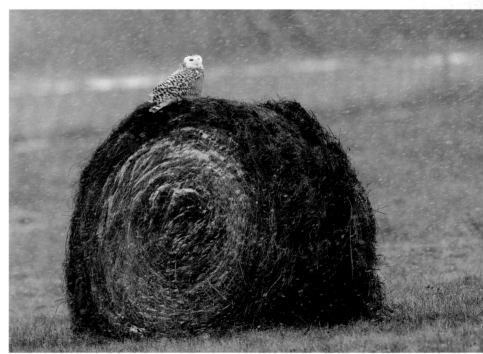

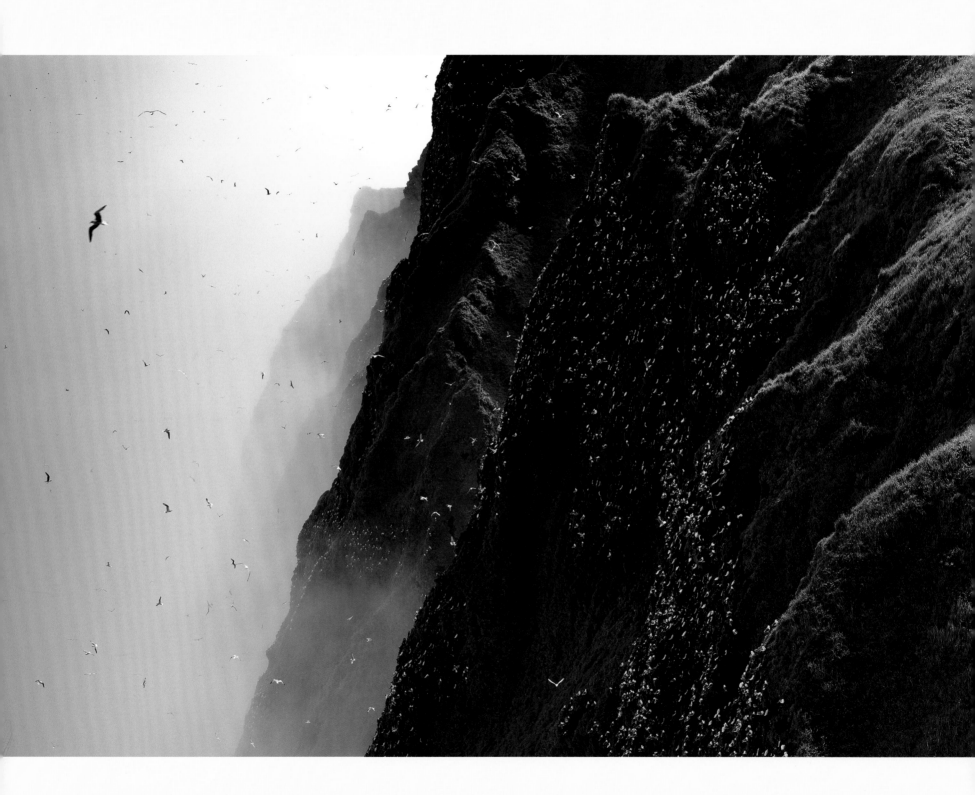

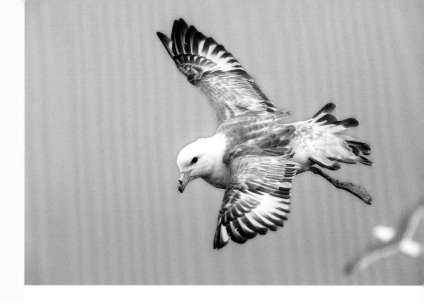

IN THE FIELD
A Congregation of Millions

Gerrit Vyn

Saint George Island, Bering Sea,
Alaska, July

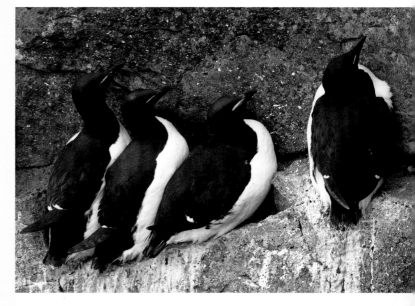

OPPOSITE More than 75 percent of the world's Red-legged Kittiwakes nest on Saint George's cliffs. RIGHT, FROM TOP Northern Fulmar; Thick-billed Murres; the high bluffs of Saint George Island

THERE ARE HARDLY WORDS to describe a spectacle like Saint George Island. Protected by isolation and fed by one of the richest seas on earth, the tiny island, born of lava and enshrouded in summer fog, hosts one of the greatest congregations of nesting seabirds in North America. Around two million murres, kittiwakes, auklets, puffins, and others jostle for every sliver of cliff ledge and each rocky crevice. During the breeding season, birds outnumber people there by about twenty-five thousand to one.

During my first five days on Saint George, the battle between sun and sea ebbed and flowed, but the sea held its grip, keeping the island's most spectacular nesting cliffs obscured in a foggy embrace. On day six I could wait no longer. I packed up my camera gear and began the rugged trek up to the towering and sheer thousand-foot basalt sea cliffs known as the high bluffs.

The grasses were especially tall that year on Saint George. Fording my way through wet waist-high blades, I could have been in a mountain meadow in West Virginia or a tallgrass prairie in Kansas if not for the occasional bird reminding me otherwise. A Rock Sandpiper, endemic to the Bering Sea region, sprang from behind a clump of bold purple lupine to issue alarm calls and

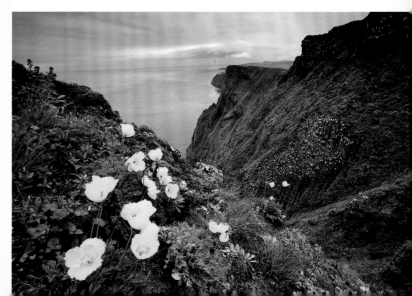

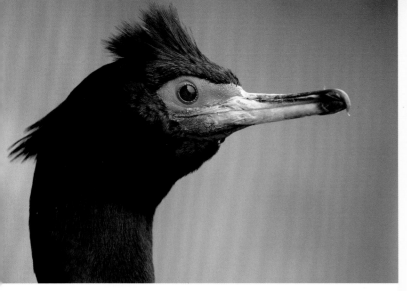

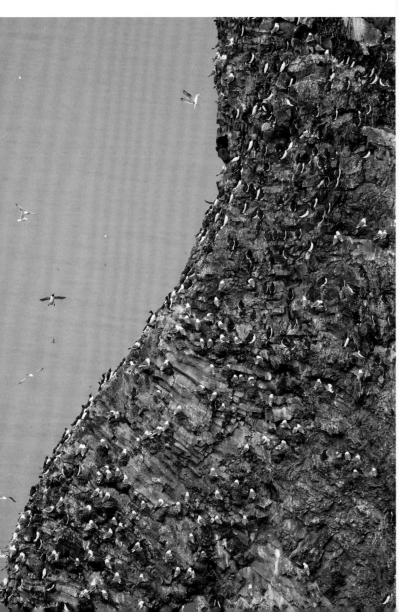

frantically guide me away from a cryptic chick lying motionless in the vegetation somewhere nearby. Rosy-finches, a third larger than the continental forms, clambered on oversized parsnip heads before disappearing among the grasses to feed chicks of their own.

At the end of the climb, the flowing green grasses suddenly stopped, and the earth dropped away before my feet into a bottomless cauldron of churning fog and the relentless conversations of a hundred thousand birds. Nervously, I inched closer and, gripping a clump of grass with one hand, peered over the flowing green precipice. Falling away beneath me into an oblivion of fog were the stacked black-and-white bodies of thousands of penguinlike murres clinging to subtle ledges, many with an oversized turquoise egg or a smoky-gray chick cradled neatly on top of two black, webbed, reptilianlike feet—comfortably but literally clinging to the edge. The scale of living mass was staggering: in the air, fulmars and kittiwakes appeared and disappeared, while I could hear the rumbling din of more distant birds.

Saint George has been altered little since Russian navigator Gavriil Pribylov first landed there in the summer of 1786. On a tip from a native Aleut, he ended the long search for the breeding grounds of the northern fur seal—more than fifteen thousand pups are born on the island every year. Forty-five years earlier, Vitus Bering had commanded two ships to the south of Saint George on one of the most grueling expeditions in maritime history. On board was a young naturalist, George Steller—the first European to set foot in northwest North America and the first to describe several Bering Sea species. Some, like the Steller's sea cow, a giant oceangoing manatee, are long extinct at the hand of man.

Though these early expeditions were sponsored by barons seeking riches in a new world—and paved the way for the plundering of seals and otters for their pelts—the men who undertook these voyages were explorers, driven by restless hearts and an

LEFT, FROM TOP A year-round resident of the Aleutian Islands and southern Bering Sea, the Red-faced Cormorant is one of our least studied bird species and appears to be significantly declining in numbers; basalt lava formations provide ample nest ledges for kittiwakes and murres.

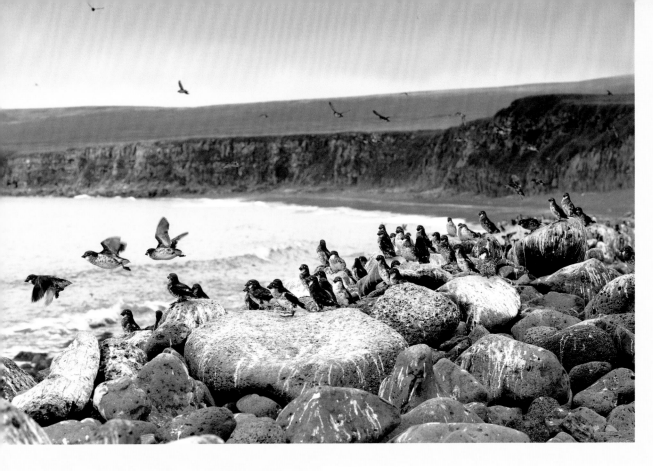

LEFT Tiny and highly social, Least Auklets nest in enormous colonies in the cracks and crevices between rocks and boulders on beaches and hillsides.

RIGHT Least Auklets are the most abundant seabird of the North Pacific with a population of more than 20 million.

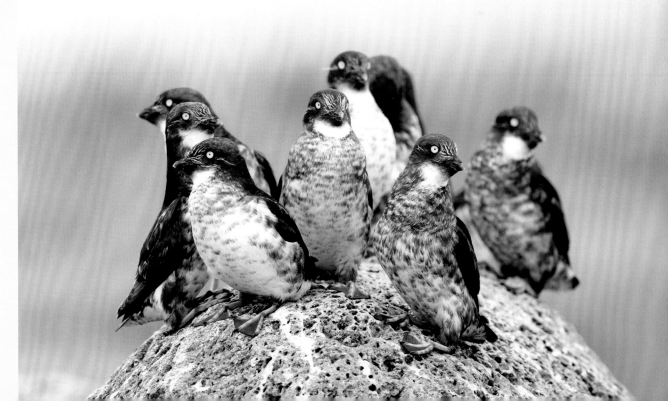

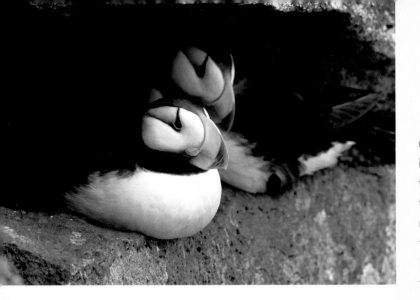

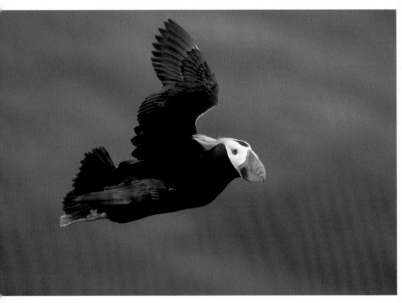

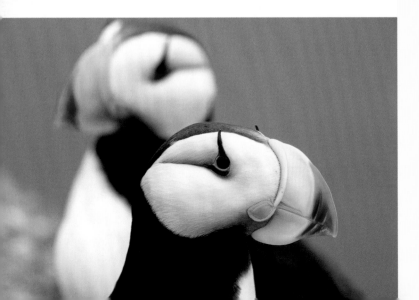

unquenchable thirst to experience what lay beyond a beckoning horizon. There still are many of us, I count myself among them, whose conditions as human beings depend on opportunities to seek and discover—to bask in the natural intricacies and rhythms of our planet, to find fascination in the myriad creatures that inhabit it. Being on Saint George, I was no less thrilled than Pribylov was to see the island for the first time, or more enchanted than Steller to observe the lofty flight of a puffin at his fingertips.

I continued along the cliff ledge, escorted by a procession of flying birds strafing the cliff en route to their nests. In my ears were the constant conversations of tightly packed neighbors squabbling over property lines, and the occasional strained barks of egg-stealing foxes—their daring trails winding down chutes and impossibly steep slopes to nests that geology has not quite put out of reach. For a while I sat to photograph a cluster of Thick-billed Murre and Red-legged Kittiwake nests and watch their comings and goings—many of the murres were arriving from rich feeding grounds sixty miles away, carrying glowing pink squid for growing chicks. Eventually, the rising angle of the sun's rays prevailed and beat back the fog, unveiling the towering cliffs and birds that swarmed like bees around some kind of gigantic blackened hive. I had never seen or felt such a throbbing pulse of life.

Being at a place like Saint George, I mourned the loss of the world that existed before the age of man, when natural systems everywhere were fully intact and producing at their fullest potential. It must have been very much like Saint George everywhere. From the flowing marshes of the Florida Everglades, to the vast prairies thundering with bison and booming prairie-chickens, to Great Lakes marshes teeming with migrant waterfowl. If the last of these places and this planet are not heaven, then surely they are heavenly enough to be held with such awe and esteem that they be cared for as if eternity depends on it. These are places where great swarms of birds and restless souls take flight.

LEFT, FROM TOP The Horned Puffin is a bird of the sea, only coming to land to nest. Most of its life is spent far from land in the oceanic waters of the North Pacific where it feeds primarily on lanternfish and squid by diving beneath the surface; a Tufted Puffin in flight; the ornate, colorful bills of Horned Puffins become smaller and drab during the winter months
OPPOSITE Murres compete for space on the cliffs wherever there are ledges big enough to hold an egg.

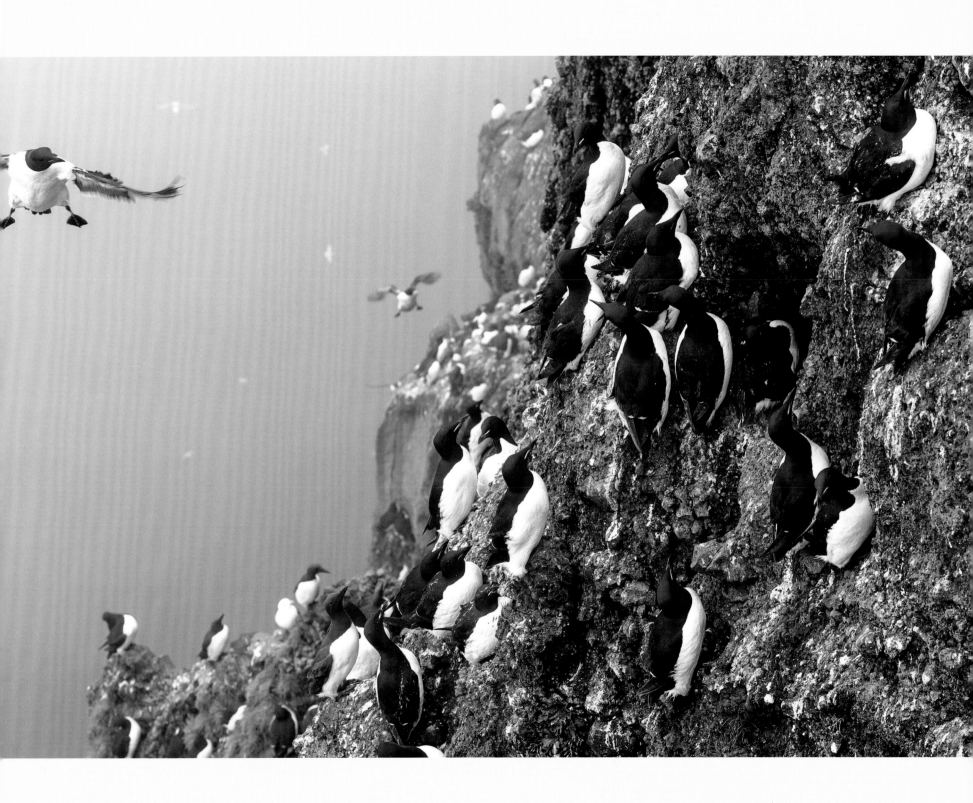

Shawn Langston, Citizen Scientist

THE FIRST BIRD SHAWN Langston identified on his own was a Red-breasted Nuthatch. The little male was tucked high in a lodgepole pine at Grand Teton National Park, where Langston had a summer job cleaning campgrounds. When the bird hopped onto a lower branch, Langston got a good look at its cinnamon belly, white throat, and black eye stripe like a burglar's mask. He flipped through his guidebook and found a match. A lifelong passion was born.

Langston now makes his living looking for birds. As a wildlife biologist for the Bureau of Land Management (BLM), he monitors Ferruginous Hawks and Northern Goshawks and makes an annual headcount of Peregrine Falcon nestlings. He prowls riverbanks for Yellow-billed Cuckoos, keeps an eye out for endangered Willow Flycatchers, and listens in the desert dusk for the call of the Common Nighthawk.

When he's not tracking birds for work, he does it for fun—and as a contributor to eBird. Langston submits one hundred or more bird lists every year to the online repository of sightings established by the Cornell Lab of Ornithology and National Audubon Society.

His observations, gathered both on and off the job, are helping fill in what has long been a blank on eBird's maps: the remote and rugged swath of land north of the Grand Canyon where Langston lives and works.

The so-called Arizona Strip is bigger than Massachusetts, with only a handful of paved roads. There are no visitor centers and no souvenir shops. The region encompasses habitats that range from the Mojave Desert to ponderosa pine forest, and from slot canyons to eight-thousand-foot peaks. Most days when Langston is in the field, he doesn't see another human being.

The BLM's local headquarters is in Saint George, Utah, where Langston lives. For spring surveys he leaves home before dawn, driving as much as two and a half hours over washboarded roads where washouts are common. All of the agency's vehicles, including the heavy-duty pickup Langston drives, are equipped with beefy tires and extra gear for fixing flats. The isolation and terrain have kept most birders and scientists out.

"One thing I like about it here is that there hasn't been a lot of bird research," Langston said. "So I feel like I'm actually contributing a lot to the understanding of bird distribution in Arizona."

Langston never expected to find himself chasing birds. With a father in the US Marines, his family bounced around the world. He switched high schools three times, from Arizona, to Texas, to Okinawa. After graduation, he joined the army to experience military life for himself—and to get money for college. He served in the quiet period between Operation Desert Storm and 9/11, working in a mortar squad for more than five years.

Langston had always been fascinated by nature and the outdoors. When he left the military, he thought he might pursue a career in wildlife management and focus on bears, cougars, and other big predators. But during the same summer he made the acquaintance of the nuthatch at Grand Teton, he also met his future wife. Langston followed her to the University of Montana in Missoula, where he enrolled in an ornithology class that set the course for his professional life.

The professor required his students to learn all the birds in western Montana, and he made it fun with engaging lectures and weekly field trips. "It just opened my eyes to everything that was around me," Langston recalled. "I was learning everything from morphology to ecology and migration and the evolution of

flight." Unlike wolves and bears, birds are everywhere, he realized. And even the most secretive species can usually be ferreted out by their songs.

As the sole BLM bird expert for an area covering almost eight thousand square miles, Langston gets to spend more time in the field than most federal biologists. Whenever he can, he makes note of all the birds he sees or hears in a particular area, adding them to the eBird database.

One of his BLM jobs is to inspect the old stock tanks and troughs that act as oases for wildlife in the arid landscape. While he's checking the tanks, he'll often piggyback an eBird observing session. "I'll hang around for an extra half an hour or so and record all the birds that are around," said Langston. He also writes up sightings when he's riding his bike around town or taking a walk with his family. "I can turn pretty much anything into a bird survey," Langston said, with a laugh.

He finds it exciting to see the eBird data accumulating—and to see his name on most of the reports from the Arizona Strip. Langston also uses eBird for work, mapping sightings of different species and noting when migrants arrive and how numbers vary from year to year.

Participating in the data-gathering project has made him a more careful observer, he said. When he's just jotting down a casual bird list, he might shrug off the distinction between subspecies. But if he'll be adding the report to one of the world's most comprehensive sources on bird abundance and distribution, it pays to take a closer look.

Langston's young son, who often tags along on his dad's outings, is already developing his own eye for birds. At the age of two and a half he can name most of the common birds near his home, and some he's only seen in books.

His favorites so far? Coots and Great Blue Herons.

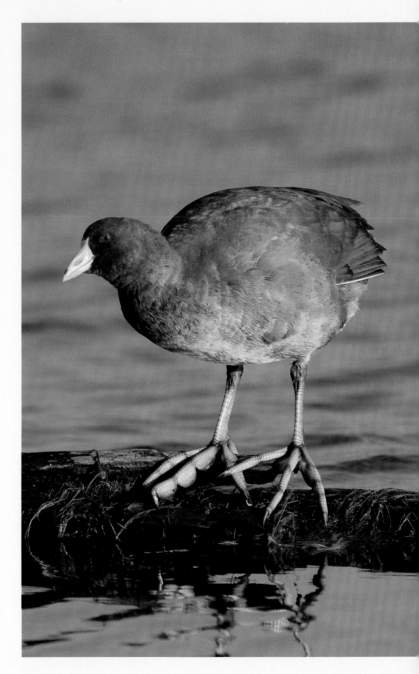

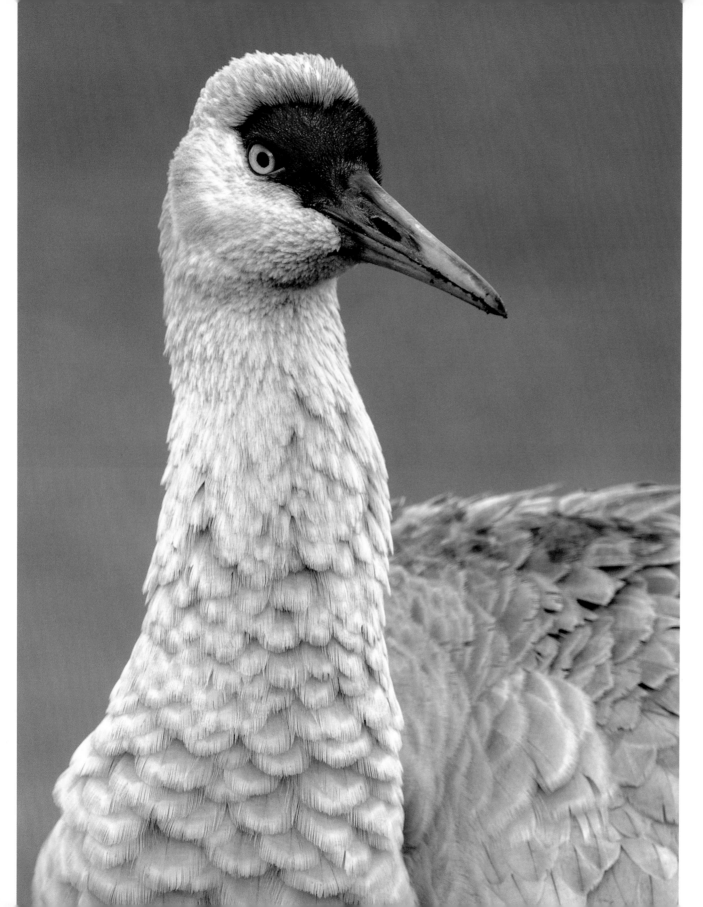

SANDHILL
CRANES

Throughout human history, cranes have been admired and featured prominently in art, literature, and folklore wherever they occur. They are known for their beauty, their elegance, their courtship dances, and their sounds. They form enduring monogamous pair-bonds and are among the most invested parents in the bird world. They begin communicating with their chicks when they are still inside their eggs; they show them what to eat; they protect them fiercely; and they lead them on great migrations. In the lives of cranes, we see a model of devotion to children and families.

LEFT The color of the forecrown's red bare skin can be intensified by blood flow during aggressive or sexual interactions.

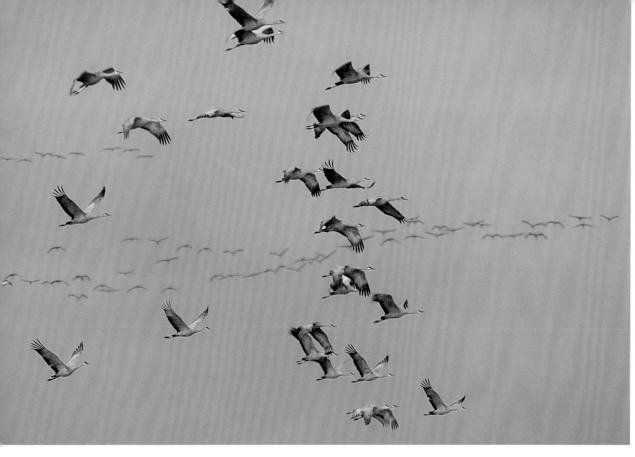

LEFT Sandhill Cranes migrating from Northern Mexico to the Alaskan and Russian Arctic

RIGHT Florida Sandhill Cranes, like this one, are nonmigratory.

FOLLOWING PAGES Cranes are devoted parents, the adults caring for the young until they fledge at about two months of age. Chicks hatch in a downy state with well-developed legs and feet, so they can leave the nest within a day or two and begin feeding themselves hours after hatching.

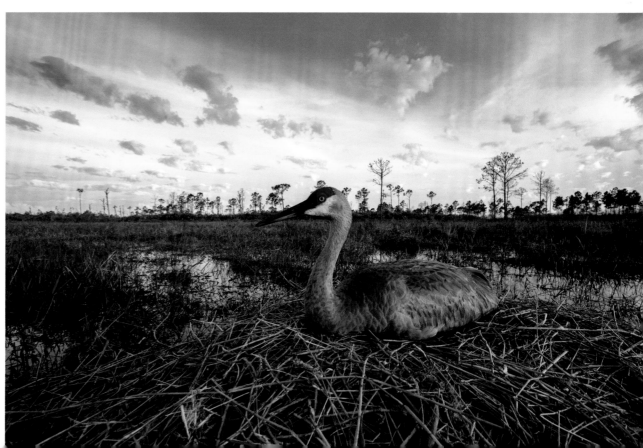

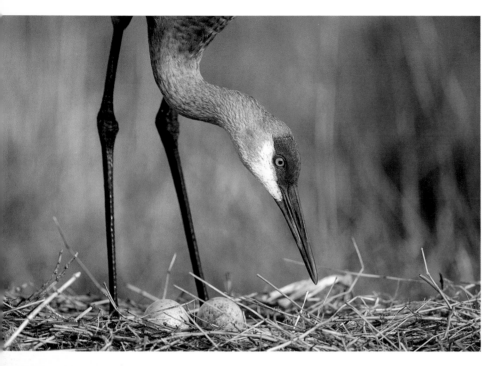
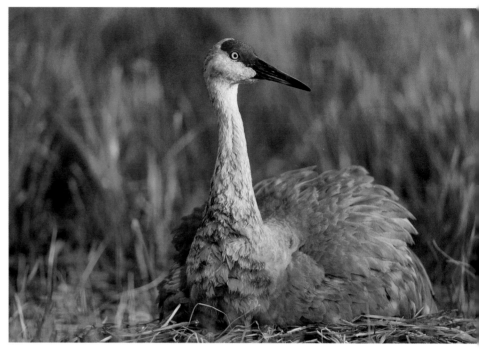
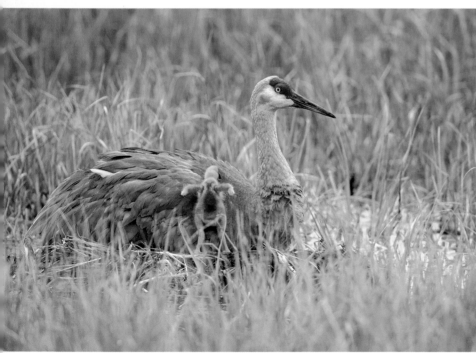
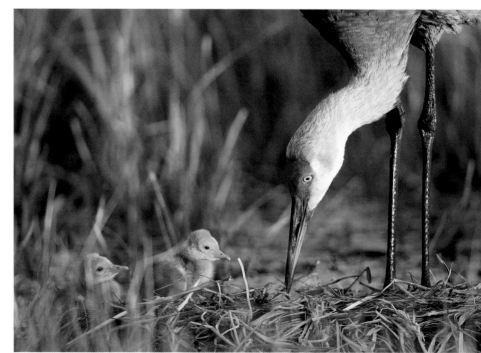

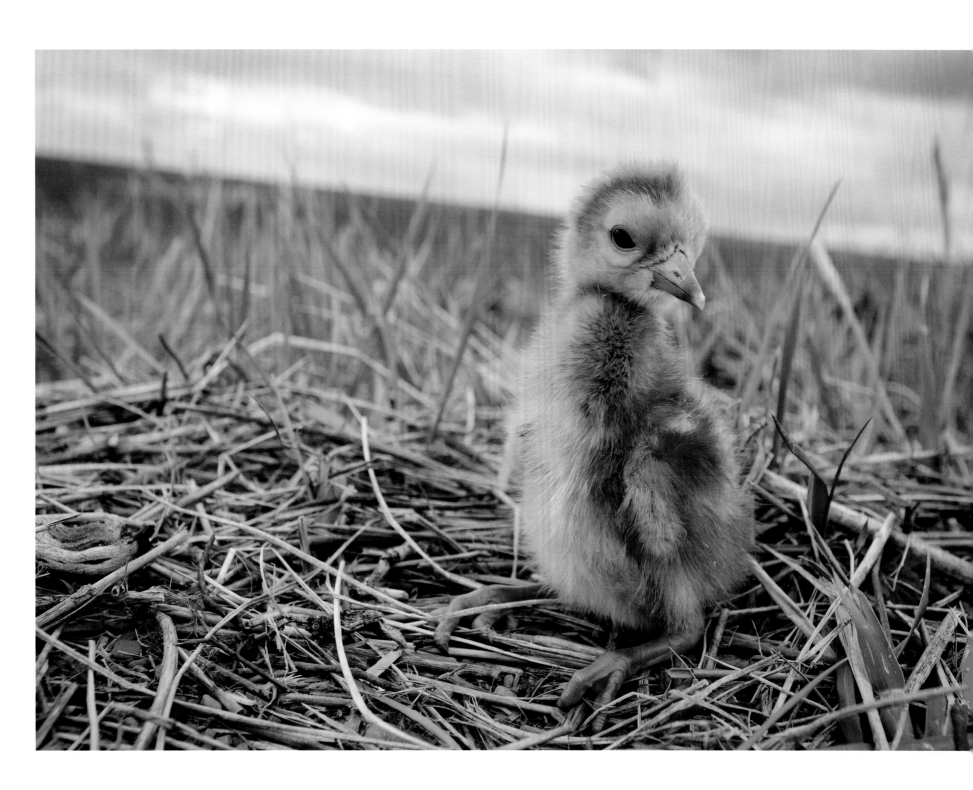

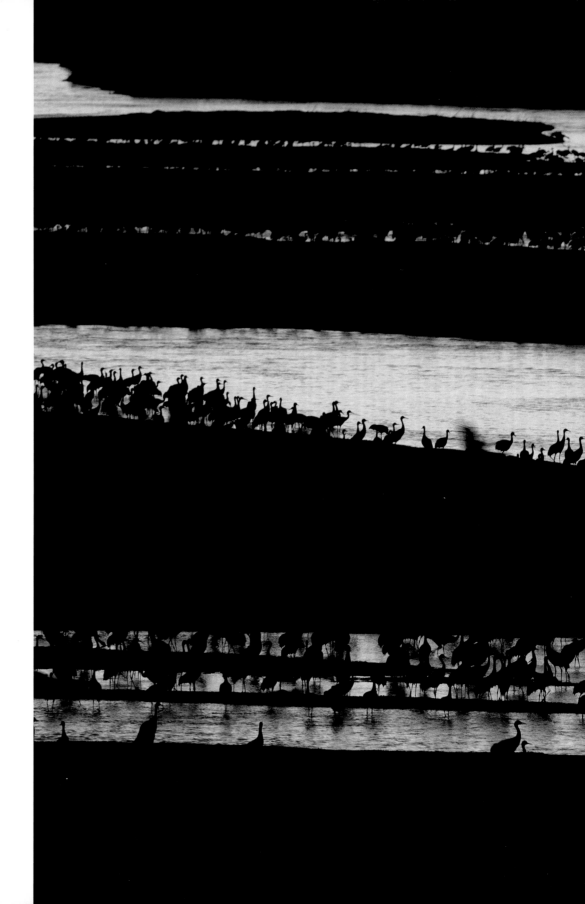

A half million migrating Sandhill Cranes stop each spring along the Platte River in Nebraska.

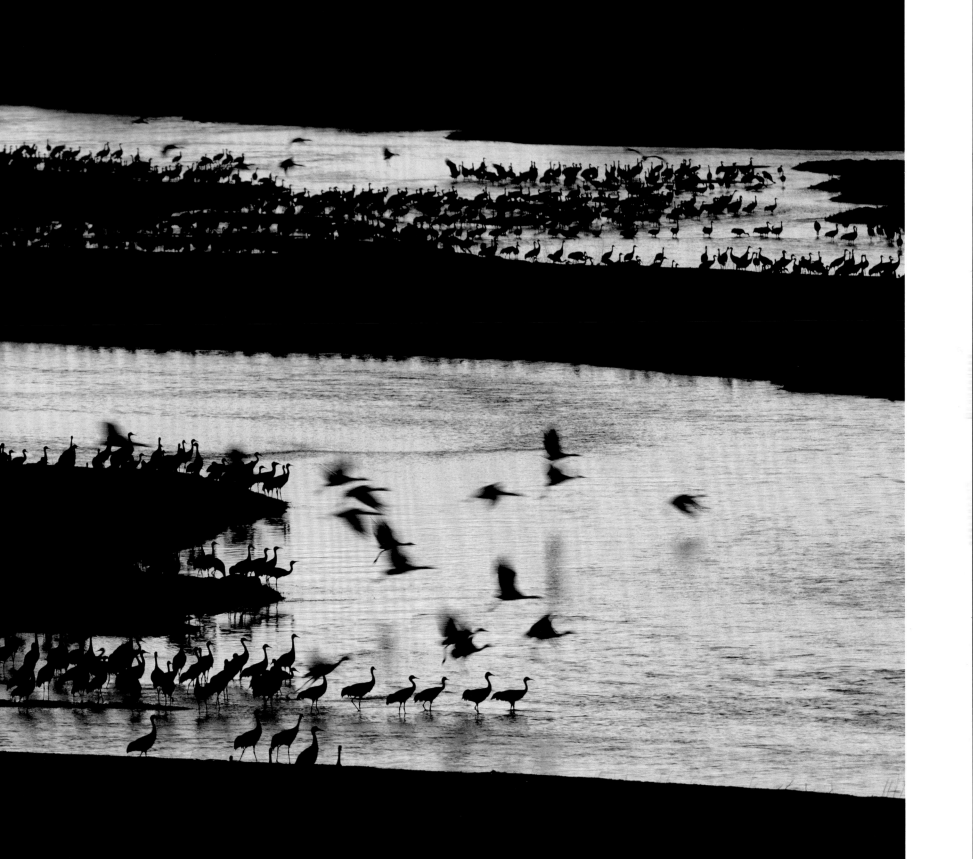

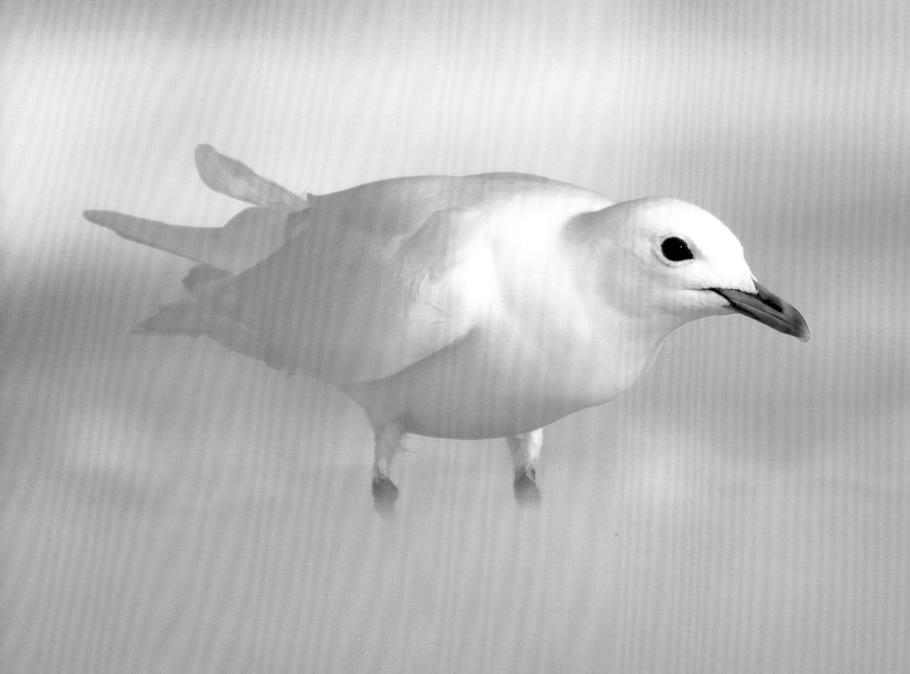

BEACONS OF OUR PLANET

John W. Fitzpatrick

AMONG NATURE'S MOST PRECIOUS gifts to humans, birds have the power to stimulate both sides of our brain. Their beauty, diversity, song, flight, and seasonal movements evoke our highest aesthetic sensibilities, trigger our emotions, and connect us spiritually with nature. Birds have inspired artists, poets, writers, and musicians for centuries. At the same time, birds present amazingly accessible models for the mechanics of how nature works. They appeal to our strictly rational curiosities, inviting us to count them, measure them, document and compare their behaviors, analyze their movements and ecological preferences—all of which enables us to deduce basic biological and environmental principles via scientific study. Birds serve as our most accessible gauges for measuring habitat condition and as beacons of environmental problems that demand our attention.

THE HUMAN FOOTPRINT

One cannot fully grasp how much birds reflect planetary conditions without first acknowledging the devastating scale at which humans have already altered bird populations.

As recently as a few hundred years ago, Elephant Birds—the largest bird ever to walk the earth—were still seen and described by European and Middle Eastern explorers. This ostrichlike behemoth stood nearly 10 feet tall and weighed 880 pounds. It occupied much of Madagascar, until the interior of that magical island was converted to monoculture grassland following human colonization, and the last of these gentle giants were eaten.

The Elephant Bird is but one of many such stories, all emblematic of the relationship modern humans have had with the natural world since we dispersed from Africa beginning more than fifty thousand years ago. As humans moved across the planet, we hunted birds for food, clothing, and ornamentation. In each newly colonized area, we encountered birds that had no defenses against our ever-more-advanced hunting techniques and our steadily increasing numbers. On remote islands filled with uniquely adapted species, we introduced new diseases (e.g., malaria and avian pox) and new predators (e.g., cats, rats, and mongooses). On the continents, we did the reverse,

systematically destroying the largest predators—wolves, bears, and big cats—thereby releasing cascades of herbivores and medium-sized "mesopredators" that altered ecosystems in numerous ways. Everywhere, we introduced domesticated herbivores (cattle, pigs, goats, horses, and rabbits) into habitats that had evolved without them.

Eventually, as agriculture and technology advanced, we systematically cleared forests, replaced grasslands with crops, built towns, drained marshes, filled swamplands, irrigated dry areas, lowered water tables, suppressed natural fire in some places, and increased fire frequency in others. By making the world more accommodating for ourselves, we profoundly altered every natural system we encountered, spreading waves of extinction across every major landmass and tropical island on earth.

INDICATOR SPECIES

Given our relentless impact, it is a testament to birds' remarkable resiliency that more than ten thousand species still grace every landscape on earth, from the wildest places to the most manicured gardens. On land, birds breed from the windswept Arctic tundra all the way south to Antarctica's ice sheets, and from snowcapped peaks and fog-shrouded cloud forests to the world's wettest swamps and driest desert scrubs. At sea, birds ride the great oceanic wind, sometimes spending years at a time without seeing land. Along the world's coasts, birds breed on rocky cliffs and crags, sun-drenched tropical beaches, remote coral atolls, and storm-tossed sub-Antarctic islands. Besides using all of the earth's natural biomes, birds inhabit our grazing lands, croplands, pine plantations, city parks, and even our backyards.

While birds as a group have an uncanny ability to live everywhere, no single species actually does. Just as no two places on earth are precisely the same, so with bird communities—no two areas have exactly the same bird species in exactly the same numbers. In fact, many bird enthusiasts enjoy the game of guessing where they are in the world with only birdsong as a guide.

Birds can occupy such an array of terrestrial and oceanic habitats because each species has evolved adaptive specializations that permit individuals to both cope with the challenges and capitalize on the opportunities of the species' respective place. These adaptations range from the biochemical, physiological, and structural to all aspects of behavior, such as mating system, foraging, and seasonal movement. Because they represent an ensemble of evolutionary adaptations to a specific location, most bird species are finely tuned to a narrow range of habitat conditions.

Though key for birds' phenomenal success and diversity, habitat specialization can have negative repercussions in a human-dominated world. Specialization works well as long as the rules and resources of a habitat stay constant. But when these begin to change—whether from natural events or human influence—birds experience reduced survival or decreased reproductive success, or both, because they cannot instantly adjust to the new reality. In places where changes persist, especially if they become extreme, once-typical bird populations dwindle and eventually disappear. Bird species that are most narrowly tuned to a habitat are the most vulnerable when conditions change.

Because ecological specialists—including many specialized birds—are vulnerable to habitat change, we can actually use their sensitivity as a real-time proxy for the health of a specific habitat. Ecological specialists function as canaries in the coal mine, or in the jargon of conservation biology, *indicator species*. Their overall numbers, their year-to-year survival, and their breeding success are barometers of ecological conditions within their habitat. Because birds tend to

No bird has been the subject of greater conservation concern and controversy in North America than the northern sub-species of the Spotted Owl. Now extinct in Canada and declining across the Pacific Northwest, these birds of old-growth forests have disappeared from large parts of their former range as these forests have been logged. Even with a conservation plan in place, the Spotted Owl now suffers from the invasion of the related Barred Owl, which thrives on the forest edges created by a long history of logging. More aggressive, it invades the small remaining pockets of old growth and competes with and even eats its smaller relative.

be high in the food chain (i.e., they mostly eat mature fruits and seeds, big insects, and other vertebrates), their success within a particular habitat provides an integrated measure of that habitat's ecological integrity. The elements of this integrity that matter most to birds—and often to humans—include completeness of the native species pool, overall food productivity during the growing season, and either the presence or absence of alien species, diseases, and chemical toxins.

DUCKS BECOME A MODEL FOR SUCCESS

The conservation movement began in earnest around the beginning of the twentieth century, largely as a reaction against the conspicuous and merciless human exploitation of wildlife that characterized the late 1800s. Species such as the Passenger Pigeon, superabundant only a few decades before, were market-hunted to extinction. Killed by the thousands so their decorative plumes could adorn high-fashion clothing, egrets and herons seemed poised to join the Passenger Pigeon. Gradually, natural philosophers, social activists, and even some politicians began questioning the scale of human impact on the earth's species, ecosystems, and processes. Recognition spread that while humans were the perpetrators of environmental exploitation and destruction, we also had the power to regulate our behavior, protect natural areas, and even manage habitats to reverse some of the damage.

Perhaps the first bird species in the United States to benefit from changes in laws and attitudes was the Wood Duck. In the wake of the Passenger Pigeon's demise, it was hunted so extensively that in 1901 the noted ornithologist and editor of *Forest and Stream*, Joseph Grinnell, deemed it "likely to be exterminated before long." With the historic Migratory Bird Treaty Act of 1918, closing of the Wood Duck hunting season set the stage for one of the most spectacular population recoveries ever witnessed. By the 1960s,

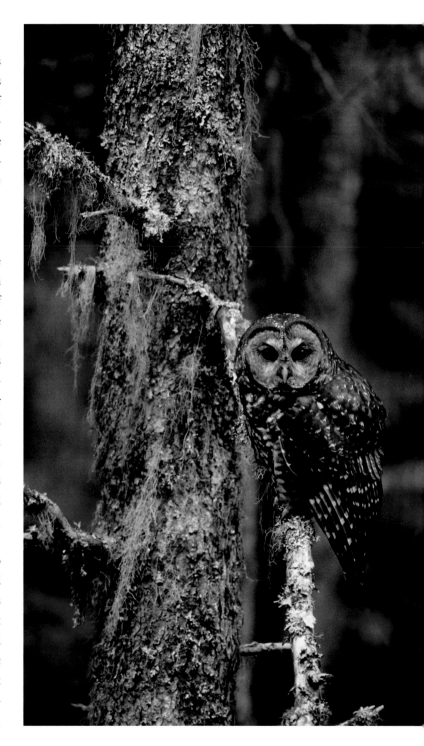

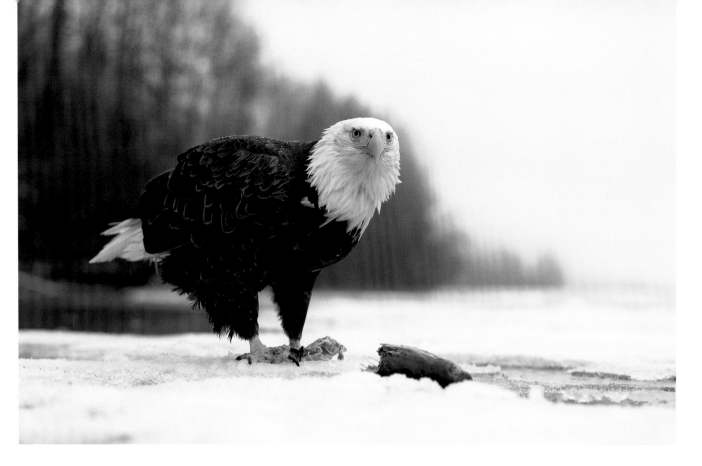

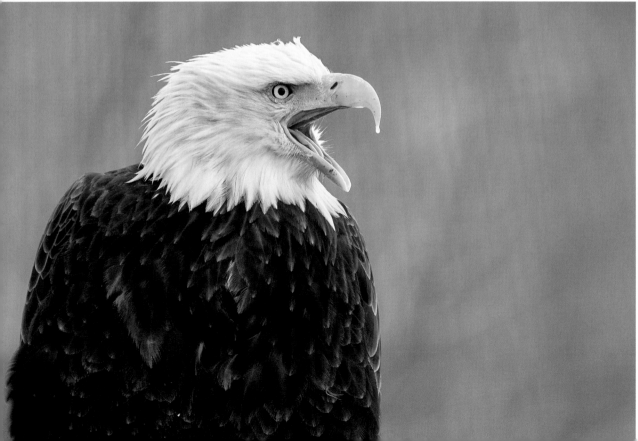

ABOVE, LEFT, AND OPPOSITE Few birds have shown such a remarkable recovery from hard times as Bald Eagles. Their numbers plummeted during the DDT era, when they ate fish and birds full of by-products of that pesticide, concentrating them in their own tissues. These chemicals interfered with calcium metabolism, so eggshells became increasingly thin over time until the eggs were being crushed beneath the weight of the incubating bird. With the banning of DDT in 1972, eagle populations initially rebounded slowly and then began to grow rapidly. Reduced to about five hundred pairs in the Lower 48 in 1972, there are now more than ten thousand pairs.

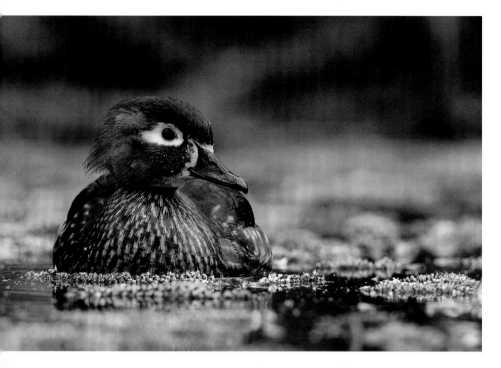

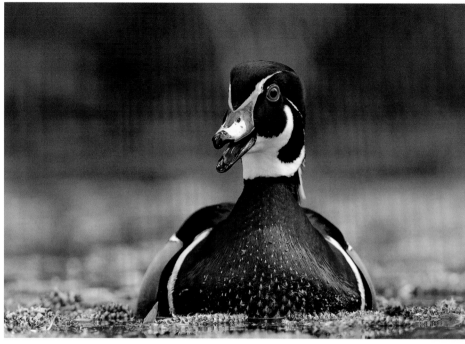

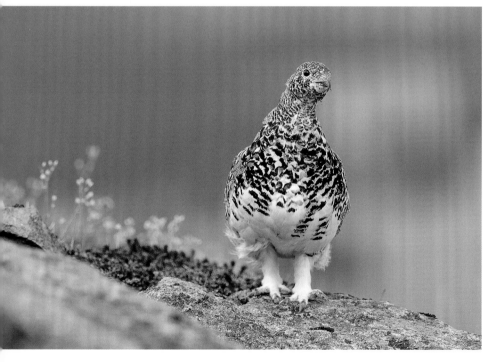

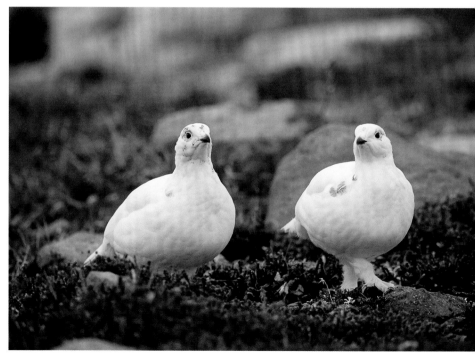

population estimates for the Wood Duck ranged between one and two million. During the 1970s and 1980s, their pop-ulations spread into previously unoccupied swamp forests, from northwestern Canada to northern Mexico. By the end of the twentieth century, scientifically grounded regulation of waterfowl hunting, combined with sustained public and private investment in protecting wetlands for waterfowl breeding, yielded the world's most successful—and repeat-able—model for conservation success.

To this day, the lovely Wood Duck is a symbol of what can go right when we become aware of our environmental impacts, adjust our attitudes, pass laws to curb unlimited exploitation of natural resources, and protect and manage habitats for their natural values. Across North America, from southeastern swamp forests to prairie potholes and Arctic tundra ponds, ducks and geese are true barometers of the abundance and productivity of our freshwater wetlands.

FALCONS AND EAGLES SOUND THE DDT ALARM

No stories of birds as environmental indicators are more dra-matic than those of the Peregrine Falcon and the Bald Eagle, two of North America's most majestic birds of prey.

In 1960, Rachel Carson published *Silent Spring* and alerted the world to the potential dangers of chemical pesticides. Her worst fears would prove well founded a few years later, when biologists began suspecting that widely used pesticides were directly responsible for dramatic population declines in many birds of prey, especially falcons, eagles, and Ospreys in the United States and Sparrow Hawks in Europe. Across their ranges, these raptors were rapidly disappearing from long-occupied habitats, and reproductive failures were rampant among paired, breeding adults. Strangely, eggs in the nest were being crushed by the incubating female. Scientists compared fragments of these crushed eggs with

eggshells stored in museum collections and discovered that the destroyed shells were 30 percent thinner than normal. The culprit turned out to be DDT.

At the time, this common organic pesticide was one of the most used pesticides in the world and was spread far and wide just by wind currents (traces were even found in the Antarctic ice sheet). When ingested by an animal, DDT is quickly metabolized into a stable and highly per-sistent compound, DDE. As top predators, birds of prey were accumulating huge loads of DDE by eating birds, mammals, and fish that had taken in this poison from the lands and waters where they fed. Contaminated raptors experienced elevated death rates and laid dramatically thinner-shelled eggs, meaning they could not reproduce. Their populations were plummeting. It wasn't long before DDT also proved pervasive in foods eaten by humans. In the race to control agricultural pests, we had begun poisoning ourselves. The declining populations of Peregrine Falcons and Bald Eagles sounded an alarm pertinent not just to wildlife but also to human health.

DDT was banned across North America in 1972, and almost instantly the affected raptor populations began to increase. The Peregrine Falcon was removed from the US endangered species list in 1999, and the Bald Eagle—with more than ten thousand breeding pairs across the Lower 48 states—was similarly delisted in 2007. Other raptor species have also enjoyed the ride. Today, Cooper's Hawks are ten times more common in the forests of eastern North America than they were in the 1960s, a population increase that says as much about postagricultural forest recovery as about reduced accumulation of pesticides. Equally striking is the recent population increase and southward spread of Merlins, whose breeding populations in the mid-1900s were mainly confined to Canada and Alaska. Today, Merlins breed

commonly across much of the northern tier of United States, and their numbers continue to grow. As top predators in their food chains, robust raptor populations present an exciting signal of healthy habitat and prey conditions.

VANISHING MEADOWLARKS

But the news is not as good for other birds. Among the most characteristic and pleasing sounds of the great North American grassland ecosystems are the songs of the Eastern and Western meadowlarks, which come together along a north–south contact zone in the eastern Great Plains. So popular is the Western Meadowlark's bright-yellow breast and clear, descending warble that six western US states chose it as their state bird. Once common and widespread across the continent, meadowlarks have undergone steady population declines for half a century. They are now difficult to find in many of the regions where they were once numerous.

Even more alarming is that the entire grassland community of birds is disappearing along with the meadowlarks, including another distinctive favorite and noted songster, the Bobolink. Others include the Grasshopper Sparrow, the Field Sparrow, the Dickcissel, and the Upland Sandpiper. Taken as a group, these species represent a gas gauge for North America's native grasslands, and the needle has been steadily heading toward empty for more than a century.

The meadowlark began vanishing as far back as the early 1800s, when croplands began replacing native grasslands as American and Canadian farmers discovered the deep, rich, loamy soils of the eastern prairies and Great Plains. By the mid-twentieth century, unplowed tallgrass prairie had been reduced to barely 2 percent of its original extent, making it the rarest of all North American native habitats when compared to its original extent. Vast areas of native grasslands became fragmented into smaller and smaller patches of habitat suitable for grassland birds. In the smallest patches, grassland-specialist birds disappeared very quickly even though some habitat remained. Today, especially east of the Great Plains, only the very largest remnant tracts contain the full suite of grassland birds.

Spread of croplands was only the beginning of the problems for grassland birds. Today, a more recent trend threatens remnant grassland ecosystems: the disappearing small family farm. Regions once dominated by single-family operations, which for a century or more were interspersed with hedgerows and fallow fields, are rapidly being converted into horizon-to-horizon row crops, planted clear to the road edges and boosted by pesticides and fertilizers. Consequently, open-country birds that once sang from fence posts and utility poles over the grassy margins of small farm plots are becoming scarce, or are disappearing altogether.

Moreover, as native grasslands go under the plow, so do their deep root systems that once intercepted silt-laden runoff, leading to a host of secondary environmental problems. All-important topsoil is rapidly eroding away, clogging rivers so much that boats and barges often become stuck in the sediment and dam spillways become obstructed. In some areas the excess nutrients in agricultural runoff have led to toxic algae blooms, contaminating drinking water. Our disappearing grassland birds do not just signal the precarious health of bird habitats; they also warn of broad environmental changes that directly affect our own quality of life.

HENSLOW'S SPARROW WHISPERS SUCCESS

Perhaps the most obscure grassland bird of central North America is the Henslow's Sparrow, whose barely audible *ts-lik* song was described by famous field-guide author and illustrator Roger Tory Peterson, in *A Field Guide to Eastern North American Birds*, as "one of the poorest vocal efforts of

LEFT Who would have thought that the air conditioner and our love of orange juice could endanger a bird? The only bird species unique to the Florida peninsula, the Florida Scrub-Jay requires dwarf, scrubby oaks that grow only on fine sandy soils—soils that also provide optimal conditions for housing developments and orange trees. Furthermore, the rapidly growing human population has suppressed wildfires, causing natural scrub to grow too tall to be suitable for the Florida Scrub-Jay. Their populations have declined by more than 90 percent since historic times, but it is hoped that a network of scrub habitat preserves, actively managed with prescribed burning, can prevent further declines.

RIGHT Populations of aerial insectivores (birds that feed on insects while flying), like this Common Nighthawk, have experienced steep declines over the last twenty years or so. Though a single cause of these declines is unlikely, the increased effectiveness and use of agricultural insecticides has greatly reduced the prey base of flying insects.

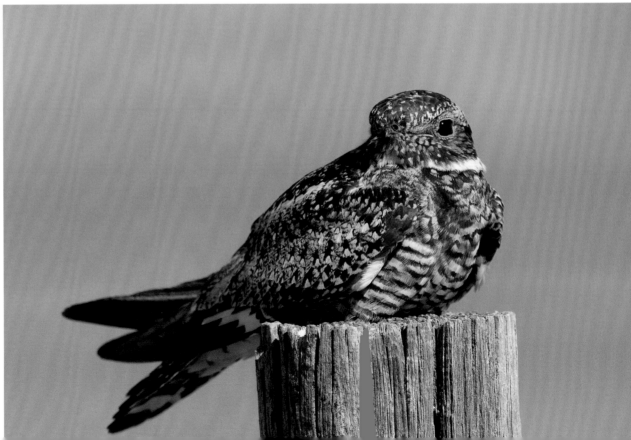

any bird." Henslow's Sparrows were (and still are) listed as threatened, endangered, or a species of special concern in sixteen states because they experienced a staggering 8 percent annual decline across the species' range between 1966 and 1989. Then a remarkable reversal happened. The population began to increase, and it has experienced a steady 4–5 percent annual rise since 1990.

Careful study of the recovering populations, especially in Illinois, revealed that Henslow's Sparrows were colonizing and successfully breeding in farm fields that had been enrolled in the US Department of Agriculture's Conservation Reserve Program, or CRP. Farmers in the program commit to leaving previously farmed tracts as uncultivated, fallow grassland for ten to fifteen years at a time. Studies also revealed that the sparrows breeding in larger fallow fields experience higher survival and reproductive success than those breeding in small tracts.

Today, Henslow's Sparrows are sufficiently common in some areas of the Midwest that they are even breeding in less preferred habitats, such as recently burned, grazed, or mowed grassland. Rescued from its precariously low numbers, the Henslow's Sparrow has become a "poster species" for the value of the CRP as a strategy for recovering the health, composition, and function of native grassland ecosystems across the United States.

LOUISIANA WATERTHRUSH SINGS OF HEALTHY STREAMS

Of the many fanciful names applied to North American birds by the great artist-naturalist John James Audubon, one of the most wonderful was Aquatic Wood-Wagtail—a vastly more accurate and evocative name than this species' current moniker, Louisiana Waterthrush. This lively bird—neither a thrush nor especially common in Louisiana—is a true habitat

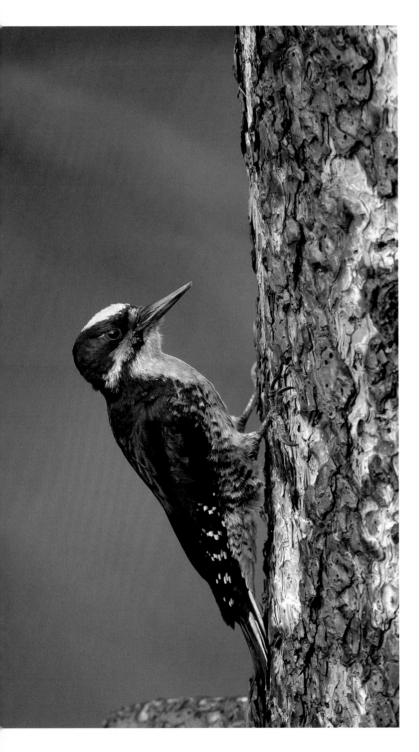

specialist, with both breeding and wintering grounds along the edges of clear, rushing, rocky streams under dense forest canopy. Ecologically comparable to the American Dippers of the Rocky Mountain West, these terrestrial wood warblers forage most actively right along the edges of streams, feeding on caddisflies, stoneflies, mayflies, and other aquatic invertebrates.

Studies in Pennsylvania have demonstrated that Louisiana Waterthrush density and breeding success are significantly reduced along streams that have elevated acidity owing to acid rain or acidic drainage from nearby mines. The species' density is also reduced in areas where forest cover over streams has been opened, either through local logging or by damage to the tree canopy from defoliating pests, such as gypsy moths or woolly adelgids. Such openings increase water temperature, decreasing the density and diversity of the aquatic invertebrate community and limiting the Louisiana Waterthrush's rate of food intake. This, in turn, hampers the birds' ability to raise young and requires them to expend energy defending larger territories. The most pristine streams of eastern North American forests thereby possess an exceptional biological indicator in the distinctively piercing, descending whistles of the Louisiana Waterthrush.

BIRDS THAT LIVE WITH FIRE

In many habitats around the world, species diversity is maintained by recurring episodes of natural disturbance, such as intense storms, large-scale floods, and insect outbreaks. Periodic wildfire is perhaps the most widespread of these necessary disturbances, but because humans fear fire, its significance for natural communities was underappreciated until well into the twentieth century.

Fire is an inevitable event in almost any productive plant community that is subject to seasonal drying or frequent

LEFT After a forest fire in our northern and western conifer forests, the dead and dying trees are subject to attack by several kinds of wood-boring beetle larvae. They are soon followed by Black-backed Woodpeckers, which feed on the larvae. No one knows how the woodpeckers can find a burned forest so rapidly, seemingly from long distances, and they have not yet divulged their secret.

OPPOSITE Human activities have many subtle effects on wildlife populations, which may be good for some species while detrimental to others. By using human structures for nest sites and supplementing their natural diets with trash and road kill, Common Ravens now thrive in some landscapes in the west and far north where historically they were scarce or absent. Ravens also prey on other birds' nests and chicks, meaning added pressure for local bird populations that previously were not exposed to these brilliant and resourceful predators.

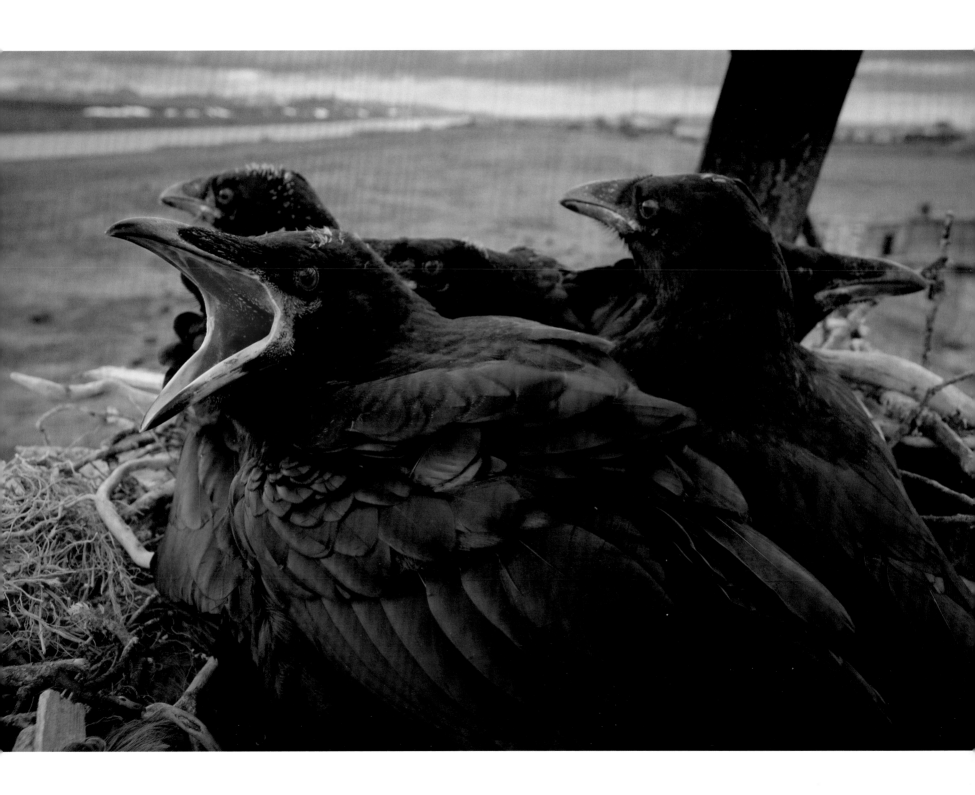

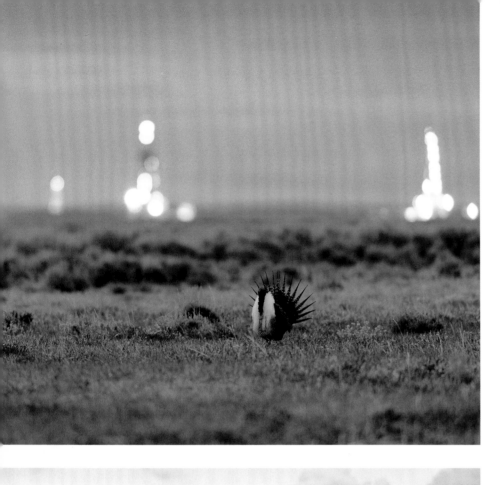

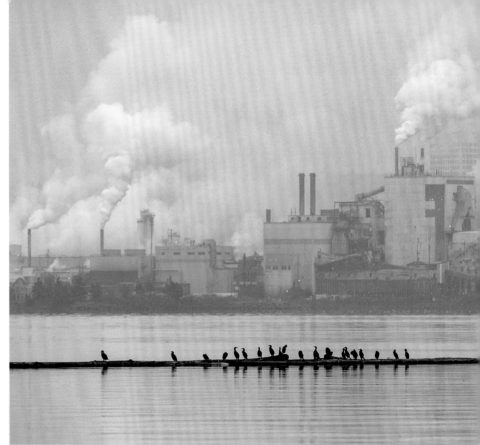

Greater Sage-Grouse and natural gas drill rigs; cormorants roosting on a log boom in front of a pulp mill; migratory shorebirds and a wind turbine; a Great Blue Heron feeding in a tidal estuary near an oil refinery. Our water, air, and soil are laden with invisible pollutants that can affect the health and reproduction of both birds and humans. Declines in bird populations are often the first sign that something is wrong. We desperately need to invest in and develop alternative energy sources to lessen our dependence on fossil fuels, and wind energy is such an obvious choice, free and as renewable as the air itself. But it comes with a cost: Migrating birds of many kinds use the same air space as the wind turbines, and collisions are frequent. Other birds have such an aversion to the tall structures that they no longer utilize the habitat where turbines are placed. When thinking about green energy sources, we need to consider all the ramifications of those technologies and be thoughtful in their implementation.

lightning strikes. It is especially common where these two factors combine, such as in native grasslands, wooded savannas, dense scrubs and chaparral, and all but the wettest conifer-dominated forests. By the 1930s, game managers in Florida recognized that Northern Bobwhite populations responded immediately and favorably to regular burning of the wiregrass understory beneath mature longleaf pines. Today, the charismatic quail is experiencing an extraordinary, range-wide population decline. The only exceptions are among populations that occupy game preserves and wildlife refuges of the southeastern United States; these lands are intensively managed, with regular prescribed burns timed to mimic the intervals between the wildfires that were typical of native conditions.

We now understand that in habitats where lightning-caused fires are frequent, the absence of fire leads to population declines for dozens or even hundreds of plant and animal species. Indeed, many such postfire specialists may be more endangered by fire suppression than by outright habitat loss. Proper habitat management in these areas requires prescribed burning to maintain the ecological conditions of periodic disturbance under which the species evolved.

On the Florida peninsula, for example, the endangered Florida Scrub-Jay has declined in areas of oak scrub where fire has been suppressed, mainly because in long-unburned scrub the populations of certain snakes, mammals, and other predators increase dramatically. These predators reduce the ability of young Florida Scrub-Jays to survive, so the overall jay population begins to drop. In large and small habitat patches alike, Florida Scrub-Jay numbers rebound rapidly after a fire, and they remain high for five to ten years before beginning to drop again. The Florida oak scrub is now highly fragmented, and land managers use prescribed burning to maintain populations of Florida Scrub-Jays, making them

outstanding indicators of ecological health for this endangered ecosystem.

The Red-cockaded Woodpecker is another endangered fire-dependent bird of the southeastern United States. It originally occupied the vast pine forests that stretched unbroken from the Carolinas and Florida west to Texas and Arkansas. Among the world's most specialized woodpeckers, the species is now limited to widely disjunct remnant populations, where it serves as a superb indicator species for well-managed forests of longleaf, loblolly, or slash pines. Cooperative family groups of Red-cockaded Woodpeckers roost and nest exclusively in cavities that they drill high on the trunks of living pines, favoring trees that are eighty to one hundred years old. Curiously, the adults also drill tiny "resin wells" into the bark surrounding the nest cavity, creating a thick coating of sticky pine pitch to protect nests from predation by snakes and small mammals. Mature trees are essential for successful nesting, but Red-cockaded Woodpeckers disappear even from old pine stands if fire has been suppressed. In the absence of fire, the otherwise open, grassy understory fills in with rapid-growing hardwood shrubs and saplings, providing opportunities for predators and competitors to reach the woodpeckers' nests.

The Florida peninsula is best known for its sandy beaches, expansive wetlands, and Spanish-moss–laden cypress forests (not to mention theme parks and retirement communities), but the interior also features several extensive prairie systems dominated by wiregrass, palmettos, and miniature oak shrubs called runner oaks. Most of these prairies have been ditched, drained, and planted with tropical grasses to create grazing land that supports Florida's booming cattle industry. Genuinely native Florida prairie is now so rare that its signature sparrow—the Florida Grasshopper Sparrow—has become the rarest North American

songbird. This distinctively dark subspecies now occurs on only a few large preserves managed strictly for conservation values. Best management practices for these Florida prairie preserves include frequent prescribed burning to reduce encroachment by pines and hardwoods and to maintain the open wiregrass-palmetto structure typical of the prairie's original condition. The Florida Grasshopper Sparrow is hanging on by a thread and hopefully will rebound as more of its wide-open habitat is protected and restored.

CLIMATE CHANGE THREATENS MARINE BIRDS OF THE FAR NORTH

If polar bears clinging to melting icebergs represent our most iconic image of climate change, then look more closely at some of those same icebergs. Perched atop may be the lovely and ghostly Ivory Gull. This striking snow-white gull is even more closely tied to Arctic ice than polar bears, and its numbers are plummeting in many parts of its circumpolar range.

Among the world's most mysterious birds, Ivory Gulls breed in remote areas of the High Arctic in Canada, Greenland, Scandinavia, and Russia. The species recently joined the endangered species lists of Canada and Norway because breeding populations in both countries dropped as much as 80 percent from previously documented numbers. During some recent years in Canada, not a single juvenile gull could be found (first-year birds are recognizable by the black scaling on the back and wings), and a long-established breeding colony on Baffin Island disappeared altogether. On remote islands of the Canadian High Arctic, Ivory Gulls nest on tall mountain cliffs and peaks that emerge above glaciers (called nunataks by the local Inuits). Such sites protect the nests from egg-eating Arctic foxes and lemmings, but this natural protection is in jeopardy as the glaciers recede and Arctic ice steadily disappears.

The precise reasons for Ivory Gull declines are not fully understood, but there is broad agreement that environmental conditions along the edges of Arctic ice packs are changing extremely rapidly with the warming of our planet. In addition to exposing gull nests to increased mammal predation, shifting ice conditions and altered currents can radically change the distribution and composition of the marine fish and invertebrates that Ivory Gulls depend on. Being at the top of the marine food chain also makes these gulls surprisingly vulnerable to chemical contaminants produced from industrial and agricultural practices far to the south. Elevated levels of mercury, organochlorine pesticides, brominated flame retardants, and other toxins have been documented in Ivory Gull eggs from several breeding colonies in the Norwegian and Russian Arctic—they are among the highest contaminant levels ever reported for an Arctic bird. These toxic loads may be responsible for the decline of this gull, the northernmost-breeding bird in the world.

A striking and well-documented example of how seabird breeding success reflects changes in ocean currents occurred in 2013, when thousands of Atlantic Puffins in Maine failed to rear chicks, and hundreds of starved adult puffins washed ashore. Water temperatures that summer were significantly warmer than usual, altering the distribution of the puffins' mainstay prey fish (herring and sand eels) and favoring more southerly fish species along the Maine coast. On Eastern Egg Rock, an island where Atlantic Puffins are studied intensively, hundreds of chicks starved to death despite being surrounded by piles of butterfish, which were too large for the chicks to swallow. Altered ocean currents are also believed to be responsible for unprecedented movements of other seabirds along the US Atlantic coast during that same year, including spectacular "invasions" of Razorbills along both coastlines of Florida.

OPPOSITE A Reddish Egret at the height of its breeding plumage employs an open-wing technique to corner schools of small fish in coastal south Florida.

LONG-DISTANCE MIGRANTS FACE MULTIPLE STRESSORS

Among the grandest spectacles in all of nature are the twice-yearly migrations of the millions of shorebirds that breed in Arctic and sub-Arctic habitats and winter well south of the equator. Along their migratory routes, the birds gather in enormous flocks to feed on beaches, mudflats, and tidal lagoons. The longest-distance fliers include the Bar-tailed and Hudsonian Godwits, whose remarkable routes take them to opposite ends of the planet from their breeding grounds in Alaska. Bar-tailed Godwits make spectacular, nonstop flights to winter on the coasts of New Zealand and Australia, while Hudsonian Godwits winter at the southern tip of South America. Both species feed on aquatic invertebrates, especially shrimp and worms they extract from deep in the mud with their sabrelike upturned bills. Both species almost double their body weight with fat to fuel their 9,300-plus-mile migrations. This requires access to highly productive mudflats during all four stages of a species' annual cycle (breeding, southward migration, wintering, and northward migration), but problems now exist at every one of these stages.

Climate change is altering the timing of peak productivity across Arctic breeding grounds, causing breeding failure among Hudsonian Godwits of interior Canada. Southward migration takes both species on long flights over tropical oceans precisely when hurricanes and typhoons reach their peak frequencies. On the wintering grounds and at vital stopover sites during the northward migration, the most important feeding areas are being degraded by pollution and nutrient runoff. Even worse, some of the most crucial stopover feeding areas have been lost altogether due to dredging and coastal development. Nowhere in the world is this problem more acute than in the tidal mudflats and lagoons of the Yellow Sea along the coasts of China and the Koreas.

As if these problems weren't enough, in many areas of the developing world, shorebirds—including godwits—are still being netted and hunted by the thousands for food, especially where they assemble in large feeding flocks. Images of this activity eerily recall stories of the Passenger Pigeon slaughter.

Long-distance migratory shorebirds remind us that the earth is a single integrated system. These are unusually long-lived and resilient birds, but the stresses they now face at multiple places and stages of their life cycles compound one another, gravely affecting reproductive success and survival. Globally, so many shorebird species are experiencing population crashes that many scientists consider their plight to be the most serious conservation challenge faced by birds today.

Across North America, almost all of the familiar species once known as abundant spring and fall migrants are steadily declining, some of them catastrophically. Most alarming is the Red Knot, whose numbers during migration along the mid-Atlantic shoreline are down 75 percent since the 1980s. The cause, at least in part, is believed to be massive overharvesting of horseshoe crabs in key stopover areas such as Delaware Bay, where Red Knots and many other shorebird species historically fattened up on crabs' eggs en route to their Arctic breeding grounds. Other species showing recent dramatic declines include the Whimbrel and the Semipalmated Sandpiper. The Whimbrel population along the Virginia coast is down more than 50 percent since the 1980s, while the number of migrant Semipalmateds in Ontario declined an average of 8 percent per year from 1974 to 2009. Stemming and reversing these declines will require an integrated, global-scale approach involving a combination of habitat protection and human education about the importance of wetland and shoreline habitats to our own economies and quality of life.

OPPOSITE, CLOCKWISE FROM TOP LEFT
Along the border between Texas and Mexico, birds such as Great Kiskadees continue to expand their ranges to the north with global climate change; with their quick vision, pointed wings, and broad bills, Eastern Kingbirds are superbly adapted to capture flying insects on their breeding grounds, but on their wintering grounds they form flocks and eat fruit; as the climate changes, breeding seasons are becoming earlier for many birds in the temperate zone. For many migrants, their arrival on their breeding grounds is finely synchronized with the seasonal peak of prey abundance that has only shifted slowly over the millennia. As temperatures continue to rapidly rise, researchers are monitoring the effects on populations of birds like this White-crowned Sparrow.

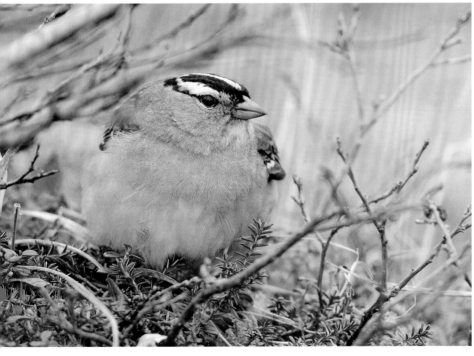

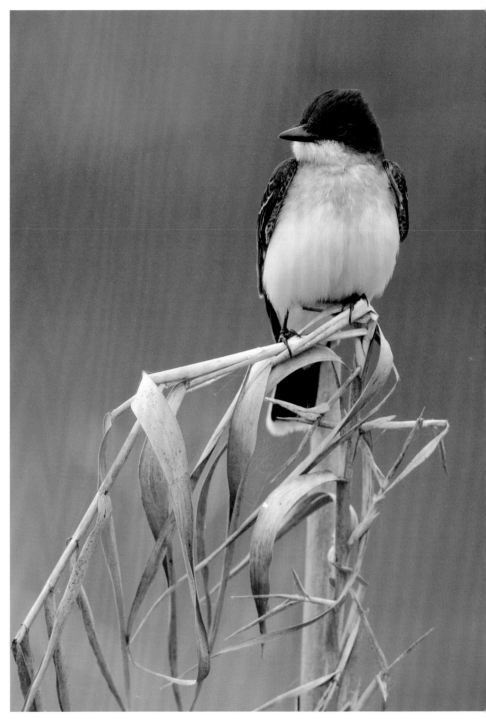

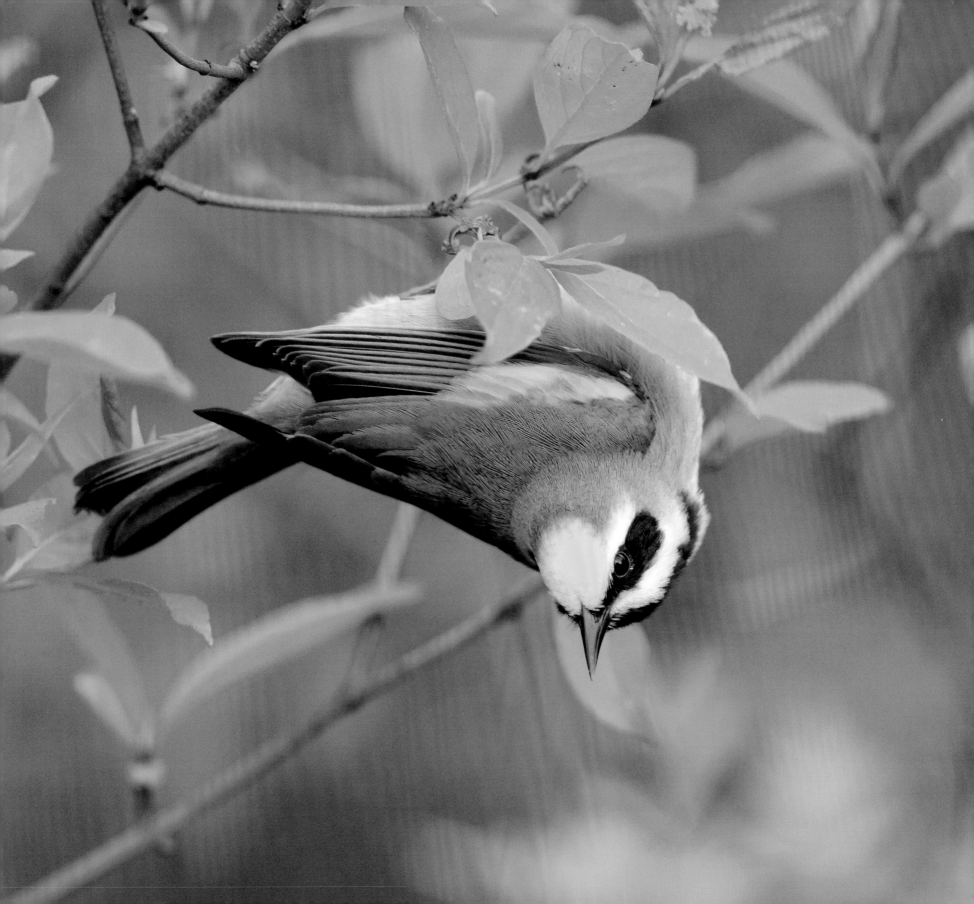

NORTHERN SPOTTED OWLS BATTLE THEIR COUSINS

In the soggy temperate forests of western North America, Northern Spotted Owls steadily declined as stand after stand of towering old growth was logged through the twentieth century. Emblematic of these spectacular forests, the Spotted Owl was placed on the US endangered species list in 1990 in recognition of the importance of protecting what remained of the bird's unique habitat. By that point, however, an unexpected and rapidly spreading new threat had appeared. Ironically, this new influence in the western forests took the form of the Spotted Owl's closest cousin, the Barred Owl, which historically had lived only in eastern North America.

Early in the twentieth century, Barred Owls began expanding westward across central Canada, eventually reaching northern Alaska, British Columbia, and finally south into the western United States, reaching Washington in 1965, Oregon in 1974, and California in 1981. This steady spread was facilitated by human influence on the landscape, including increases in hardwood forest cover across the northern Great Plains and widespread logging that created favorable habitat for Barred Owls as forests regenerated. Dramatic population increases of Barred Owls continue unabated to this day. The two species now hybridize extensively, and Northern Spotted Owls are declining rapidly (they are now extinct in Canada).

Most interesting and ominous is the dramatic ecological dominance of the Barred Owls over its cousin. The Barred Owl is a much more generalized predator, feeding on snakes, fish, crayfish, birds, and even other owls, in addition to small mammals, whereas Spotted Owls eat mainly microtine rodents. Consequently, Barred Owls can occupy much smaller territories, live in a wider variety of habitats, fledge larger broods of offspring, and therefore achieve much higher densities than Spotted Owls. In short, the Barred Owl has become an invasive competitor and a threat to the very existence of Spotted Owls in western North America. Proposals to conduct massive removal of Barred Owls as a means of protecting Spotted Owls are controversial and likely impractical as a long-term solution. It remains to be seen what the long-range impacts will be of the wholesale replacement of one owl species by another in our western forests.

HEEDING THE SONG OF THE MEADOWLARK

A global goal of humankind should be that all of our diverse cultures around the world eventually thrive and flourish side by side with fully intact and functioning natural systems—a goal that today seems distant indeed. Our ecological footprint continues to expand as our populations grow, our energy demands increase, and our cities and our agricultural landscapes sprawl ever wider. Today, about one-eighth—13 percent—of the world's bird species are under immediate threat of extinction. Uniquely specialized to their local habitats, these threatened birds directly reflect the compromised health and integrity of the planet's natural systems. In place after place, birds point out the work we have yet to accomplish in order to achieve a global goal of intact natural systems.

At the same time, in every case where birds are still singing to us, there is still time and opportunity to hear their songs and respond to their stories. *We must not give up.* We need to perceive avian voices not just as subjects for poetry and music but also as alarm songs about the state of the planet. We must recognize that declining bird populations are warning signals about the quality of our landscapes and ultimately the quality of our lives. Birds supply both the motivation and the information we need for focusing on protecting natural habitat patches large and small—for

managing and restoring healthy, interconnected ecological systems across all of our landscapes.

The good news is that environmental consciousness and on-the-ground conservation actions—which began little more than a century ago—have already achieved substantial progress in protecting natural places and systems. Case after case demonstrates that when we detect declines among birds, study the causes, and change our behaviors even slightly to accommodate their needs, bird populations respond spectacularly. In the United States, once-severely reduced populations of many species are now thriving and expanding. A few, such as the Bald Eagle, Peregrine Falcon, and Brown Pelican, are no longer listed as endangered because their recovery has been so successful. Most North American waterfowl today occur in numbers not seen since the early twentieth century. Kirtland's Warblers, once reduced to fewer than two hundred breeding pairs, now number well over a thousand pairs in an expanding range through the upper Great Lakes.

Success stories such as these attest to the resiliency of birds, provided that the habitat conditions they require are understood, restored, and protected in sufficient quantity to endure the natural fluctuations that are outside our control. Fundamentally, stories about rebounding bird numbers are stories about rejuvenated natural habitats. They inspire us to keep listening to what bird populations are telling us and to use that information to keep them singing.

Birds can continue to connect our hearts and minds with nature long into the future, but only if we commit ourselves to making it so. As managers of the planet, we are responsible for choosing exactly what remains of nature hundreds of years from now. If we want tomorrow's human generations to incorporate the songs of birds into music and verse, then we need to hear what the meadowlarks of today are telling us about their places, and we must care enough to heed their warnings.

OPPOSITE The Florida Grasshopper Sparrow is the most endangered bird in the mainland United States. This nonmigratory subspecies of the Grasshopper Sparrow is currently known to exist at only four sites in southcentral Florida. Widespread loss of Florida dry prairie habitat through conversion to agriculture or by fire suppression has led to steady declines. By 2014, fewer than one hundred singing males were detected on surveys. Population growth on existing conservation lands appears to be hindered by high nest-predation rates by both native and non-native predators. Much effort is being invested in understanding and saving this vanishing subspecies.

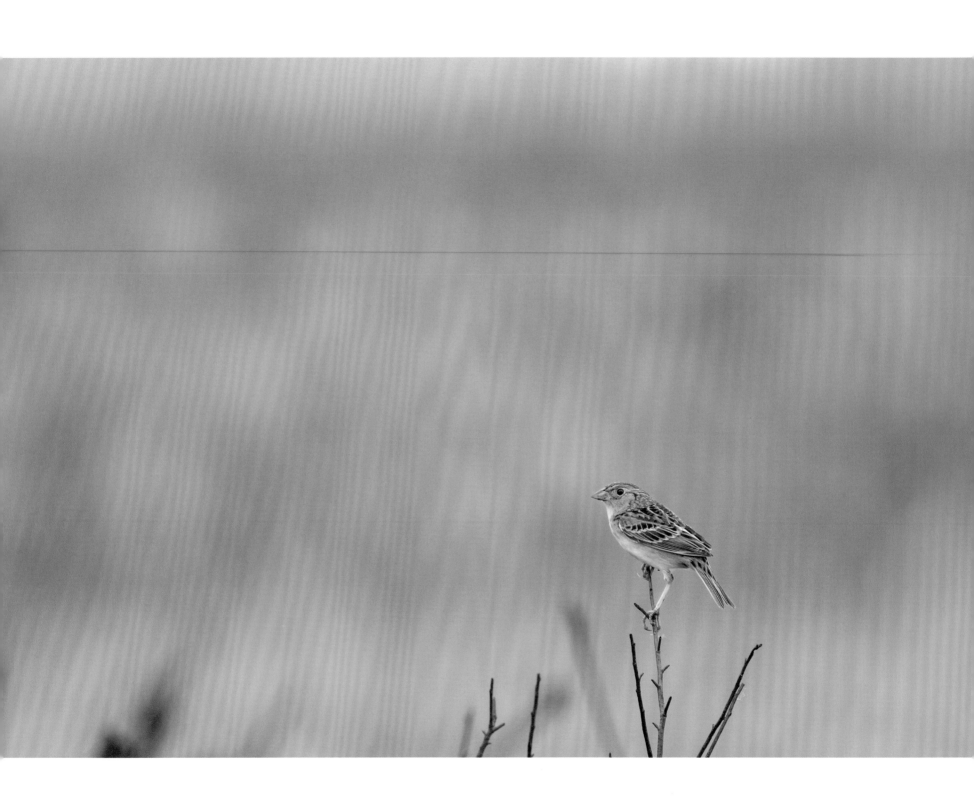

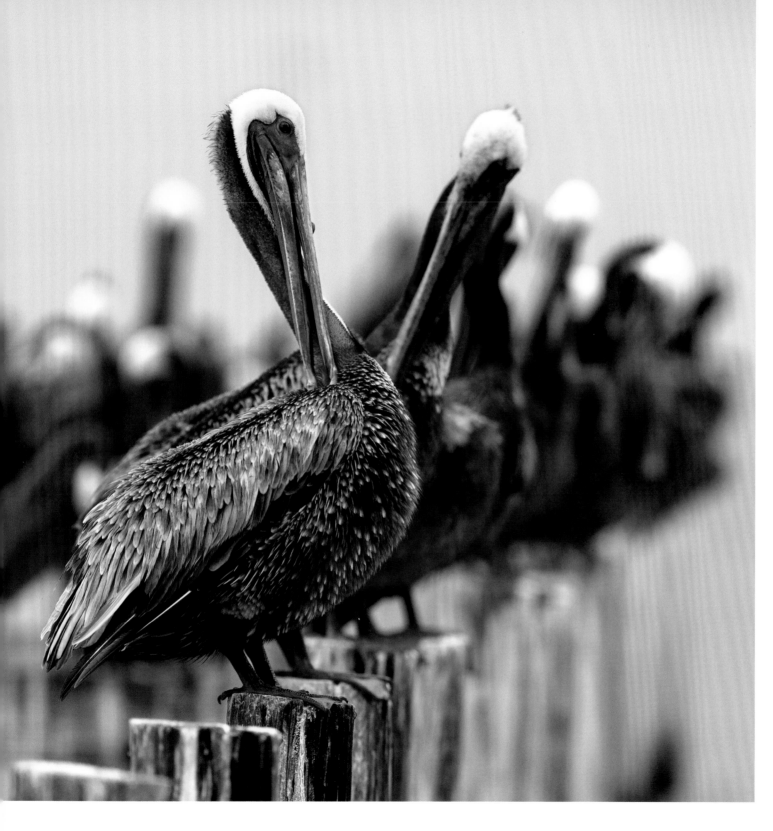

GULF OIL SPILL

Most significant environmental damage that birds alert us to occurs over many years with changes that are often too subtle to sound any alarm bells or grab mainstream attention. Other times, as was the case with the Deepwater Horizon oil spill in 2010, the damage is immediately catastrophic and cannot be ignored. The disturbing images of oil-soaked birds brought attention to much more than the individual birds affected by the spill, but it was the individuals and their suffering that touched viewers most deeply. They made us reflect on the true cost of industry's rush to extract natural resources and brought attention to a long-neglected and abused yet priceless ecosystem for both wildlife and people, the Mississippi River Delta. In the years to come, the success of restoration efforts in the Mississippi Delta may be measured by the health of the birds and other wildlife in the region.

LEFT AND OPPOSITE The state bird of Louisiana, Brown Pelicans were especially hard hit by the oil spill. Ironically, they had been removed from the endangered species list in 2009 after dwindling populations recovered from years of exposure to the pesticide DDT.

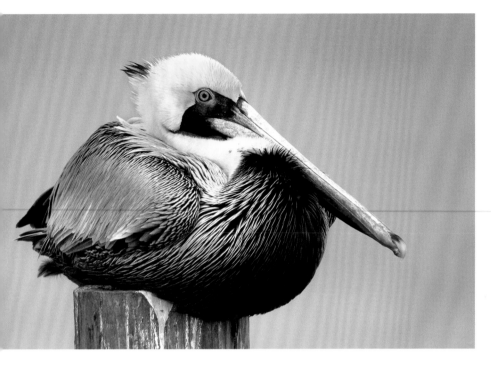
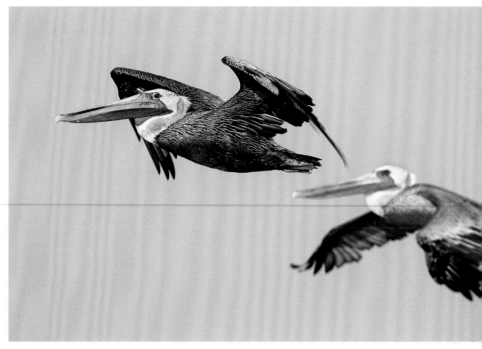
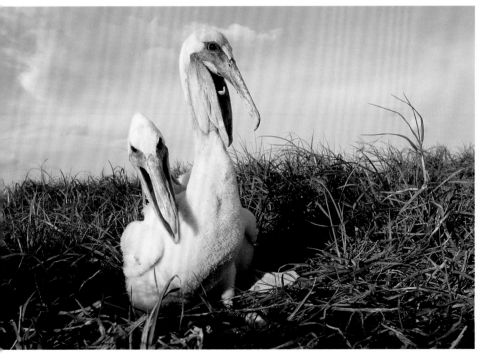
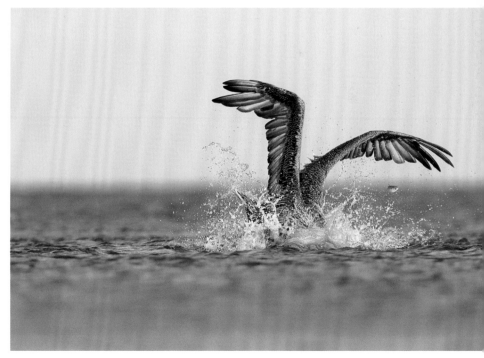

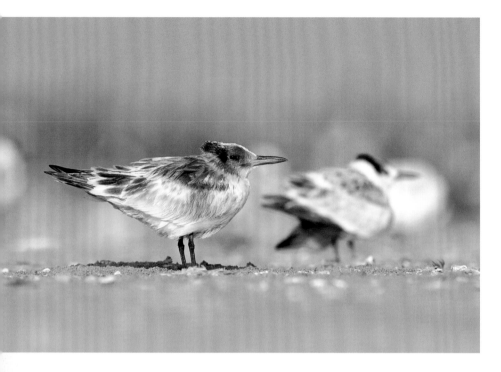

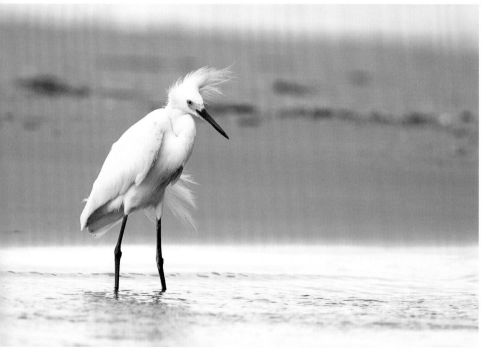

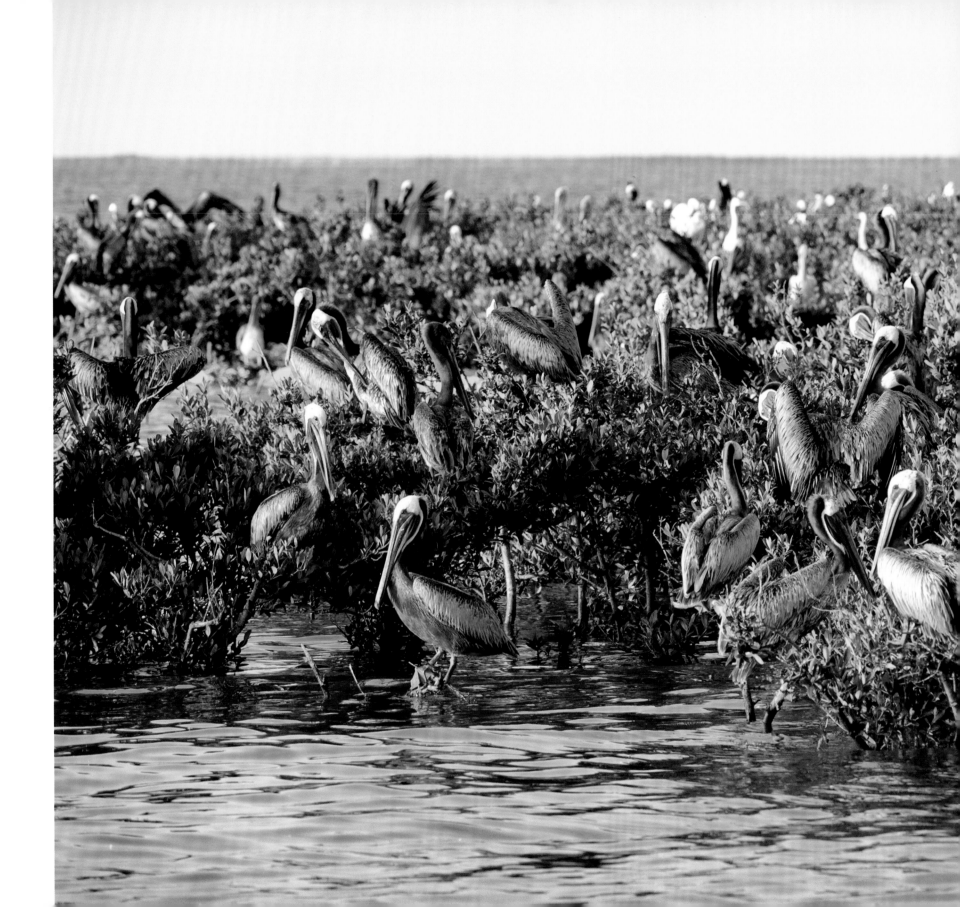

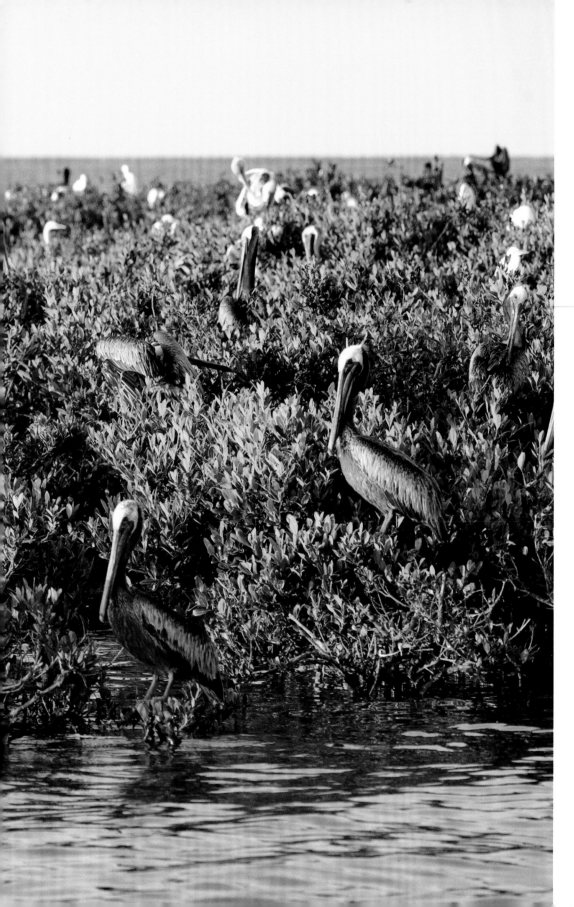

PREVIOUS PAGES, CLOCKWISE FROM TOP LEFT Sandwich Tern fledgling; Royal Tern fledgling; oiled Brown Pelican fledgling; Royal Tern chick; Snowy Egret. Bird species that feed in Gulf waters or nest on its shores were the most heavily impacted by oil from the spill. LEFT At the time of the oil spill, Cat Island in Barataria Bay was a major nesting colony for Brown Pelicans, Great Egrets, and several other bird species. Today it is almost gone. The mangroves were killed by oil from the spill and their roots, which held the island together, have decayed and allowed the island to erode into the gulf.

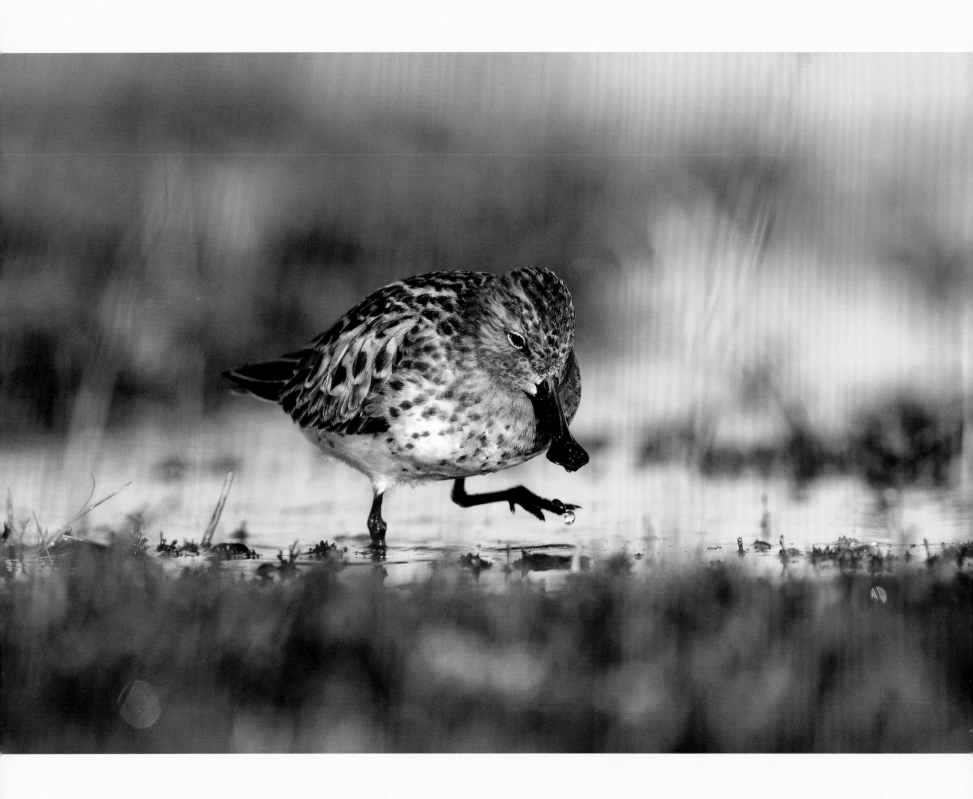

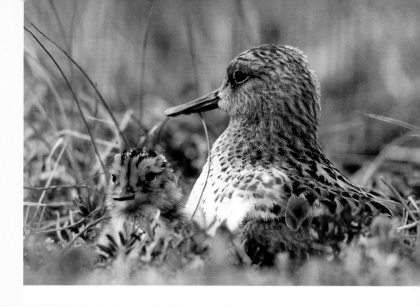

IN THE FIELD
The World's Most Imperiled Bird

Gerrit Vyn

Village of Meinypilgyno, Chukotka, Russia, July

OPPOSITE A Spoon-billed Sandpiper forages in a recently thawed tundra pond.
RIGHT, FROM TOP A hungry Spoon-billed Sandpiper chick gets ready to leave the nest hours after hatching; a Spoon-billed Sandpiper chick's best defense against predators is its cryptic plumage; the species' namesake bill is evident at birth.

THE WINDS WERE RELATIVELY CALM and the sun was shining for the first time in a week. The tundra, brown when I arrived, had greened up. Sedges, grasses, and the leaves of small willows and other ground-hugging plants had emerged from the crusty carpet of mosses and lichens. In most places the ground was covered with the dancing heads of small Arctic wildflowers.

I hiked into the rolling moraine hills, where the last of winter's snow clung to life in the draws and on the hillsides where Arctic winds left the largest deposits. Along the edges of these snow-fields is often where I could find a Spoon-billed Sandpiper, or a pair, quietly feeding on invertebrates and small seeds that the birds pick up with their remarkable spatulate bill.

The last few weeks had been quiet. The Spoon-billed Sand-piper pairs had formed, and the rhythmically repeated calls of displaying males had given way to the secretive period of egg lay-ing and incubation. I went to the hills hoping for one last chance to photograph some courtship behavior. Some nests had failed, and there was a chance that a few pairs would try again.

I had traveled to the far northeast of Russia, just across the Bering Sea from Alaska, on an assignment from the Cornell Lab of

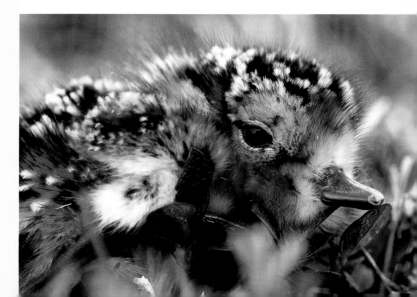

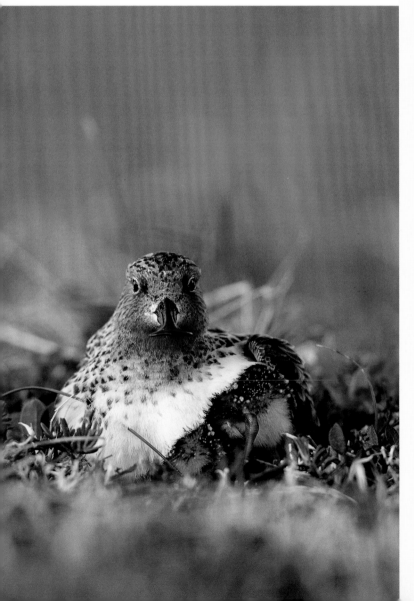

Ornithology, to document the last of these critically endangered birds on their breeding grounds. It was a difficult task—skittish, sparsely distributed birds, challenging weather and lighting conditions, and other factors contributed to more failures than successes. But that evening was the kind that makes up for all the long hours and frustrations endured on a mission like this.

Far into the hills I located a female standing motionless on the tundra beside a snowfield—her beak was tucked neatly into her russet-and-black scapulars. I saw the male too—a beautiful russet-headed bird that was intently foraging but always aware of potential predators. Whenever a gull passed in flight, he froze momentarily and cocked his head skyward. The two sandpipers were clearly bonded. The male kept a tight watch on the female, and the female followed the male in her own unhurried way.

I spent several hours watching and photographing them as they worked their way around the edge of the snowfield and up a small knoll. As they neared the top, another male in flight began giving courtship vocalizations and landed nearby. The male I'd been watching quickly took a position atop a tussock and began delivering hurried calls of his own. He stood tall, with his head craned forward and his spooned lower mandible vibrating wildly with each trilled burst. The intruder responded, but not with the vigor of the paired male, and the female's behavior showed she was well committed to her selection. She walked close to her male and with wings raised, tail cocked, and a burst of calls as he moved toward her in a bid to copulate. She avoided his advances for the time, but remained close. Perhaps she was not yet ready to expend the energy necessary to produce a second clutch. Or maybe that particular moment was just not to her liking.

As this interaction was going on, another bird appeared—a pale frosted male I recognized. He had been paired with a female that had been killed on her nest by an unknown predator. He entered the scene and gave a few spirited series of vocalizations before quickly departing. For him, the breeding year was over. The

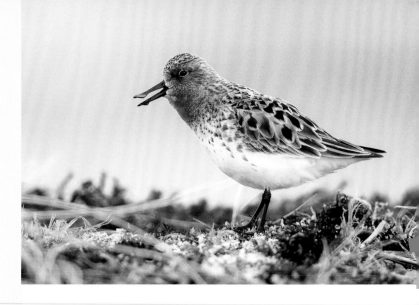

RIGHT, FROM TOP Days after arriving on the breeding grounds, a male Spoon-billed Sandpiper gives his territorial vocalizations to fend off rival males and attract females; male Spoon-billed Sandpiper in a flight display; a male pursues his mate with a precopulatory display.
FOLLOWING PAGES A Spoon-billed Sandpiper forages during migration beneath the shadow of a wind turbine along the industrialized Yellow Sea coast; a Spoon-billed Sandpiper incubates its eggs in the pristine wilderness of Chukotka.

only female available had made her selection, and there were no others to be had. Perhaps the next year, or the year after that, another young female would make her way north, and he too would have the chance to try again.

When Spoon-billed Sandpipers lift off and migrate south, they follow a flight plan etched into their DNA during the countless millennia of their evolution. Their brains direct them to specific stopover sites along their journeys, where they can rest, feed, and replenish their energy. They follow a route known collectively as the East Asian–Australasian flyway, but some of the vital waypoints along their five-thousand-mile journey aren't the same as they were one hundred or even five years ago.

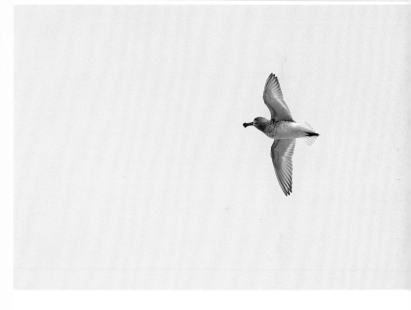

No place on its migratory pathway is more important to the Spoon-billed Sandpiper than the tidal mudflats of the Yellow Sea, but that sea's shorelines are being converted from natural intertidal habitat to rice paddies, salt pans, aquaculture, and industry. Ecological systems that wildlife and humans depend on are being eliminated at an astounding rate. An estimated 51 percent of China's and 60 percent of South Korea's coastal wetlands have already been lost, and development continues unabated. Through its devastating population crash, the tiny Spoon-billed Sandpiper is telling us that the Yellow Sea has passed the tipping point.

That evening in Chukotka, as skylarks and pipits sang overhead and the Spoon-billed Sandpiper pair drifted off among the tussocks, I reminded myself just how rare these sandpipers are and savored what I had seen. When in a place where a rare species can be readily found, it is easy to forget that it's one of the only places on earth where that is possible. Sitting in that idyllic landscape, icy peaks looming on the horizon and brown bears patrolling coastal lagoons for salmon, I found it hard to believe that we are driving this one-of-a-kind bird to extinction.

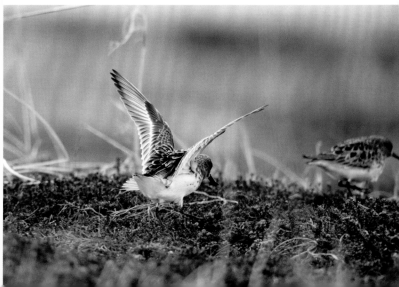

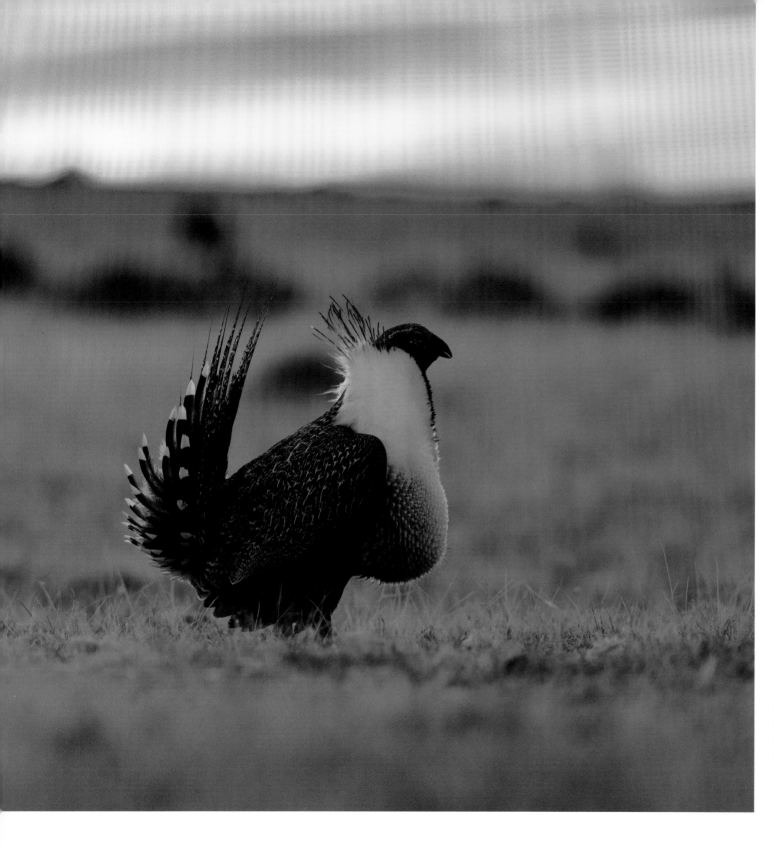

SAGEBRUSH STEPPE

America's vast western sage-brush steppe is one of our country's most romanticized and enduring landscapes. But like the seemingly endless Great Plains prairies before them, they are in danger of being degraded by human uses to a point where they can no longer sustain the unique wildlife species that have occupied them for hundreds of thousands of years.

The stark population declines of our two sage-grouse species have alerted us to the failing health of our sage country. These birds symbolize not only overall ecosystem health but also our ability to responsibly steward our public and private lands for both wildlife and people. While we can only mourn the loss of our great prairies, we have a chance with our sagebrush steppe to do things right.

LEFT A male Greater Sage-Grouse displaying at dawn.

OPPOSITE, CLOCKWISE FROM TOP LEFT
Female grouse gather around a favored male on a breeding lek; a female visits a lek to choose a mate; day-old chicks; a female sits on its nest tucked beneath sagebrush.

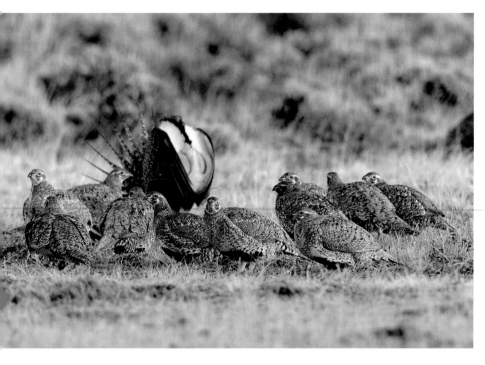

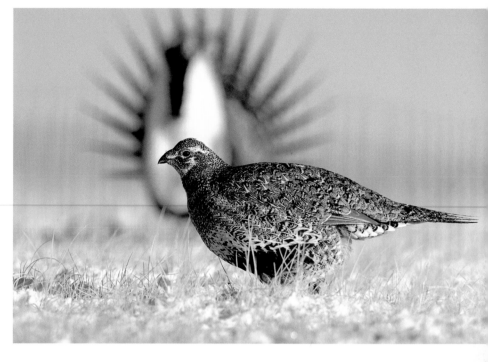

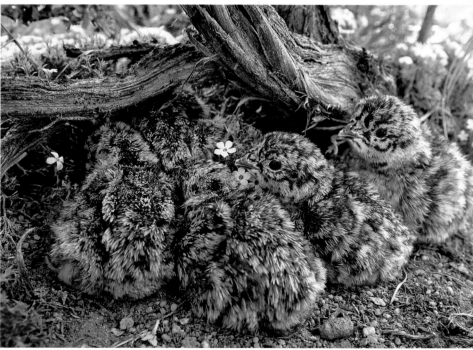

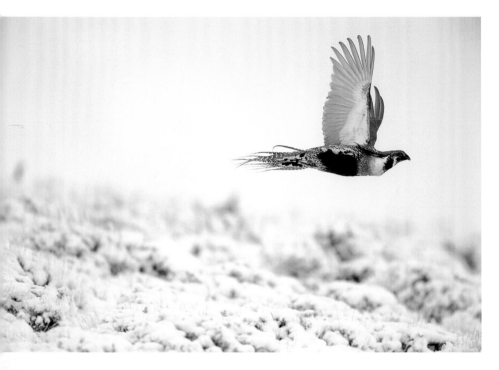

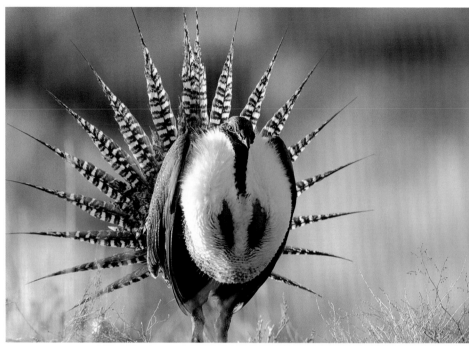

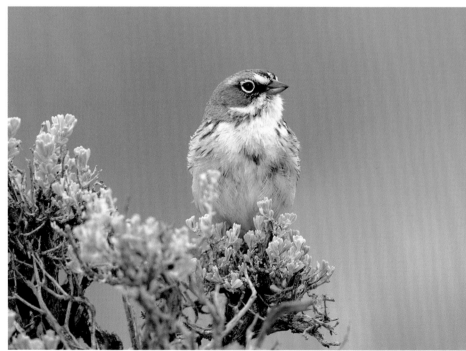

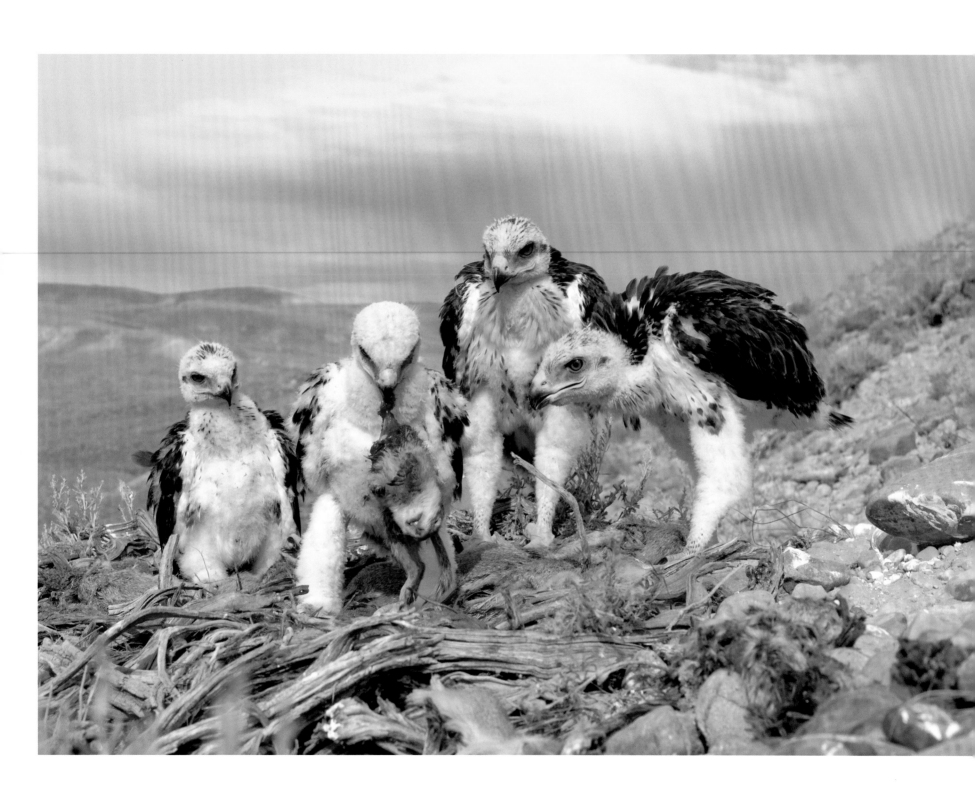

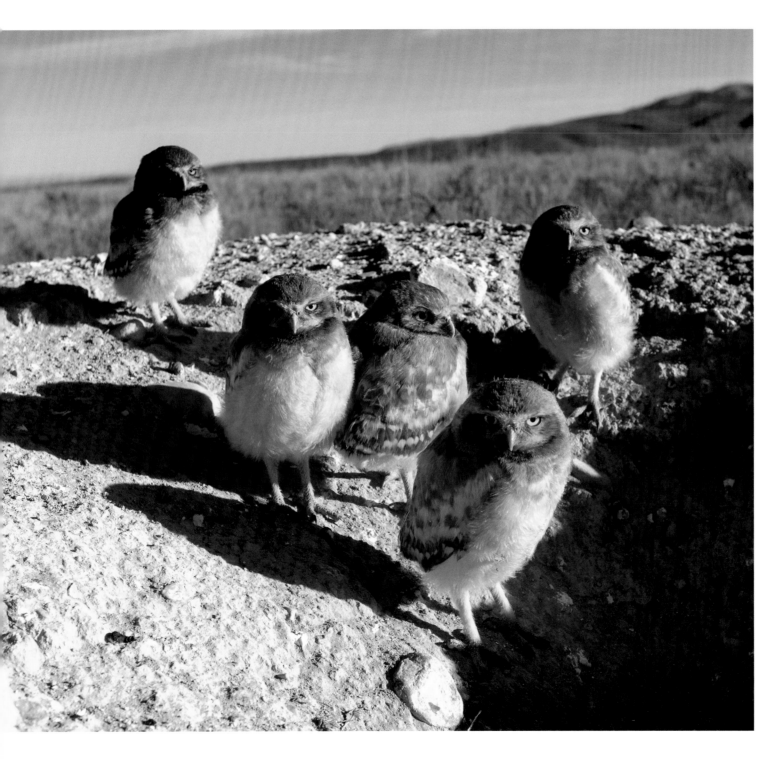

PREVIOUS PAGES, CLOCKWISE FROM TOP
LEFT A Gunnison Sage-Grouse
flies over the snow-covered
steppe; after a long wait, the
unique and imperiled Gunni-
son Sage-Grouse was listed as
a threatened species in 2014;
Ferruginous Hawk chicks eating
a white-tailed prairie dog; Sage
Sparrow; Mountain Bluebird
LEFT Burrowing Owl chicks wait
to be fed outside their nest hole, a
repurposed badger burrow.
OPPOSITE Sagebrush steppe in
southern Wyoming

PROFILE

Sara Kaiser, Researcher

EXTRACTING A BIRD from a mist net requires a delicate touch. Wings must be disentangled and twiglike legs freed from the mesh without harm—all while the creature is struggling in your hand, its heart beating so furiously the frail ribs seem about to burst.

That's when Sara Kaiser slips into her Zen state. "You have mosquitoes biting your hand. If it's a chickadee, it will be drilling on your fingers. You just have to put it all out of your head and focus," she said. "That bird's life depends on you getting it out of the net."

Kaiser mastered the skill as an undergraduate at Iowa State University, when she trapped and banded songbirds as part of a project to monitor their condition during migration. The lengths of fine mesh, strung between poles like volleyball nets, were the researchers' main method of snaring birds in flight.

Since then, Kaiser has expanded her bird research tool kit to include DNA tests, hormone assays, and cameras that spy on nests. She has also learned to farm mealworms—but more about that later.

As a PhD student and postdoc at Cornell, Kaiser progressed to complex questions about how animals cope with a shifting environment. What better subjects than migratory songbirds, with their repertoires of hardwired and learned behavior and their life histories so tightly coupled to season and place?

Kaiser wasn't always drawn to ornithology, though. When she first studied animal behavior at Iowa State, she was frustrated that the professor spent so much time on birds. Only after a summer class forced her to spend time listening to the dawn chorus and watching birds interact with each other did Kaiser

change her mind. "Birds are everywhere and they have all of these fascinating behaviors," she said. "I knew then that this was what I wanted to study."

In her suburban hometown of Waterloo, Iowa, Kaiser was the kid who tailed her dog like a detective. She scrutinized the way it sniffed and barked and greeted other canines for clues to what was going on in its head. Not dissimilarly, her first graduate research project found her lugging a ladder through the woods of southwest Michigan to peer into Wood Thrush nests. She counted the tiny blue eggs and measured the growth of nestlings to gauge the effects of forest fragmentation.

But Kaiser was ambivalent about academia, and so after earning a master's degree in zoology at Michigan State University, she opted for real-world experience. She joined the Institute for Wildlife Studies in California, where she was in charge of efforts to ensure the survival of the San Clemente Bell's Sparrow, an unprepossessing little bird that happens to live exclusively on an island the US Navy uses for target practice and commando training.

Kaiser quickly realized that the story was more nuanced than military vs. wildlife. In fact, the navy's eradication of nonnative goats that ravaged the island's vegetation helped preserve the boxthorns where the sparrows nest. Sitting around a table with military officers, federal biologists, and environmentalists, Kaiser learned to appreciate different perspectives and understand what it takes to make conservation projects work on the ground.

She was also able to explore the connections between animals and their environments that had always fascinated her. By analyzing precipitation and El Niño cycles, Kaiser discovered that nothing affects the birds more profoundly than water. In drought years, most pairs don't breed at all. But when winter rain is plentiful, nesting pairs can raise five broods in a single season.

That work rekindled Kaiser's desire to ask big questions, which led her back to academia and to Cornell, where she received her doctorate in behavioral ecology. Cornell was intimidating at first,

but Kaiser quickly felt at home. "The Lab of Ornithology is such an inspirational place to work. You just walk down the hall and bump into incredible people."

She decided to focus on climate change and how birds might respond to shifts in their food sources. That's where the mealworms came in.

Kaiser planned to run experiments in a well-studied ecosystem in the White Mountains of New Hampshire. She would supplement some Black-throated Blue Warblers' diets with the nutritious worms and see how food availability affected behavior—particularly the propensity of males to engage in what scientists drily refer to as "extra-pair copulation." When an outbreak of mites decimated the national supply of mealworms, Kaiser learned to grow her own.

The results of the experiment weren't what she expected. Kaiser thought the well-fed birds would fool around more often, but it turned out that abundance fostered fidelity. It was when times were hard that the birds' eyes wandered most.

Surprises like that show how complex birds are, and that gives Kaiser hope for the future. Against the odds, the San Clemente Bell's Sparrows she studied in California seem to be holding their own. The Black-throated Blue Warblers in the White Mountains show remarkable adaptability to fluctuations in their food supply.

Not all birds have that flexibility, Kaiser said. Some species will surely be lost when change overwhelms their ability to adapt. "But if the changes are gradual enough, it appears many species will be able to track those changes pretty well," she said. "I'm optimistic about the future of birds."

RIGHT A male Black-throated Blue Warbler

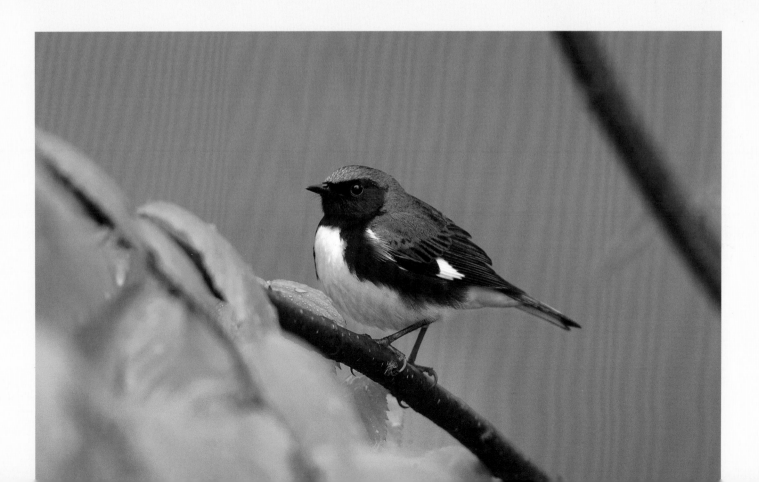

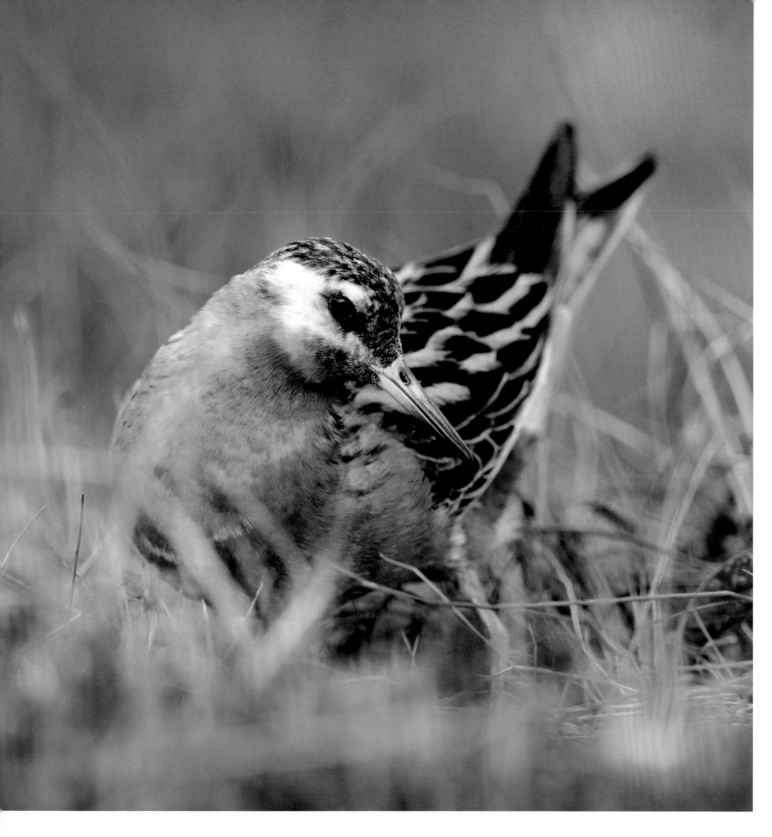

YUKON DELTA

Previous generations of Americans have left us a great legacy of protected natural areas in the form of national parks, forests, and wildlife refuges. At over 19 million acres, the Yukon Delta National Wildlife Refuge in western Alaska is one of the largest, and its vast low-lying wetlands host one of the largest and most productive breeding assemblages of migratory water birds in the world.

Today we face a far greater challenge than protecting the land itself. Our changing climate is beginning to disrupt landscapes once considered static and will cause abrupt changes to even the most remote corners of our planet if we fail to act. Even the pristine Yukon–Kuskokwim Delta will be affected. Sea level rise, increased storm surges, and the melting of permafrost could radically alter the majority of the Delta's wetlands, making them unsuitable for the millions of shorebirds and waterfowl that nest there.

LEFT A male Red Phalarope
OPPOSITE An Emperor Goose in defensive posture at its nest

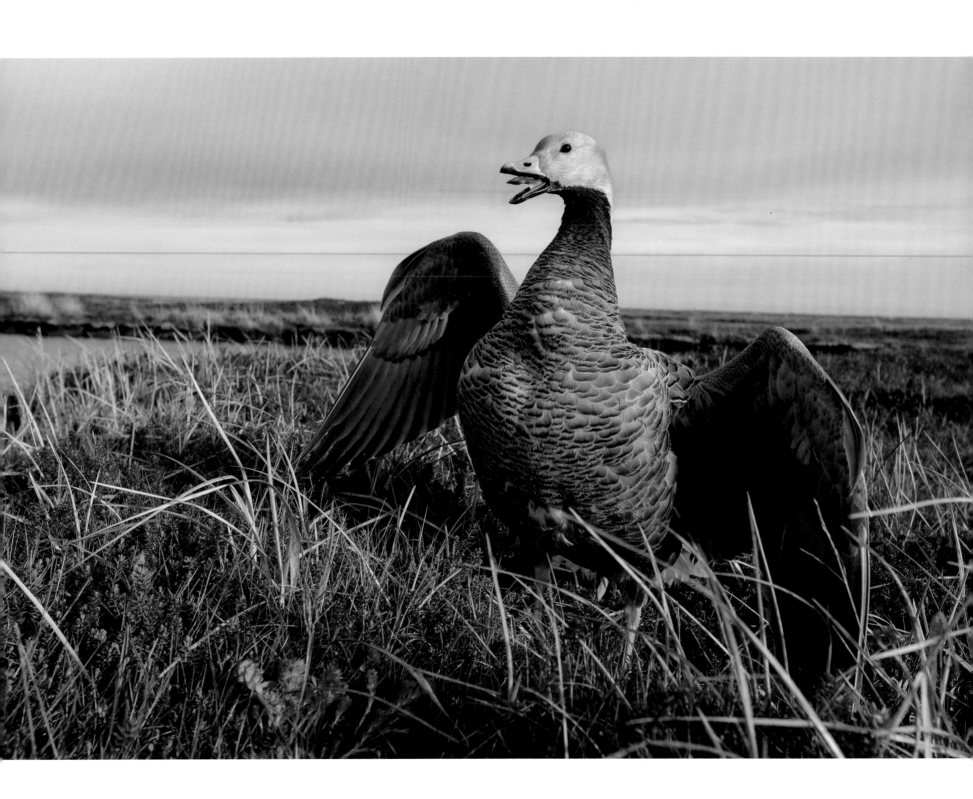

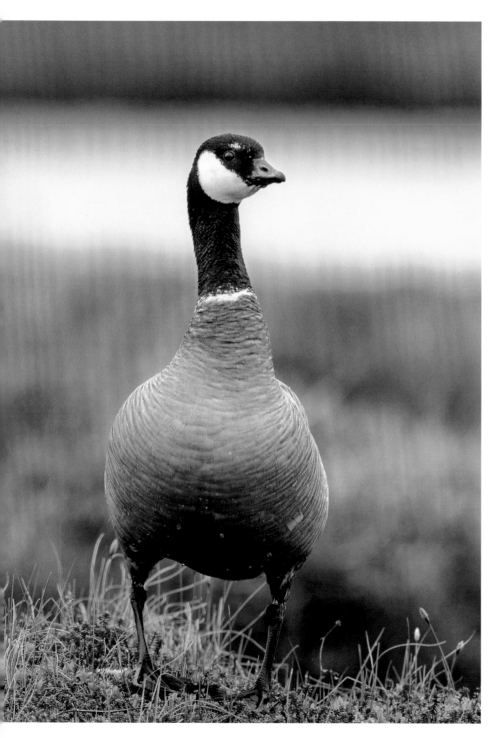

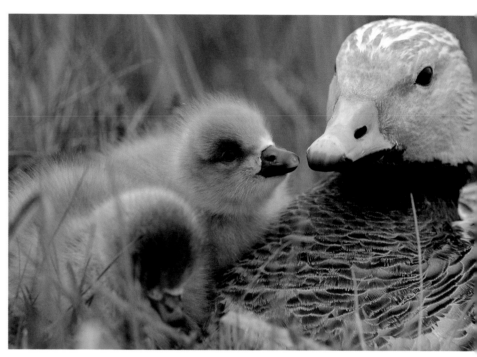

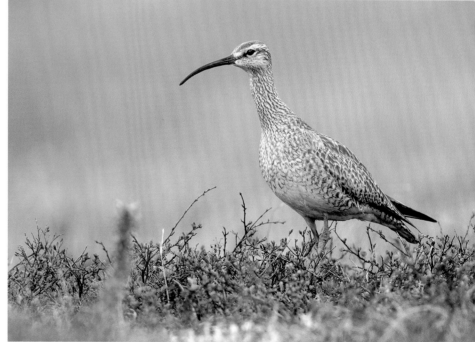

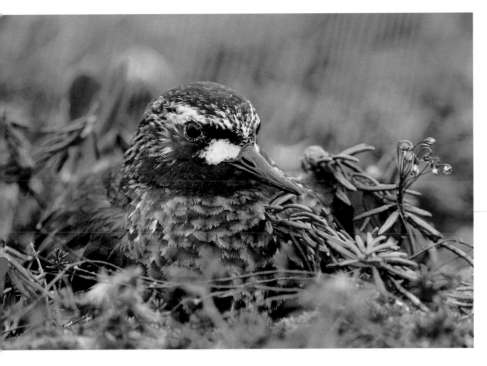

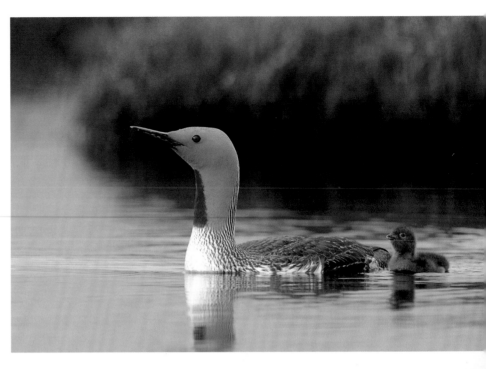

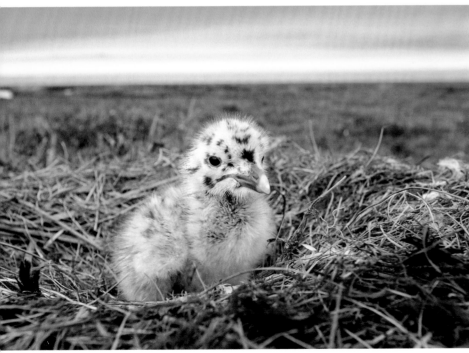

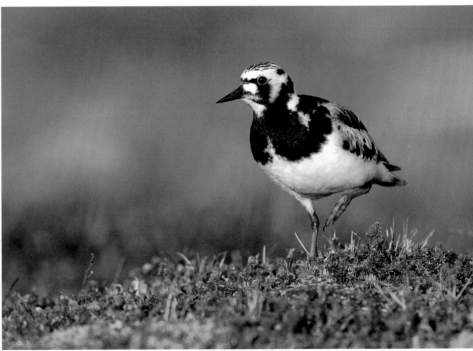

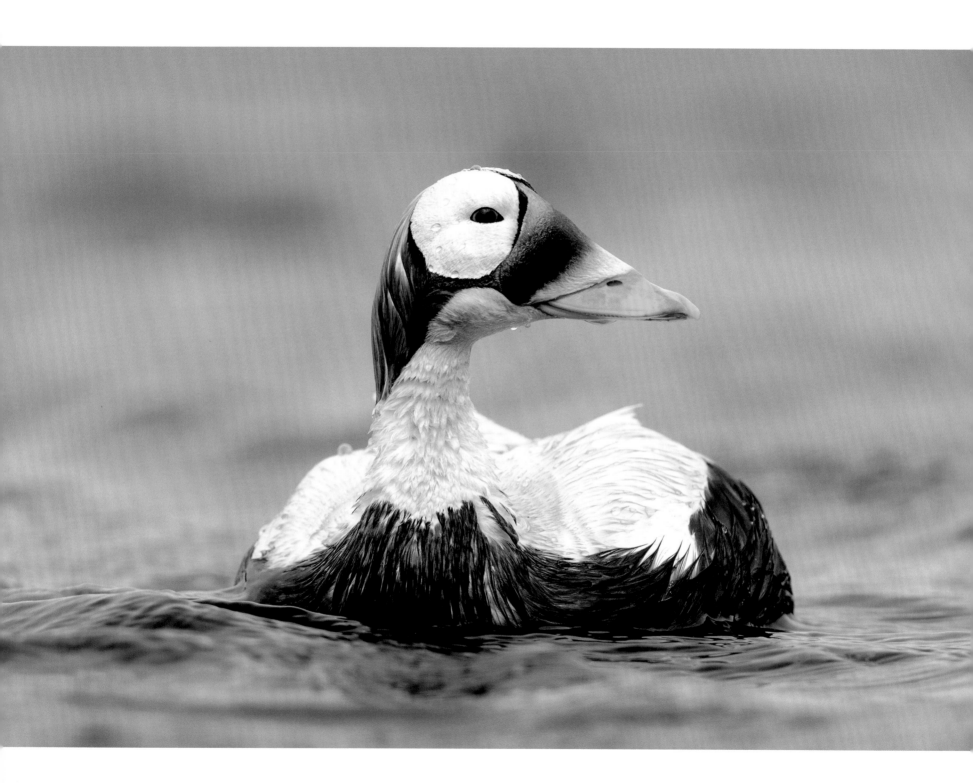

PREVIOUS PAGES, CLOCKWISE FROM
FAR LEFT Cackling Goose; Emperor
Goose adult and chicks; Black
Turnstone; Red-throated Loon;
Ruddy Turnstone; Glaucous Gull
chick; Whimbrel
OPPOSITE Spectacled Eider male
RIGHT Spectacled Eider female
FOLLOWING PAGES Red-throated
Loon chick; camouflaged Red
Phalarope on nest

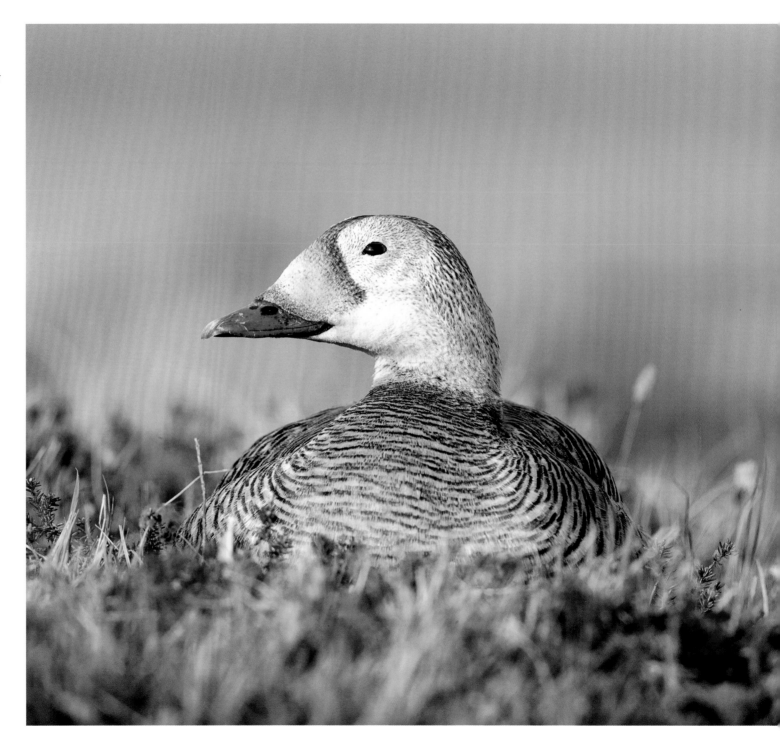

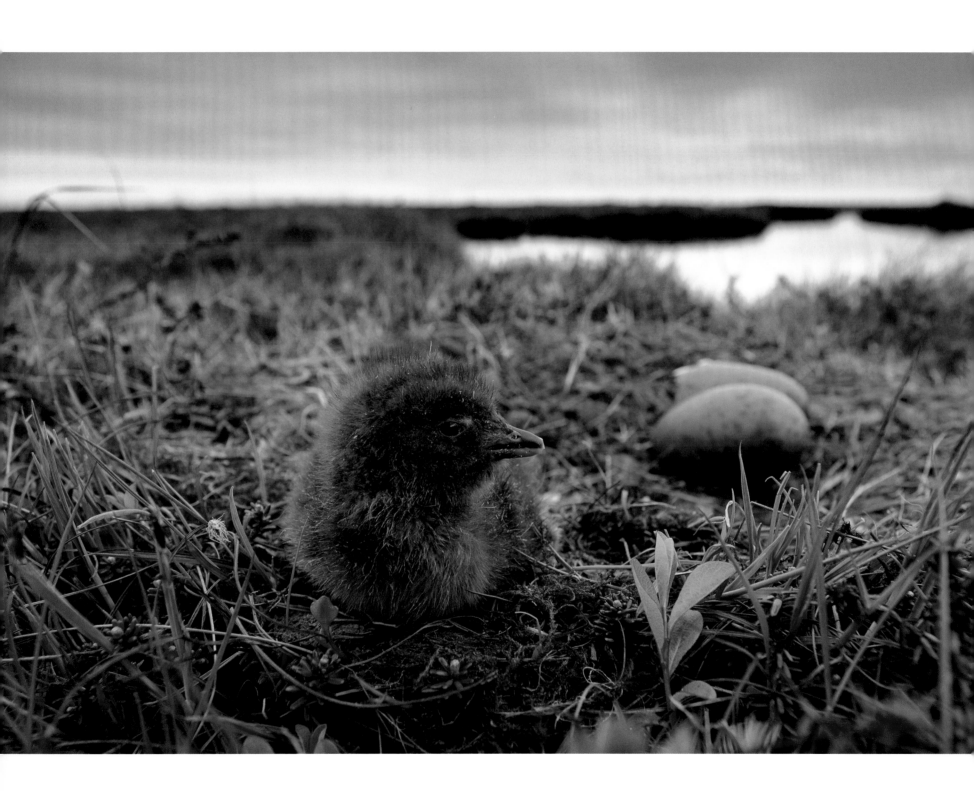

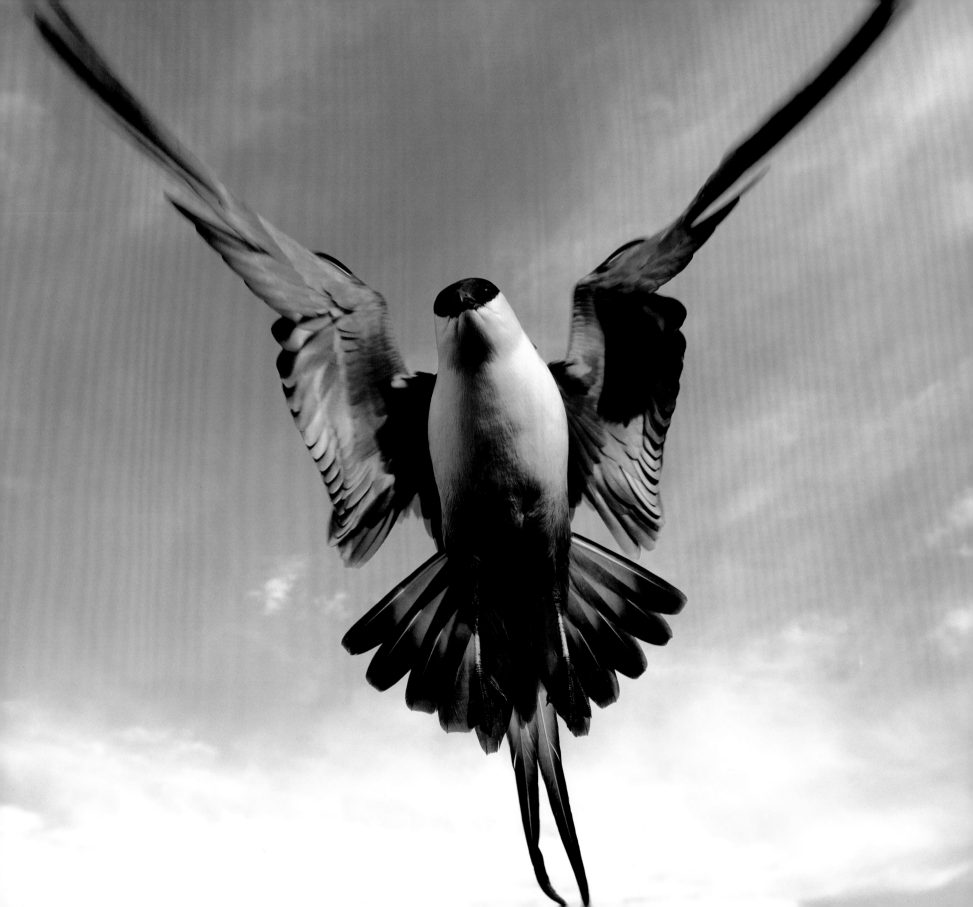

THE COMING DECADES

Jared Diamond

LIKE MANY BIRD-WATCHERS, I got hooked on birds as a child—in my case, at age seven. I looked out the window of my parents' house in a Boston suburb, saw a flock of small brown birds on the lawn, and spontaneously felt a need to identify them. That need arose from somewhere inside my psyche rather than from any model: neither my parents nor anyone else I knew were bird-watchers. I persuaded my parents to buy me a bird book: the classic Forbush and May *Birds of Massachusetts and Other New England States*. While hardly a field guide, it sufficed to convince me that the birds on my lawn were Chipping Sparrows, a "good" species for Boston suburbs.

Alas, a little more observation made clear that my birds were not that "good" species, but instead the ultimate "rubbish" species: House Sparrows. By then, though, I was already hooked on birds. I've stayed hooked ever since. I have to restrain myself from identifying birds at inappropriate moments. For example, my wife and I got married in our garden in August, a good bird-watching month. As we strode hand in hand before our guests toward the far end

of the garden where we would say our vows, birds were around that I reflexively continued to identify. The last bird that I identified before saying my vows was a Bushtit. At that point, I pulled myself together and said to myself, "Jared, you're about to get married: pay attention to the experience, not to the birds!"

Why do so many people spontaneously become interested in birds, as did I? Why are there more bird-watchers than watchers of mice or of any other group of animals? Perhaps it's because different animals depend on different senses to perceive the world. Birds perceive the world, and signal each other, through the same senses on which we humans depend: sight and sound. As a result, birds are easy for us to perceive, identify, monitor, and understand; they operate as we do. In contrast, mice depend heavily on smell, and on touch detected by their whiskers, both of minor importance to humans. Other animals variously depend on vibrations, electric fields, and other sensory modalities foreign to us. We can't relate to mice, spiders, and electric field–sensor eels in the ways that we can relate to birds.

Those facts help explain why, while some of my friends share my passion for bird-watching, others—in most respects equally intelligent, nice, perceptive people—didn't become bird-watchers. To be a bird-watcher, it helps to be like birds: to have eyes alert to small moving objects, to be quick moving oneself, to have a good sense of color, to be musical, to like to wake up around sunrise, and to not be nearsighted. My herpetological friends tend instead to be unmusical, slow moving, and reluctant to get out of bed until long after sunrise. My bat-loving friends tend to like to stay up at night.

But that doesn't mean that you have to resign yourself to a birdless existence if you happen to have been born without the sensory equipment and diurnal rhythm of the typical bird-watcher. One biologist friend of mine who is color-blind and unmusical just assumed that he was thereby condemned to have to devote himself to some other animal group, in his case insects. His epiphany didn't come until the age of fifty, when he and I were walking together without binoculars and a wren flitted past. I immediately identified it by its size, posture, flight, and buzzy call. That proved to my friend that birds offer many identification clues besides those of color and song music. He repented of his previously wasted life, threw himself into bird-watching, now teaches his university's ornithology course, has published several bird books, became an avid bird lister, and designs his international travel schedule around opportunities to add species to his life list.

The match between our sensory capabilities and those of birds explains not only the proliferation of bird-watchers but also the proliferation of scientific studies of birds. Advances in virtually every area of field biology—including evolutionary biology, ecology, biogeography, behavior, sociobiology, reproductive biology, molecular taxonomy, conservation biology, responses to climate change, and responses to habitat disturbance—have depended disproportionately on avian examples. Just to mention the most famous cases: the Galapagos Finches gave Darwin his crucial insights into evolution; barbet and honeyeater distributions in the Malay Archipelago gave Alfred Russel Wallace his crucial insights into biogeography; geese and gulls gave Konrad Lorenz and Nikolaas Tinbergen their crucial insights into animal behavior; and five species of parulid warblers gave Robert MacArthur his crucial insights into quantitative ecology.

The same reasons that draw modern bird-watchers and modern scientists to birds already operated to draw traditional peoples to birds in the past. Every tribe of the New Guineans among whom I've been doing ornithological field work for the last fifty years possesses detailed knowledge of their local bird species, which they name individually in their local language. Hence whenever I come into a new area of New Guinea, I begin by gathering those bird names from the local people: hundreds of names for individual species of birds, as well as of rats, spiders, trees, and other animals and plants. Once I've learned those local-language names, I can tap into the encyclopedic knowledge of natural history possessed by New Guineans. I won't get answers if I pose questions using English or Latin bird names: my New Guinea friends don't know about the Common Smoky Honeyeater or *Machaerirhynchus flaviventer*. But if I ask them instead about the *isawanotába* or *tiyó,* they'll respond with masses of valuable information, much of it unknown to Western scientists.

For example, until recently we Western scientists knew many cases of poisonous butterfly and fish species, but no well-analyzed case of a poisonous bird species. That was until an American ornithologist named Jack Dumbacher was doing a study in New Guinea forests that involved catching live birds in nets. One of the birds (a Hooded Pitohui) that

OPPOSITE The striking male Blackburnian Warbler is an insectivorous bird of the forest canopy whether on its breeding grounds, in a boreal spruce forest or on its wintering grounds in northern South America. To conserve birds we must protect the habitats they rely on throughout their yearly cycle.

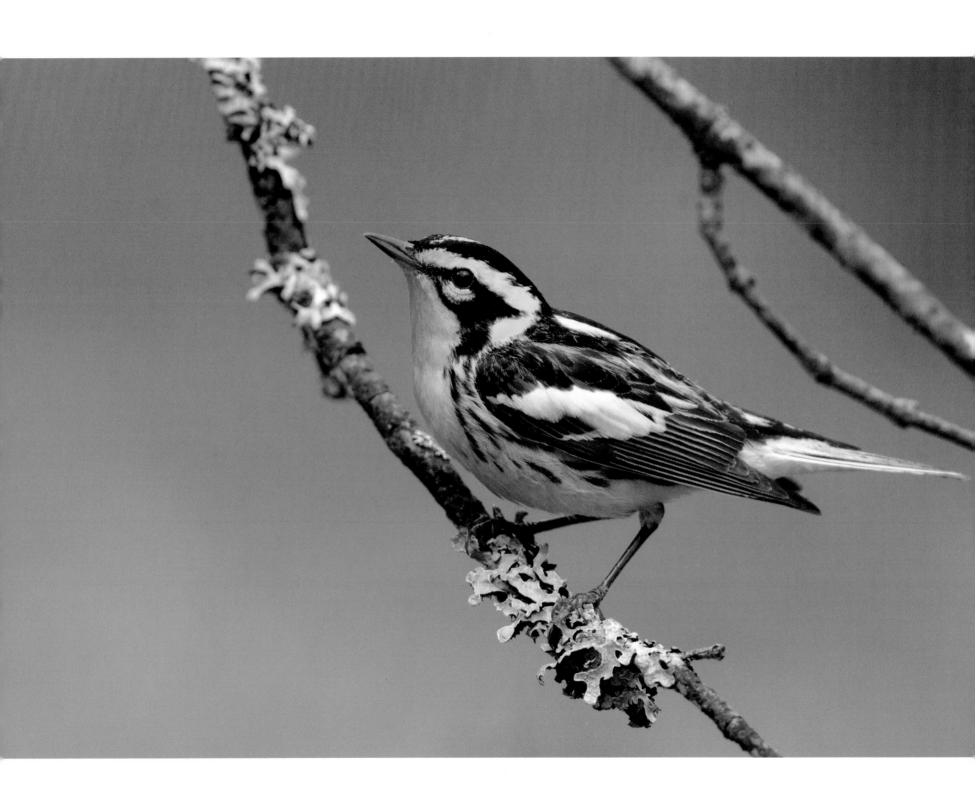

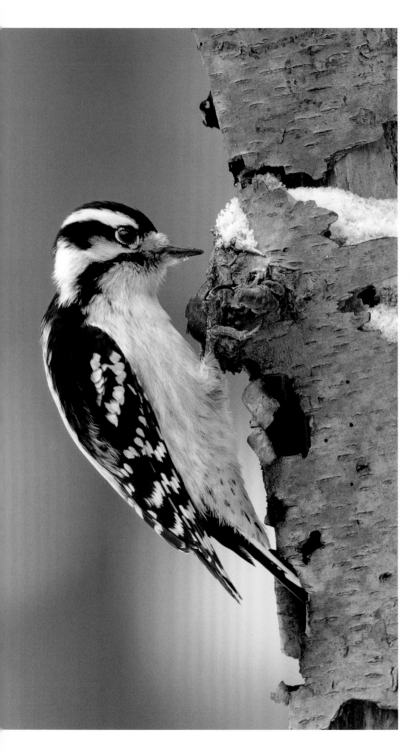

he removed from a net scratched one of his hands, causing that hand to bleed. Because Jack's other hand was occupied with holding another bird, he removed the blood from his injured hand by licking it off with his tongue. Within a short time, his mouth began burning, then went numb, and he realized that he had been poisoned, which he confirmed by licking one of the bird's feathers. When he told his New Guinea field associates what was happening, their reaction was, in effect: "Of course! Don't you know that Hooded Pitohuis are poisonous? We realized that Europeans are ignorant, but how can one be *that* ignorant?!"

Jack's "discovery" of a fact well known to New Guineans led to a series of other remarkable discoveries. The pitohuis' poison turned out to be a chemical previously known only in South American poison dart frogs, thereby providing a notable case of convergent evolution. Poisonous pitohuis associate in mixed-species flocks with nonpoisonous bird species that mimic pitohuis in plumage and voice, reminiscent of the intensively studied mimicry complexes of poisonous and nonpoisonous butterflies.

Before Jack's report, any claim by a New Guinean that a bird species was poisonous would have been greeted with skepticism by scientists. Now, I'm reminded of other strange properties of particular bird species that New Guinea friends have described to me. They insist that the *yása* (Papuan Frogmouth, or *Podargus papuensis*) often feeds by sitting with its mouth wide open and secreting onto its palate a sticky smelly substance that attracts and traps insects. They also insist that both the *óa* (Red-legged Brushturkey, or *Talegalla jobiensis*) and the *píni* (Greater Black Coucal, or *Centropus menbeki*) are avoided by hunters and predators because their flesh begins to rot and stink so quickly after the bird is killed. These reports, if true, would be very surprising—but no more surprising than was the report of a poisonous bird.

LEFT The Downy Woodpecker, our smallest and most widely distributed woodpecker species and a familiar backyard bird, thrives across many habitat types including those altered by humans.

OPPOSITE The mysterious Gray-headed Chickadee is virtually unstudied in North America and perhaps our continent's hardest-to-find resident bird species.

What do the coming decades hold for the birds of New Guinea, of North America, and of the whole world? Birds are now under threat for some of the same reasons that human civilization is now under threat, such as climate change. Birds are also now under threat for additional reasons that affect birds more directly than they affect human civilization, such as habitat destruction and introduced pest species. It has been years since I saw a quail or a mockingbird in my garden in Los Angeles, although they were to be seen daily when I bought my house a few decades ago. The current pace of change in the world is so rapid that, under any plausible scenario, a significant fraction of the world's bird species will be endangered or extinct by the time that my children (born in 1987) reach retirement age.

The state of the world in the year 2057, and what will happen after 2057, depends on what we humans do today and in the near future. By 2057, it will have become clear whether we succeeded in switching in time to a sustainable economy, or whether we continued on our current dead-end trajectory. In a worst-case scenario, some bird species and some peoples will survive much better than others. Open-country bird species will survive better than rain forest–interior bird species. New Guinea traditional societies will survive better than high-tech Western societies, because New Guineans will have much more recent experience of stone tools, subsistence farming, and subsistence hunting and gathering than will modern Americans.

But in a best-case scenario, most bird species, and high-tech Western societies, will still be around in 2057. In that case, if my great-grandchildren get turned on to birds by sighting some "rubbish" species as was I, there will be plenty of "good" bird species left to excite, delight, inspire, and teach them and their generation. We don't need any new technologies to solve our problems. We "just" need the

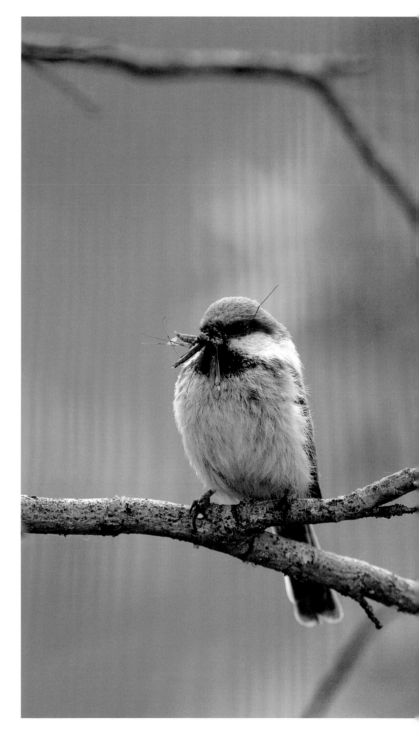

political will required to adopt the features of a sustainable economy that are already widely known and discussed. That will be good for both the birds and for us.

RIGHT Conservation of migratory stopover habitat is critical if birds like this three-month-old Arctic-born Sanderling are to reach their wintering grounds thousands of miles away.

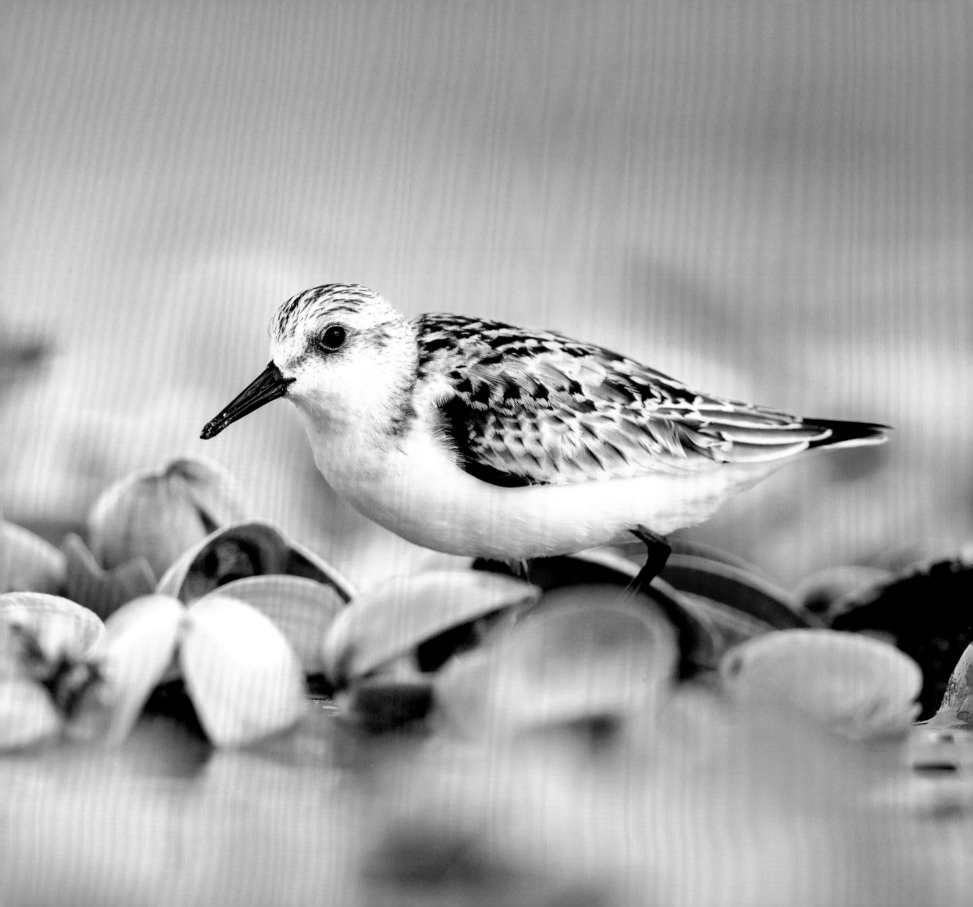

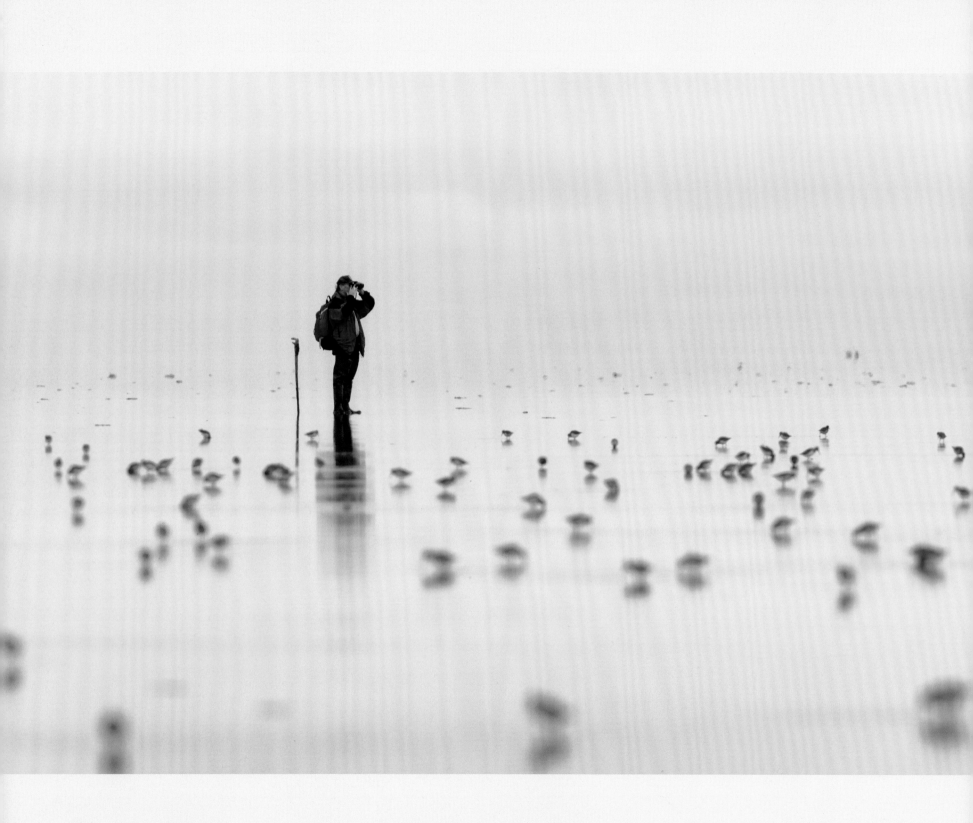

The Future of Birds Is in Our Hands

THE FUTURE OF BIRD POPULATIONS everywhere depends on our willingness to protect natural places and ecosystems, both large and small. Birds are remarkably resilient creatures. On every continent today they display their capacity to rebound quickly—provided we humans restore the conditions they require. It is up to each of us to accept this conservation challenge.

True, many conservation opportunities can be complex, requiring coordinated action through community organizations, public agencies, research teams, land management specialists, not-for-profit groups, educational programs, fund-raising efforts, and even political initiatives. But not all bird conservation requires massive effort. Individual citizens can contribute in many ways.

CREATE A BACKYARD SANCTUARY

Every piece of outdoor space, from city parks and suburban backyards to rural farmlands and working forests, can serve as habitat that sustains birds. The required elements are simple: shelter, food, water. Varied habitat is key, so pesticide-free gardens interspersed with open space, dense shrubs, and trees of different species and heights serve both year-round residents and migrants. Bird baths and small ponds, especially if located near protective shrubbery, work wonders.

Just as healthy forests are filled with dead and dying trunks and limbs, dead wood in yards of any size is attractive to many bird species. Essential for woodpeckers, it also provides impor-tant foraging habitat for songbirds, homes for cavity-nesting birds, and key perches for raptors, shrikes, and flycatchers.

Because cats will instinctively attack birds (in the United States alone, about 2.4 billion birds are killed annually by house cats), we should make "cats indoors" a year-round rule, and pro-hibit feral cat colonies.

BECOME A CITIZEN SCIENTIST

Monitoring bird populations provides essential data. But how can we possibly monitor every species, habitat preserve, and import-ant bird area in a way that contributes usefully to conservation? Enter the citizen scientist. Bird-watchers have led the way, and monitoring projects involving volunteers are carried out all over the world. Legions of enthusiasts contribute crucial information of direct relevance to bird conservation while having fun and enriching their lives at the same time. Data-intensive citizen science projects such as eBird yield fine-scale modeling of bird distributions and movements. Contributing your backyard obser-vations to any citizen-science project that connects to a globally available database is an easy (and addictive) way to contribute to bird conservation.

ADOPT A PLACE

Sustaining bird populations and biodiversity in perpetuity requires that, as stewards of the world's species and natural systems, we adopt a "land ethic." In the words of Aldo Leopold, having a land ethic "enlarges the boundaries of the community to include soils, waters, plants, and animals, or collectively, the land."

You can express such a land ethic by personally committing time and attention to a local park, school yard, recreation area, commercial woodlot, beachfront dune, or grounds of a corporate headquarters. Do a bird census at regular intervals through the year to supply key information on how the place you've chosen is

faring. Alternatively, get involved with a broader land ethic: BirdLife International has identified thousands of "important bird areas" (IBA) that play huge roles in protecting birds around the world, while in the United States the National Audubon Society does the same. Private individuals contribute enormously to conservation of these IBAs by taking a special interest in them and investing time, energy, and resources to their protection and monitoring.

PRACTICE VIGILANCE, ACTIVISM, AND ADVOCACY

You have great power to promote bird conservation by exercising vigilance, by noticing and reporting violations of wetlands or endangered species laws, and by acting to pass public referendums that support open-space conservation. You can also advocate for birds by supporting efforts to prohibit the less obvious, but still pervasive dangers, such as lead in bullets and fishing gear, and anticoagulant rodent poisons, both of which poison raptors and other birds.

MAKE THOUGHTFUL CONSUMER CHOICES

You can promote conservation through your choice of "bird friendly" products. In Central and South America, for example, millions of migratory birds depend on shade-grown coffee plantations for their wintering habitat. Certification programs for coffee and other products include both environmental and social standards, allowing individual consumers to vote for conservation through their pocketbooks.

PROMOTE ENVIRONMENTAL EDUCATION

Participating in local environmental education helps broaden the community of people who grasp the importance of conserving birds and biodiversity. Humans are more likely to protect what they understand and love, so hands-on experience with nature centers, environmental media, natural history museums, and classroom curricula are ever more crucial in this digital age.

Conservation will endure only if each generation contributes. The singular thrill of seeing a beautiful bird or witnessing an amazing display through binoculars can open a child's mind to a lifelong appreciation of diversity and beauty in nature.

SUPPORT CONSERVATION ORGANIZATIONS

Hundreds of nonprofit conservation organizations play vital roles all around the world. These organizations are on the front lines of conservation, achieving land acquisition, conservation easements, scientific research, public outreach, environmental education, environmental advocacy, and even crucial environmental litigation. Most are staffed by passionate, hard-working individuals, overseen by volunteer boards whose members contribute through a combination of wealth, work, or wisdom. From the smallest local land trust to the largest globally focused international organization, the mainstay for these vital groups is charitable giving from private individuals. Find a few that you like and make donations to support their ongoing work.

NEVER GIVE UP

The Dodo, Great Auk, Carolina Parakeet, Passenger Pigeon, and other birds stand as sobering testimony to the nature of our mistakes, and to the permanence of extinction. Around the world, however, dozens of success stories prove that we *can* bring species back from the very brink of extinction, as long as we value them enough and keep improving on our behavior as managers of the earth. We have unprecedented capacity to repair damaged ecosystems, and the ability to predict the ecological consequences of our actions. Instantaneous global communication gives us the chance to influence new generations of humans in every culture, our next managers of the earth. We must not be bogged down by fear of failure. Conservation is vital work for all of us who live on this planet. Happily, enjoying and learning from birds will always be part of the process.

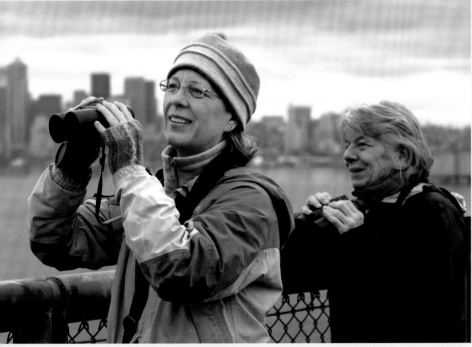

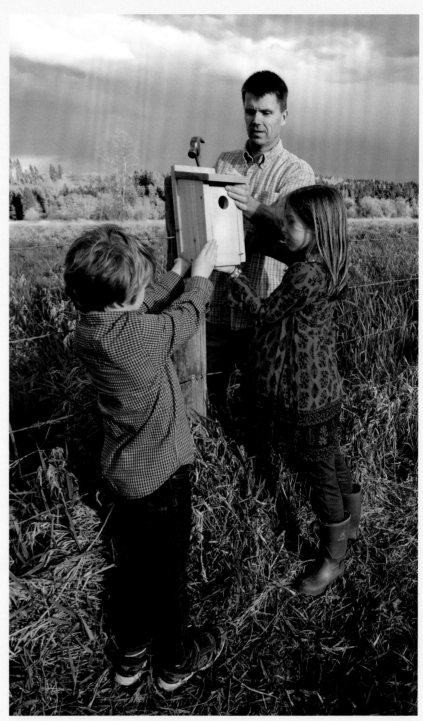

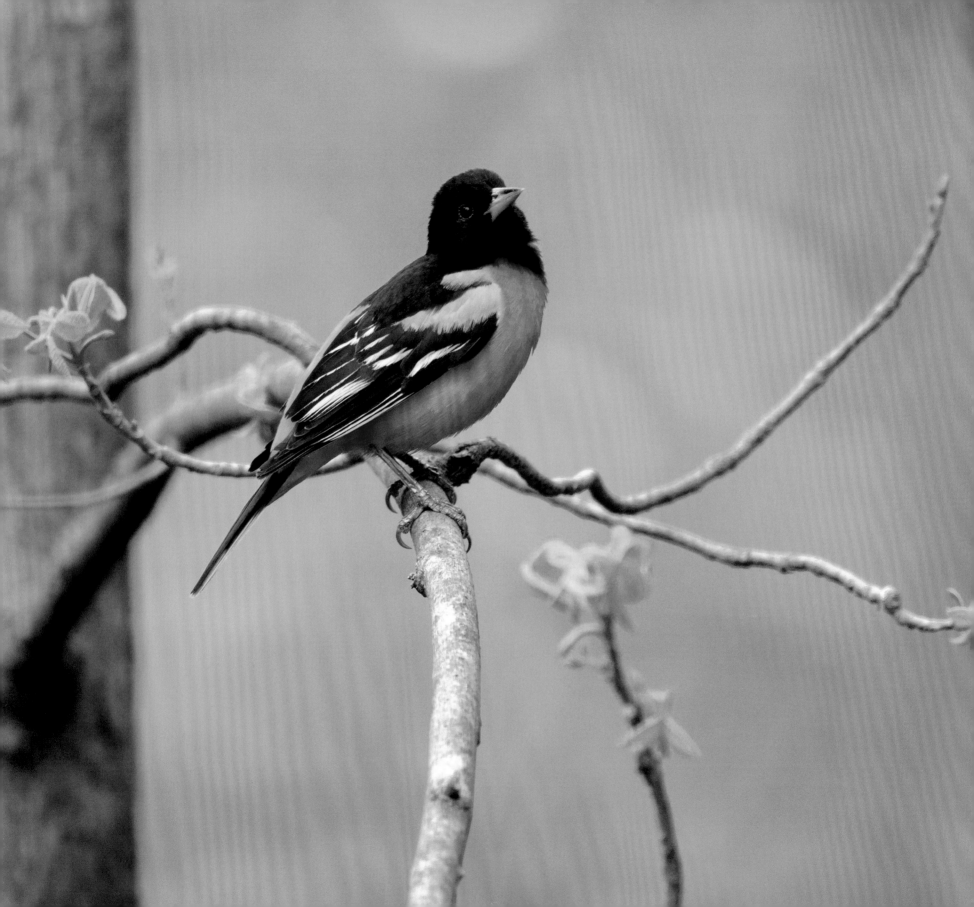

About the Cornell Lab of Ornithology

Miyoko Chu

IN 1915, CORNELL UNIVERSITY hired the nation's first professor of ornithology, Arthur "Doc" Allen, and set aside office space in the entomology department's attic for his "Laboratory of Ornithology." From this modest beginning, the Cornell Lab of Ornithology has grown into a global hub for scientific discovery, conservation, education, and public engagement to advance the understanding and protection of birds.

Supported by more than eighty thousand friends and members, the Cornell Lab today is located in the Imogene P. Johnson Center for Birds and Biodiversity in Sapsucker Woods, four miles from the Cornell campus, in Ithaca, New York. Here, more than two hundred people come together daily to make breakthroughs in understanding our natural world, apply the best science to conservation efforts, and share passion and expertise with millions of people.

At any given moment, observations from citizen-science participants pour in online from locations around the world and information on birds flows out to more than eighteen million people through the Lab's websites and mobile apps.

Bird enthusiasts interact with one another and the Lab's staff through live webinars and Bird Cams; kids across the hemisphere watch birds and engage in scientific inquiry with the Lab's curricula; and researchers and students travel to field sites from the mountains of New Guinea to the Alaskan tundra.

All these activities can be traced back to Doc Allen's style of ornithology. He taught new generations of ornithologists but also led bird walks in Sapsucker Woods. He wrote popular magazine articles and hosted a radio show about birds. Taking advantage of emerging technologies, he helped capture the first birdsong recordings and pioneered the study of bird behavior using motion-picture film. He catalyzed innovations for field recording. As early as the 1930s, he raised conservation awareness by leading expeditions to record the sounds and images of vanishing wildlife.

His successors have carried this vision through the decades in a rapidly changing world, creating powerful approaches to help solve the most pressing conservation challenges of our time. Today, the Lab's mission is as

relevant and as vital as ever: "To interpret and conserve the earth's biological diversity through research, education, and citizen science focused on birds." Combined with Cornell University's motto, "Any person, any study," together these have defined the Lab for a century and continue to shape its future.

Overlooking Sapsucker Woods Pond, the Johnson Center features a visitor center and three floors behind the scenes—headquarters for scientific discovery and innovation. Inside the Lab, the Macaulay Library houses the world's largest collection of natural sounds. In 1929, Doc Allen and Peter Paul Kellogg helped record the songs of wild birds for the first time, using massive equipment from the motion-picture industry, hauled to a local park in the back of a truck. Since then, volunteer recordists have traveled the world, amassing more than two hundred thousand audio and video recordings in the collection today, each one annotated and archived as carefully as a museum specimen. On a typical day, the Macaulay Library's studios hum with activity as archivists listen to the sounds of animals as diverse as Montezuma Oropendolas in Mexico, indri lemurs in Madagascar, and bearded seals beneath Arctic ice—adding digital sounds to an ever-growing collection.

Meanwhile, people from around the world call up recordings from the Lab's online databases—as many as ten thousand clips may be heard by people in ninety-four countries in one day. In addition to these constant hits, sounds from the Macaulay Library are widely used in science and conservation. Vocalizations of birds have helped scientists recognize new species that otherwise look alike. Conservationists have even used recordings to help birds directly by broadcasting the calls of threatened species, such as Roseate Terns, to attract birds displaced by hurricanes to nest in areas safe from predators and human development.

Across the hallway from the library is the Bioacoustics Research Program. It looks like a NASA room with banks of computers and analysts gazing at the screens, but these scientists are listening to the sounds of the earth. Here they can monitor the calls of North Atlantic right whales in Massachusetts Bay in real time, detected by underwater recorders designed by the Lab's engineers and transmitted by satellite signals. When the analysts detect right whales in shipping lanes, they send an alert for ship captains to slow down to avert collisions with this endangered species.

One hundred years ago, the sounds of wildlife were as ephemeral as the wind; scientists had no way to capture and study them. In the adjacent offices at the Lab, programmers and engineers are making unprecedented advances in the automatic detection, visualization, and classification of wildlife sounds—whether the songs of whales, the infrasonic rumbling of elephants, or the fleeting calls of night-migrating birds. In their latest breakthrough, the Lab's engineers have adapted their marine acoustic detectors to recognize the sounds of chickadees—and have installed the first prototype in the Lab's bird-feeding garden. Imagine a day when entire networks of affordable, portable smart recorders might generate a real-time inventory of birds vocalizing across a landscape. It's just one of the many ways that innovations from the Lab may completely change the way we listen to—and understand—wildlife.

Down the hall is the Fuller Evolutionary Biology Program laboratory, where researchers unravel mysteries from evidence too small to see. Analyzing DNA, they have explored the mating patterns of dozens of bird species, generated landmark studies of the family trees of wood warblers and tanagers, discovered bird populations so genetically distinct that they are classified as new species, and tracked how endangered birds move among patches of remnant habitat.

OPPOSITE The Cornell Lab's live Bird Cams give people an unprecedented, intimate look into the fascinating lives of Great Blue Herons and other birds.

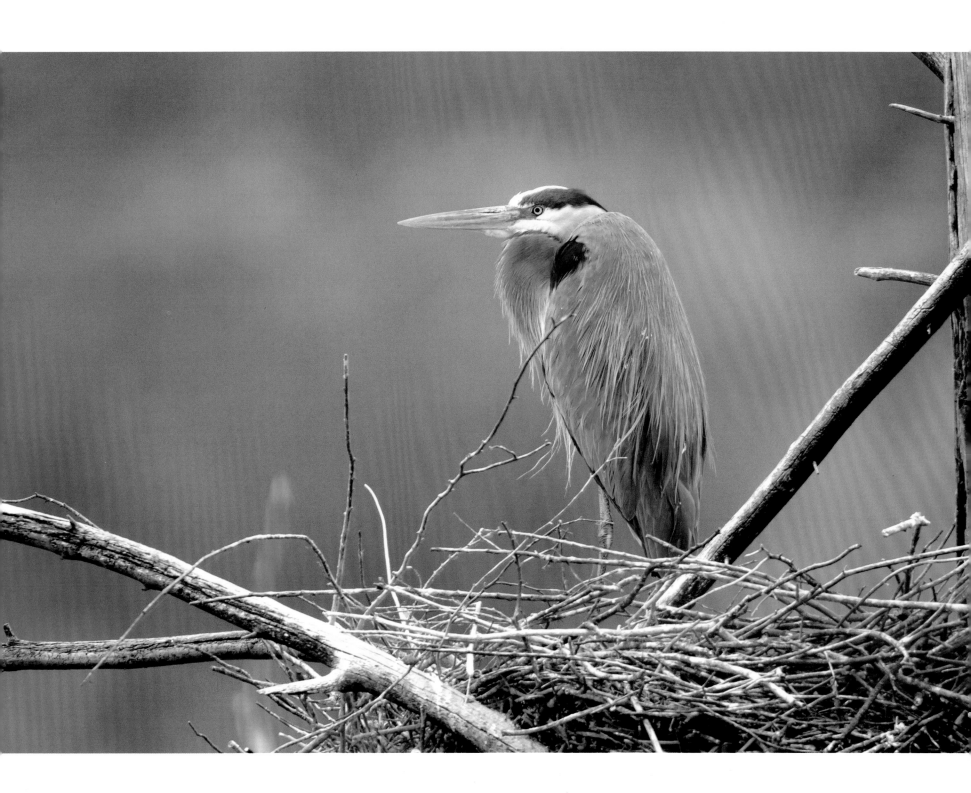

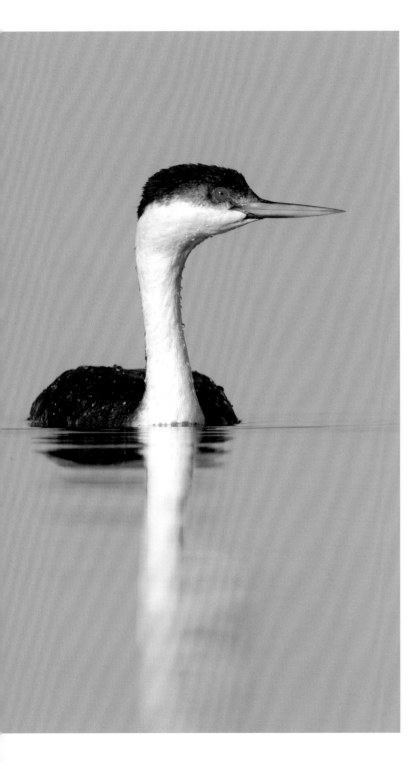

Some of the most ambitious research uses DNA to study the process of speciation in groups such as chickadees, warblers, and seedeaters, tracking what parts of the genome are involved in making new species different from one another.

Beyond the DNA lab, nature's classroom is the world, and the Lab conducts research on or offshore of all seven continents. Students are the Lab's lifeblood, bringing fresh ideas and energy to new quests. From the beginning, the Lab of Ornithology has been a critical training ground for young scientists. The scale of their global reach and impact have grown as year after year they generate new discoveries and continue their work as leaders in science, policy, communications, and biodiversity conservation.

The next floor is the home of the Lab's public participation programs in citizen science, K–12 science education, and lifelong learning. If you are one of the hundreds of thousands of people who have submitted data to a project such as eBird, the Great Backyard Bird Count, NestWatch, YardMap, or Project FeederWatch, this is where scientists analyze your data to reveal new discoveries about birds and apply findings to conservation. Database managers, programmers, computer scientists, researchers, and statisticians manage the data pouring in from participants around the world.

Bird-watchers have submitted more than two hundred million observations to eBird alone since 2002. Scientists are using powerful new techniques to combine eBird observations with environmental satellite data, weather radar, and recordings of night-flight calls to forecast the migrations and movements of birds. High-performance computing makes it possible for the first time to generate dynamic, moving maps showing the distributions and migrations of birds throughout the year—a revolutionary advance for bird-watching, science, and conservation.

LEFT A Western Grebe rests on the still waters of an Oregon wetland.

Meanwhile, just a few steps away, designers, programmers, educators, writers, and digital content managers bring birds to life through online experiences such as birding webinars, live Bird Cams, the Merlin Bird ID app, and the All About Birds website. The portal to the Lab is open 24/7, giving millions the anywhere-anytime ability to record observations, share in new discoveries, or find inspiration in the world of birds.

Outside the windows, a panoramic view of Sapsucker Woods Pond is a living backdrop to the Lab's daily work to celebrate and protect nature. High in a dead tree in the center of the pond, a camera is affixed to the trunk. Through that lens, more than two million people have experienced Sapsucker Woods from above, watching the herons, kingfishers, and wildlife of the pond, night and day through the changing seasons. Everything at the Lab seems designed to bring the world of birds inside and the science from the Lab outside.

The Cornell Lab of Ornithology is for everyone. Whether here or anywhere in the world, people of all ages and backgrounds can connect with the Lab to enrich their understanding of birds, share their experience, and express their appreciation by helping to protect nature. What unites and fuels the extraordinary work of the Lab and its global community of people who care about birds? Most universally, perhaps it's just the love of birds. The beauty of birds, their diversity, their color and flight, their songs and fascinating behaviors all capture our imagination and inspire us to appreciate the interconnected wonders of nature. More specifically, the power of science, technology, and human ingenuity help us understand the mysteries of birds and apply what we learn to make this next century a better one for the environment. Will we stand by, witnessing more species blinking out to extinction? Or we will channel our passion and expertise to ensure that birds will remain in our world? For those who love birds, it's not a choice but a burning necessity. This job of learning about birds and protecting them will—and must—go on.

To learn more, visit the Lab, get involved, or explore its online resources, go to:

birds.cornell.edu

AllAboutBirds.org

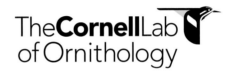

Cornell Lab of Ornithology
159 Sapsucker Woods Road
Ithaca, New York 14850

A flock of Marbled Godwits rests while waiting for tides to uncover feeding areas in a Pacific estuary.

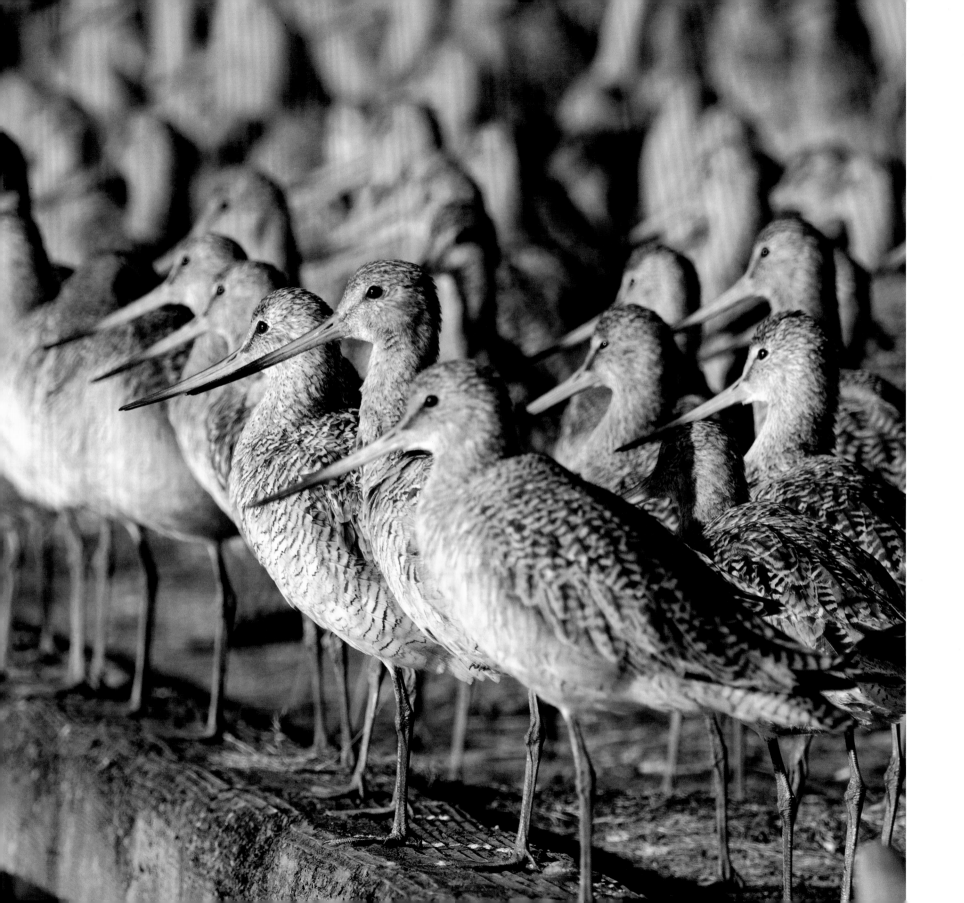

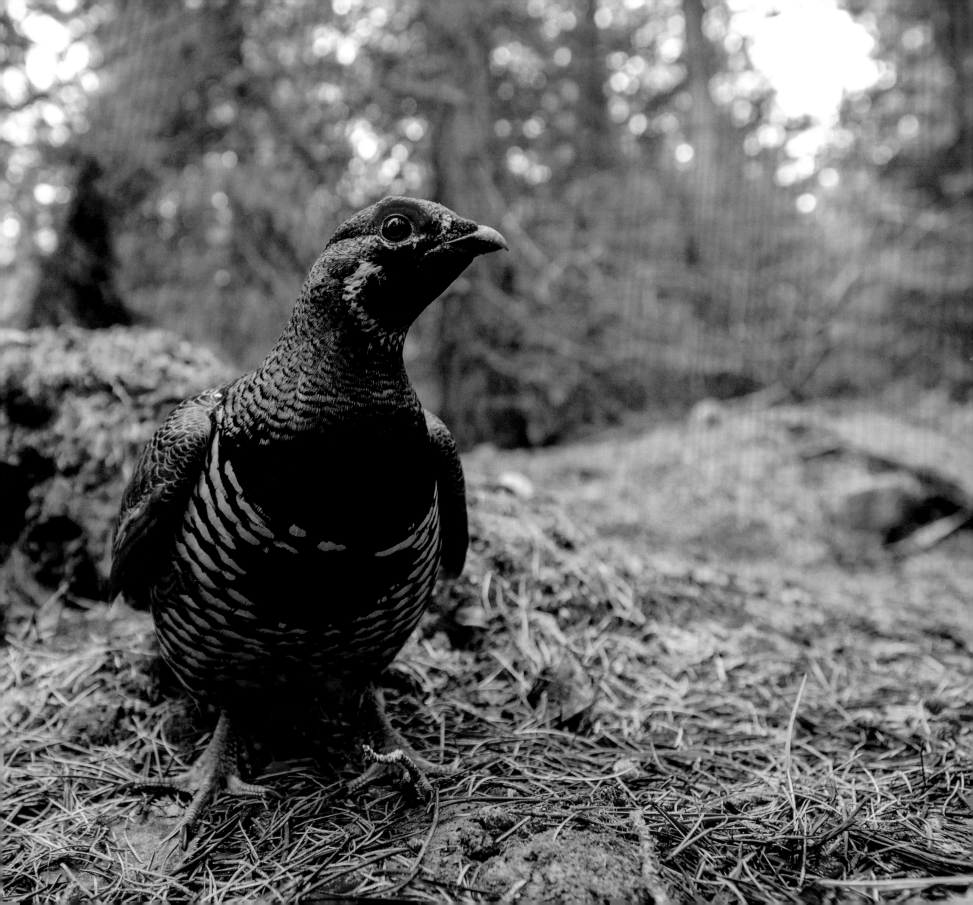

Acknowledgments

OPPOSITE The Spruce Grouse is one of more than three hundred species and billions of individual birds that breed across Canada's boreal forest—one of the largest intact forests left on earth and a habitat under increasing pressure from logging, mining, and oil and gas extraction. Nearly two-thirds of Canada's boreal forest product—including catalogs, junk mail, and tissue paper—are consumed in the United States. Consumer choices can help determine the future of boreal forest birds.

WE WOULD LIKE TO THANK Austin "Kip" Kiplinger and every past and current member of the Administrative Board of the Cornell Lab of Ornithology for their unfailing support of the Lab and its mission through the years. We are especially grateful to Ned Morgens, Rusty Rose, and Linda Macaulay, three leaders who have given generously of their time, wisdom, and resources as chairs of the Administrative Board over the past quarter century.

GERRIT VYN THANKS:

I am deeply grateful to the many people who helped bring this book to life.

First and foremost, thank-you to John Fitzpatrick and John Bowman at the Cornell Lab and to Helen Cherullo at Mountaineers Books for enthusiastically supporting the concept of this book and making it a reality. This book would also not have been possible without the leadership and creativity of editor in chief Kate Rogers and the rest of the talented staff at Mountaineers Books, especially Mary Metz. Thanks also to the writers who enthusiastically joined this project and produced inspirational work on a short timeline.

Working at the Cornell Lab I am constantly inspired by my colleagues' passion for and dedication to bird conservation and scientific excellence. I'd like to particularly thank Lab staff and friends Marc Dantzker, Eric Liner, Mike Andersen, Ben Clock, Martha Fischer, and Andy Johnson for their companionship in the field when many of these images were made.

In reviewing the photographs in this book I am reminded of the many individuals who made special efforts to help me be successful in the field. Sincere thanks go to Doug Backlund, Miriam Bailey, Sonny Bass, Steve Bentsen, Karin Holser, Ron Laird, Karleen Robinson, Adam Sedgley, Sue Steinacher, Mark Thonoff, Menxiu Tong, and Timmy Vincent. Special thanks to Brian McCaffery and the Yukon Delta National Wildlife Refuge. Thanks also to the staffs at Audubon's Rowe Sanctuary and the Archbold Biological Station.

My work in Russia would not have been possible without the support of Evgeny Syroechkovskiy and Birds Russia; I also offer special thanks to Egor Loktionov and Pavel Tomkovich. In Mexico, I thank Xiomara Gálvez, Rodrigo Migoya, and the Ría Lagartos Biosphere Reserve.

Many years ago, when I was in my early teens, Rick Simek, then a young twenty-something naturalist of great skill, took the time to include me in dozens of field excursions beyond my local haunts and helped me develop as a naturalist; I offer Rick my sincere gratitude. I also must thank my lifelong and inspirational friends from the Burgundy Center for Wildlife Studies.

Lastly, thank-you to my family for their constant love and support. Though I am often far from home, knowing you're always there has given me the strength and freedom to roam.

List of Contributors

GERRIT VYN is a photographer, cinematographer, and producer for the Cornell Lab of Ornithology. He leads expeditions around the world to document wildlife and conservation stories. His work often focuses on birds because they are such powerful indicators of environmental health and change. Vyn's photographs are used by most major conservation organizations and appear regularly in books and magazines including *National Geographic, Audubon, BBC Wildlife,* The *New York Times,* and *National Wildlife.* His audio and video work has been featured on radio and television programs including PBS *Nature,* NPR's *Morning Edition,* and CBS *Sunday Morning.* Vyn is a Fellow of the International League of Conservation Photographers (iLCP). You can learn more about his work at www.gerritvynphoto.com.

BARBARA KINGSOLVER is the bestselling and critically-acclaimed author of fourteen books, including the novels *The Bean Trees, Animal Dreams,* and *The Poisonwood Bible* and the nonfiction *Animal, Vegetable, Miracle: A Year of Food Life.* She is the recipient of dozens of awards including the Dayton Literary Peace Prize, Britain's Orange Prize, and the National Humanities Medal, our country's highest honor for service through the arts. She lives, works, and watches birds with her husband on their farm in southwestern Virginia.

JOHN W. FITZPATRICK is a professor of ecology and evolutionary biology at Cornell University, and a professional ornithologist with expertise in avian behavior, ecology, and conservation biology. For twenty years he has been executive director of the Cornell Lab of Ornithology, a world renowned institute for research, education, and conservation of birds and biodiversity. Dr. Fitzpatrick has authored several books and more than 150 scientific articles, including descriptions of seven bird species he discovered while leading expeditions in remote areas of South America. Winner of numerous awards for research and conservation activities, he is co-inventor of eBird, now the world's largest citizen-science project, and he is an active participant on several Endangered Species recovery teams.

SCOTT WEIDENSAUL is a naturalist, author, and researcher who has written more than two dozen books on natural history, including the Pulitzer Prize finalist *Living on the Wind: Across the Hemisphere with Migrating Birds,* as well as *The First Frontier* and most recently, *The Peterson Reference Guide to Owls of North America and the Caribbean.* Weidensaul is a contributing editor for *Audubon* and writes for a variety of other publications. He lives in the mountains of eastern Pennsylvania, where he studies the migration of owls and hummingbirds.

LYANDA LYNN HAUPT is a naturalist and eco-philosopher whose writing is at the forefront of the movement to connect people with nature in their everyday lives. She is the author of numerous articles as well as four books,

including *Crow Planet: Essential Wisdom from the Urban Wilderness,* which received the 2010 Sigurd F. Olson Nature Writing Award, and *Rare Encounters with Ordinary Birds,* a winner of the 2002 Washington State Book Award. Her most recent book is *The Urban Bestiary: Encountering the Everyday Wild.* Haupt has created and directed educational programs for Seattle Audubon, worked in raptor rehabilitation in Vermont, and been a seabird researcher for the US Fish and Wildlife Service. She blogs at The Tangled Nest, www.thetanglednest.com.

JARED DIAMOND is Professor of Geography at the University of California–Los Angeles and has been elected to the National Academy of Sciences, the American Academy of Arts and Sciences, and the American Philosophical Society. Among his many awards are the National Medal of Science, the Tyler Prize for Environmental Achievement, a MacArthur Foundation Fellowship, and the Lewis Thomas Prize Honoring the Scientist as Poet. He has published more than six hundred articles and six books, including the bestsellers *Collapse: How Societies Choose to Fail or Succeed* and *Guns, Germs, and Steel: The Fates of Human Societies,* which was awarded the Pulitzer Prize.

SANDI DOUGHTON, who contributed the three human profiles, is an award-winning science writer for *The Seattle Times* and the author of the book *Full Rip 9.0: The Next Big Earthquake in the Pacific Northwest.* During her more than twenty years as a journalist, her reporting has taken her far and wide, including from the Bering Sea, where she covered climate change and chased seals over pancake ice, to Africa, where she tracked the Gates Foundation's efforts to develop a malaria vaccine.

MIYOKO CHU is the senior director of communications at the Cornell Lab of Ornithology. She is the author of *Songbird Journeys: Four Seasons in the Lives of Migratory Birds* and *BirdScapes: A Pop-Up Celebration of Bird Songs in Stereo Sound.* She earned her PhD at the University of California—Berkeley, studying the behavioral ecology of Phainopeplas. Today she works with the talented teams that create the Cornell Lab's print, online, and mobile resources, including the All About Birds website, Bird Cams, and Merlin Bird ID app.

DENNIS PAULSON, retired director of the Slater Museum of Natural History, University of Puget Sound, has been a professional biologist and naturalist all of his adult life. He began studying natural history as a boy and is a world expert on dragonflies and shorebirds. He is the author of nine books, including *Shorebirds of North America* and *Dragonflies and Damselflies of the West,* as well as ninety scientific papers on birds and dragonflies. He researched and wrote many of the captions in this book.

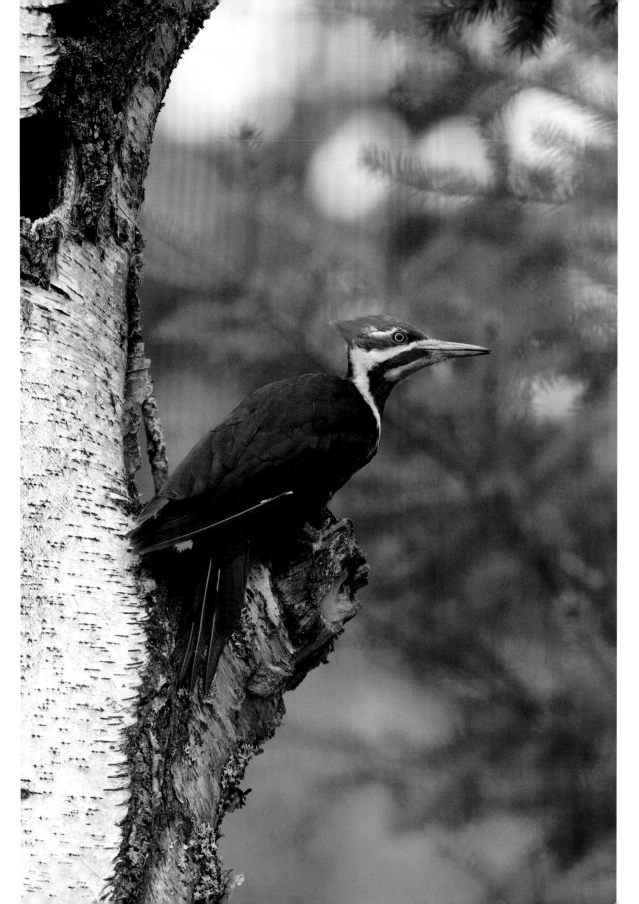

For a long time, Pileated Wood-peckers were associated with old-growth forests, but some-where along the way these big, showy birds adapted to humans, and they are now on the increase in most parts of their range, turning up in city parks and green belts everywhere there are trees large enough to furnish nest sites.

MOUNTAINEERS BOOKS is a leading publisher of mountaineering literature and guides—including our flagship title, *Mountaineering: The Freedom of the Hills*—as well as adventure narratives, natural history, and general outdoor recreation. Through our two imprints, Skipstone and Braided River, we also publish titles on sustainability and conservation. We are committed to supporting the environmental and educational goals of our organization by providing expert information on human-powered adventure, sustainable practices at home and on the trail, and preservation of wilderness.

The Mountaineers, founded in 1906, is a 501(c)(3) nonprofit outdoor activity and conservation organization whose mission is "to explore, study, preserve, and enjoy the natural beauty of the outdoors." One of the largest such organizations in the United States, it sponsors classes and year-round outdoor activities throughout the Pacific Northwest, including climbing, hiking, backcountry skiing, snowshoeing, bicycling, camping, paddling, and more. The Mountaineers also supports its mission through its publishing division, Mountaineers Books, and promotes environmental education and citizen engagement.

Our publications are made possible through the generosity of donors and through sales of more than 600 titles on outdoor recreation, sustainable lifestyle, and conservation. To donate, purchase books, or learn more, visit us online.

MOUNTAINEERS BOOKS
1001 SW Klickitat Way, Suite 201 • Seattle, WA 98134
800-553-4453 • mbooks@mountaineersbooks.org • www.mountaineersbooks.org

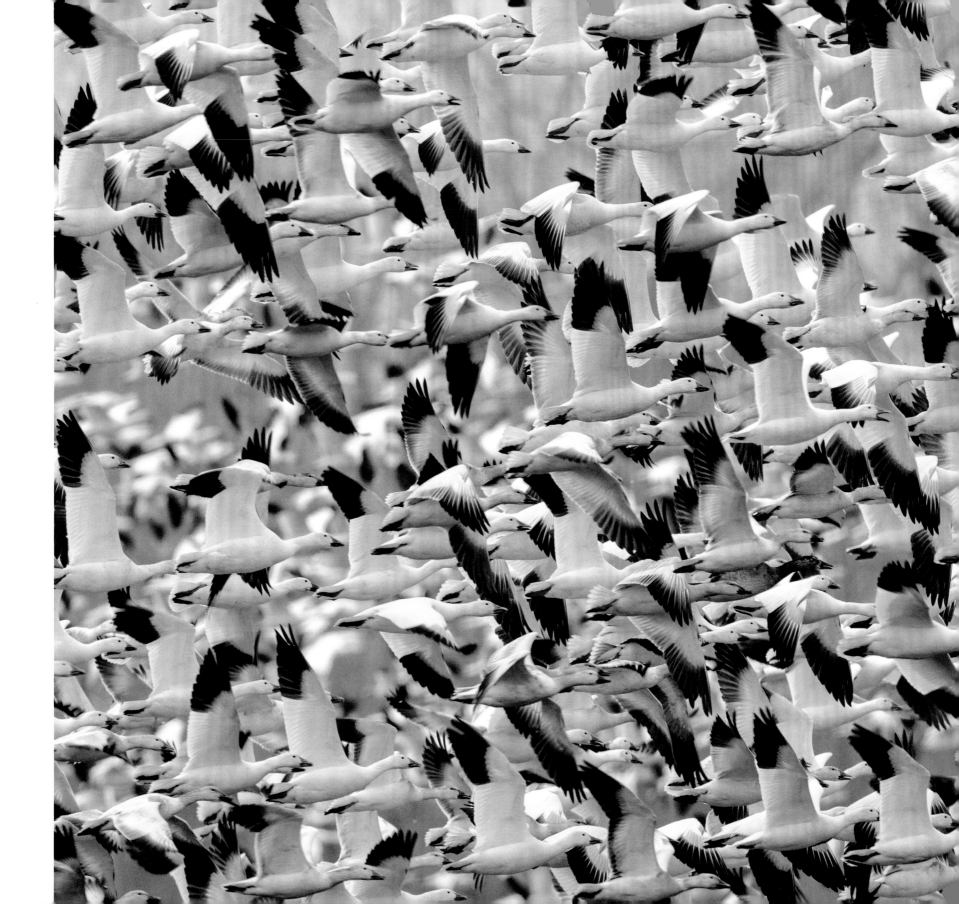

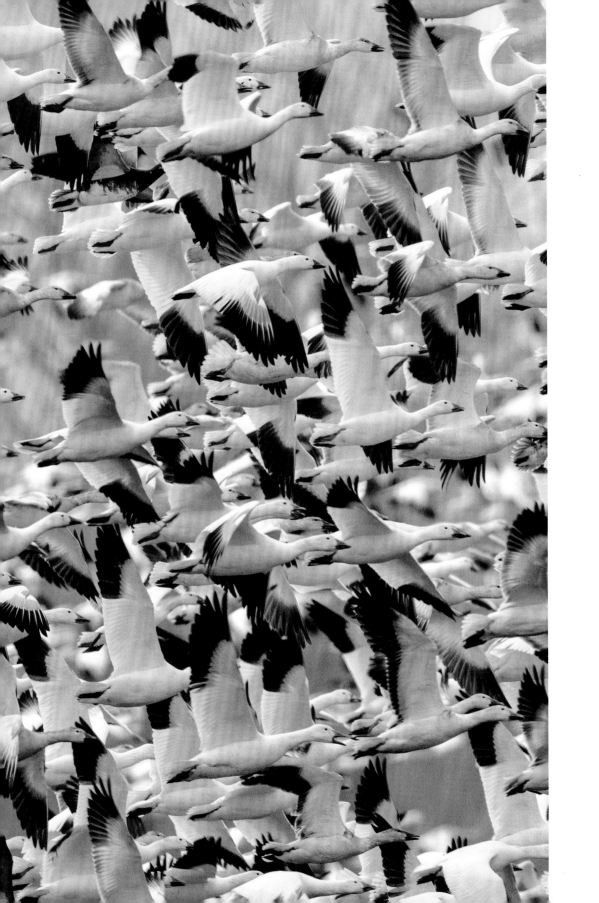

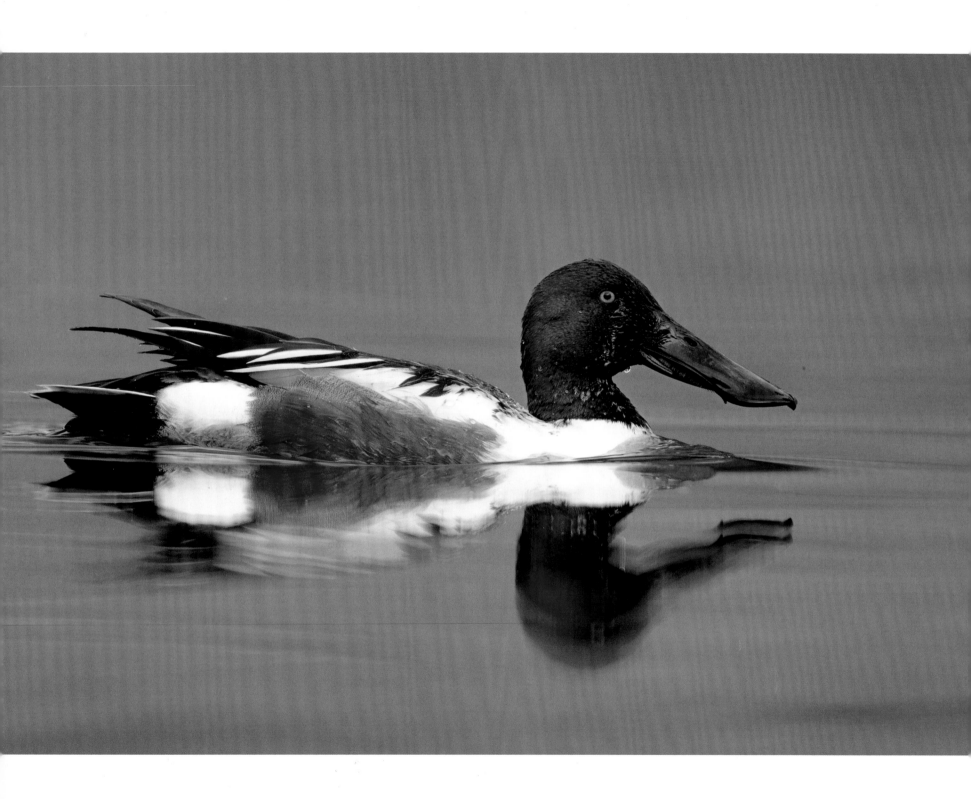

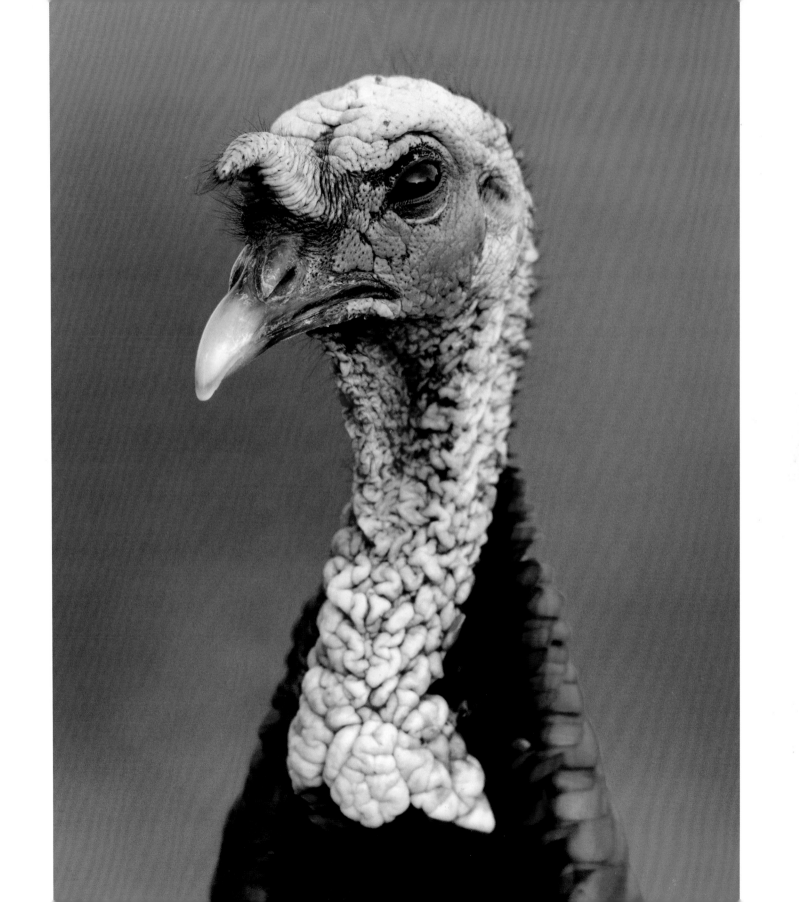

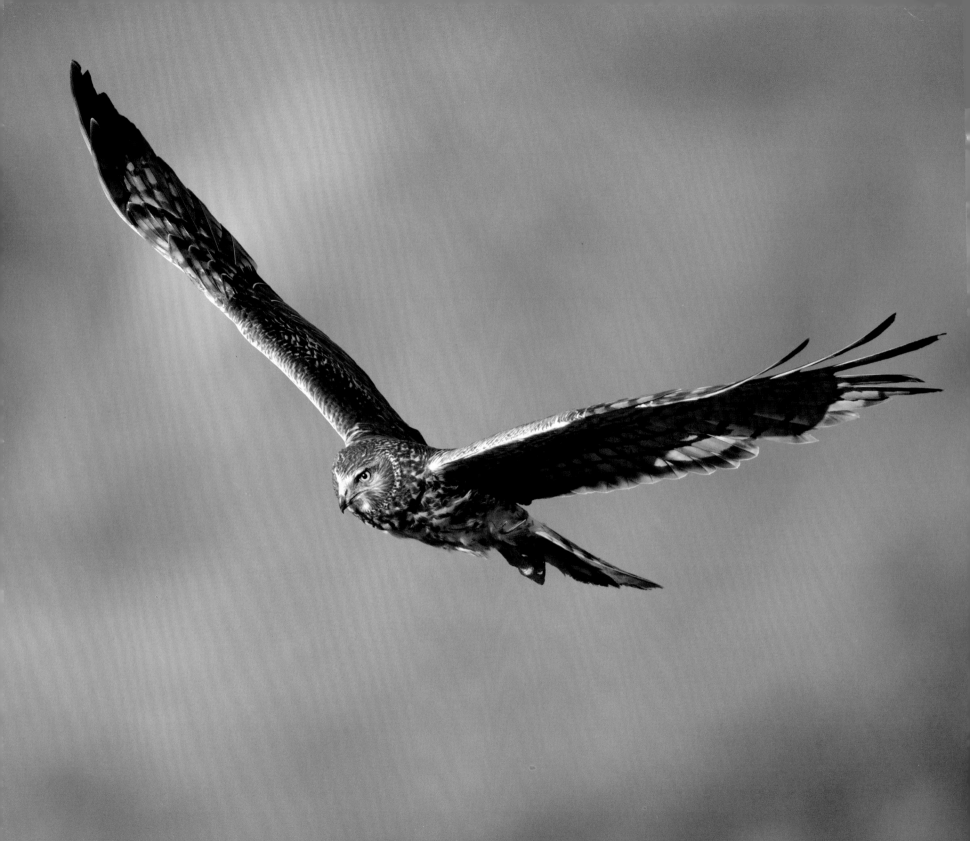